The Voice of the City

Robert W. Snyder, a writer and historian, is now an associate of the Media Studies Center in New York. He studied at Rutgers and at New York University, where his dissertation won the Bayrd Still Prize. He is also a former newspaper reporter and has taught at Princeton and at New York University.

THE
VOICE
OF THE
CITY

*Vaudeville and Popular
Culture in New York*

ROBERT W. SNYDER

With a New Preface by the Author

Ivan R. Dee

CHICAGO

For my parents,
Max and Mildred Snyder

THE VOICE OF THE CITY. Copyright © 1989, 2000 by Robert W. Snyder. This book was first published in 1989 by Oxford University Press and is here reprinted by arrangement. First Ivan R. Dee paperback edition published 2000. For information, address: Ivan R. Dee, Publisher, 1332 North Halsted Street, Chicago 60622. Manufactured in the United States of America and printed on acid-free paper.

Library of Congress Cataloging-in-Publication Data:
Snyder, Robert W., 1955–
 The voice of the city : vaudeville and popular culture in New York /
Robert W. Snyder ; with a new preface by the author.
 p. cm.
 Based on the author's thesis.
 Originally published: New York : Oxford University Press, 1989.
 Includes bibliographical references and index.
 ISBN 1-56663-298-6 (alk. paper)
 1. Vaudeville—United States—History. 2. Vaudeville—New York
(State)—New York—History. 3. Popular culture—New York (State)—New
York. I. Title.
PN1968.U5 S68 2000
792.7'09747'1—dc21 99-057802

Acknowledgments

This book could not have been written without the many people who shared with me their memories of vaudeville. Like all those who helped me, they are not responsible for any errors of fact or interpretation I may have committed. However, in interviews or correspondence, their contributions were beyond measure. My deepest thanks go to Harold Applebaum, Ted Arnow, Howard Basler, Catherine Shaffer Beecher, Bunny Berk, James Bevacqua, Joseph Brennan, Margaret Brown, Ida Davis, Capitola DeWolfe, Harold Engel, Billy Glason, Jack Gross, Ethel Gilbert Hardey, Mary Irish, Terese Klein, Arthur Kline, Lewis Kornbluth, Hal Leroy, Eva Newton, Richard Osk, Lloyd Pickard, Frances Poplawski, Jack Robinson, Michael Ross, Frank Rowan, Murray Schwartz, Florence Sinow, Bill

Smith, Harry Stanley, Norman Steinberg, George Wein-
stein, Charles Weintraub, and Joyce W. Zuk.

Originally, this study was my doctoral dissertation. I
thank the two institutions that made the initial scholarship
possible: the Graduate School of Arts and Science of New
York University, which awarded me a fellowship for the
academic year of 1983–84, and the National Museum of
American History, Smithsonian Institution, Washington,
D.C., which gave me a pre-doctoral fellowship for 1984–85.

At New York University, I received valuable advice and
encouragement from history professors Daniel J. Walko-
witz and Thomas Bender. Brooks McNamara of the De-
partment of Performance Studies provided guidance on
theatre history. At the Smithsonian I benefited from the
friendly counsel of Carl H. Scheele, Division of Commu-
nity Life, National Museum of American History. I also
owe special thanks to John R. Gillis of Livingston College,
Rutgers University, who confirmed my interest in history
years ago and who started me thinking about many of the
issues discussed here.

The members of the Smithsonian Fellows' Seminar of
1984–85, especially Christopher Clark and Robert Kor-
stad, provided useful suggestions and friendship. At New
York University, I received enormous help and encourage-
ment from Elaine Abelson, Peter Eisenstadt, and Margaret
Hunt.

I tried out many of my ideas at a variety of seminars and
conferences. For these opportunities, I thank the orga-
nizers of the 1986 New-York Historical Society conference
on immigration in New York City, the February 1986
Commercial Culture Seminar of the New York Institute
for the Humanities, the 1985 museum seminar of the Na-
tional Museum of American History, the 1985 meeting of
the Mid-Atlantic Conference of the Society for Ethnomu-

sicology, the Columbia University Labor History seminar, the 1987 American Studies Association convention, the 1988 New York–Budapest Conference of the American Council of Learned Societies and the Hungarian Academy of Sciences, and the Princeton University History Department lunchtime discussion group.

Walter Zvonchenko at the Kennedy Center branch of the Library of Congress helped me through complicated stages of my research. I am also grateful for the assistance I received from the staff of the following institutions: the New York Public Library (especially the branch at Lincoln Center), the Library of Congress, the Brooklyn Historical Society, the National Museum of American History, the University of Iowa, New York University, the Bronx County Historical Society, the Staten Island Institute of Arts and Sciences, the Queens Historical Society, the Museum of the City of New York, the New York City Municipal Archives, the New-York Historical Society, the Washington National Records Center at Suitland, Maryland, and the New York branch of the National Archives at Bayonne, New Jersey.

In the long transition from dissertation to book, I received many suggestions from many people. The most influential came from William R. Taylor of the State University of New York at Stony Brook, who persuaded me to rethink many of my original ideas. Although I argued with him at first, I eventually came to see his wisdom. Other important advice and good cheer came from James E. Goodman, Peter R. Eisenstadt, Daniel J. Czitrom, Francis G. Couvares, John Kuo Wei Tchen, Marybeth Hamilton, Henry Sapoznik, Allen M. Howard, and Marilyn B. Young. My discussions with the 1987 Commercial Culture Junior Seminar at Princeton University helped me refine my ideas, as did the astute suggestions of Sheldon Meyer and

Rachel Toor at Oxford University Press. Gail Cooper's copy editing sharpened my manuscript, and the proofreading of Albert R. Eshoo, Demetrios J. Mihailidis, Russell Olwell, Nancy M. Robertson, and Pauline Toole saved me from typographical errors. My sister, Ellen Marie Snyder, took my photograph for the hardcover book jacket.

The good words and good humor of my family and friends sustained me in my work on this project. Whether or not I have mentioned them by name, they all have my gratitude. But most of all, I thank my parents, Max and Mildred Snyder, for all their encouragement and the high example of their intelligence, curiosity, and integrity.

Contents

Introduction

Vaudeville, like most successful things, was based on a simple idea: stage shows with something for everyone. But in a city with the enormous diversity of New York, that was never a simple proposition. Each show had to have enough rough fun for workingmen, enough glamour for middle-class women, and enough old-country sentiment for immigrants far from home. A complete bill was a synchronized succession of daredevils, comics, tearjerkers, and crooners. The combination made vaudeville the most widely enjoyed form of turn-of-the-century theatre.

First and foremost, vaudeville was a business. The entrepreneurs who put the shows together were out to make money. But in New York City, they worked in a dynamic and complex metropolis that gave their creations consequences they never anticipated.

To succeed, vaudeville had to have as many voices as the city where it thrived. They swelled together in a chorus that was rarely in unison, sometimes in harmony, and always as loud, brassy, and quintessentially New York as the sound of a subway train roaring into Times Square. Vaudeville was slapstick clowns and devilish comedians who challenged old codes of propriety and gentility. It was sentimental songs about Mother and the pain of unrequited love. It was elaborately tuneful productions that heralded the beginning of American musical theatre. It was the children of slaves and immigrants, whose singing, dancing and music gave a new, multicultural meaning to American identity. And there were sour notes: the grasping entrepreneurs who squeezed their money out of performers' paychecks, the frustrations of artists who aimed for stardom but fell short, and the ugly racial stereotypes that distorted the portrayal of black Americans.

Yet the symphonic sound of New York vaudeville was shaped by more than its metropolitan environment. It was also formed by the larger times and society.

The turn of the century marked a watershed in the history of American popular culture, which is defined by its broad audience. Its expressions—songs, stories, comedy, whatever—are accessible to people in all segments of society. But when vaudeville appeared, the conditions under which popular culture was produced and enjoyed were changing.[1]

From colonial days to the middle nineteenth century, American popular culture was deeply influenced by custom, tradition, and public festivity. It was usually rooted in a place, like the Bowery of New York City, with its saloons and cheap theatres. Local likes and dislikes exercised a profound influence over the relationship between artists

and audiences, so much so that audiences sometimes seemed like coproducers of the show.

In the twentieth century, popular culture came to be defined by electronic mass media—film, radio, recordings, and television. A centralized entertainment business, which disseminated standardized products from coast to coast, undermined the local bases of culture. The rowdy spirit of the Bowery became a portable, marketable commodity. Audiences, which had once so intensely interacted with live performers, eventually became consumers of electronic sounds and images—often in the privacy of their homes.

Vaudeville arose in the middle of this transition and helped it along. The vaudeville theatre's polyphony was partly caused by the contrast between old and new popular culture. Vaudeville shows had bounce, immediacy, and energy, but the industry that presented them was bureaucratic and hierarchical. They offered the hilarity of an old-fashioned carnival and the flickering screen images of the first motion pictures. They paid close attention to local audiences, but knit them into a modern mass constituency. They featured blackface minstrels straight out of Jacksonian America and modern Jewish comedians from the Lower East Side.

The genius of such shows lay in their ability to speak to a complex and infinitely varied audience. By the 1890s, immigration and industrialization had made New Yorkers a people of divergent nationalities, religions, races, and classes—all of them wrestling, it seemed, with the definition of the proper roles for men and women. New Yorkers seemed to have as many differences as similarities.

In such a city, a form of theatre that offered something for everyone was bound to present people with the unexpected. When New Yorkers entered a vaudeville theatre,

they entered an arena for communications between otherwise separate people. There they encountered strangers and novelties and tried on new ways of thinking, feeling, and behaving. Influences flowed back and forth in the kind of reciprocal cultural exchange that scholars have called "circularity."

All who participated were transformed. Middle-class women experimented with alternatives to the chafing restraints of Victorianism when they watched the cyclonic singing and dancing of Eva Tanguay. Working people relieved factory monotony with the hilarity and vitality of Eddie Cantor. Businessmen escaped from office stress with sketches like "Blackmail," a short vaudeville play that crackled with intrigue. Irish-Americans, so recently the outcasts of the city, celebrated their ascendancy when Maggie Cline roared out the boxing ballad "Throw Him Down, McCloskey." Homesick Jews found a hymn to Mom and a new American ethnic identity when Sophie Tucker sang "My Yiddisha Mama." White Americans discovered the musical artistry of black Americans, which was already transforming popular music with the buoyant, syncopated strains of ragtime.

Culture is a many-sided conversation, and nowhere in turn-of-the-century America were the voices more complex, contradictory, and concentrated than in vaudeville. In the vaudeville theatre, New Yorkers found celebration and sentiment, freedom and confinement, abundance and exploitation, intimacy and bureaucracy, glitter and meanness: the voice of the city.

Preface to the 2000 Edition

In 1989, when this book first appeared, a pair of old vaudevillians who had played the Palace in 1919 would still have recognized their old haunts on the streets of Manhattan. On 14th Street at Union Square, where vaudeville first thrived in New York City, the old Keith's theatre could be glimpsed behind a billboard and a bargain store. In the Times Square theatre district, at 47th Street and Broadway, stood the Palace Theatre—the object of so many vaudevillians' ambitions.

Today, all is changed. The Keith's theatre on Union Square was demolished to make room for Circuit City and the Virgin Megastore, which between them supply every need for home entertainment. The Palace, from the outside, is unrecognizable. In a partial act of historic preservation, the building that surrounded the Palace was dismantled; the hall itself was preserved and is now en-

cased inside the DoubleTree Guest Suites Hotel. The marquee advertises "Disney's Beauty and the Beast." Stand on the sidewalk in front of the Palace, where anxious vaudevillians looked for work, and you can watch one sign flash stock prices while another touts BananaRepublic.com.

Clearly we have reached the end of an era for city life and for American popular culture. Michael Kammen marks the trajectory well in *American Culture American Tastes,* and his nuances are as important as his broad delineations: from "more often than not . . . a participatory and interactive" popular culture to a more often than not passive and privatized mass culture to the uncertain future conjured up by the computer in the 1980s.

At the beginning of the twentieth century, vaudeville was central to an urban, participatory popular culture defined by live entertainment for audiences that were local in their immediate composition but national in their cumulative weight. By the thirties vaudeville was all but gone. The movies appropriated its audience, gratifying it with films presented in theatre chains that often grew out of vaudeville circuits. Radio shows aside, entertainment still meant going out in public. In the fifties, however, the rise of television made the home the locus of entertainment. Variety shows like Ed Sullivan's might copy the format of the vaudeville show, and television networks could assemble mass audiences, but public entertainment was giving way to the private experience of television shows. At the beginning of the twenty-first century, the rise of cable television and the Internet portends a new era of niche audiences and interactive entertainment on demand.

Vaudeville was, as the critic David Marc put it, the biblical era of twentieth-century American show business. Its

stars invigorated early radio, film, and television. Its format, a series of acts strung together, was transplanted to radio and television variety shows. Its theatre circuits spawned chains of movie theatres. Its mass audience—constructed by calculating entrepreneurs, assembled in public, dynamically varied in its composition, significantly urban in its origins, knowledgeable and vocal in its demands—was the defining element of American popular culture for the first half of the twentieth century.

Vaudeville was public, collective, transforming without being boldly oppositional, and a meeting place for people who otherwise lived disparate lives. It was not a juggernaut of mass culture. It was a hybrid form of theatre, offering a distinct arena for communication that people could enter and leave from their own particular subcultures. Although vaudeville's structure and audience paved the way for a vast entertainment industry, vaudeville itself thrived by accommodating local preference and custom.

Although vaudeville is now part of a receding past, in its history we can glimpse both a world we have lost and the embryonic forms of enduring patterns in American culture. Vaudeville was popular in its origins and oligarchic in its distribution—a duality that has, in film, music, and television, defined American popular culture. At the same time vaudeville embodied the central contradiction of society and culture at the dawn of the twentieth century: consolidation and diversification. The vaudeville booking companies established cultural power and authority under one roof, paving the way for more centralized institutions such as television networks. Yet diverse vaudeville audiences and polyglot shows introduced people to new ways of thinking and feeling. Immigrants glimpsed the American mainstream, the proper middle

class laughed at knockabout comedians, and Bowery roughnecks wept at sentimental songs about home and mother.

Vaudeville was a deeply contradictory form of theatre, its meanings as elusive as the patter of a doubletalk comedian. Committed, then as now, to "history from the bottom up," I tried to relate vaudeville to everyday life in New York. From reading in labor history, particularly the work of E. P. Thompson and Herbert Gutman, I expected to find a working-class culture defined by its autonomy and its hostility to middle-class norms. Such characteristics could certainly be found in the labor struggles that roiled urban communities. Yet when I looked at working-class neighborhoods through the lens of vaudeville, and interviewed the performers and fans, I found little evidence of an overtly oppositional culture. Humor in immigrant and working-class neighborhoods could be inflected with an ethnic accent and acutely aware of the differences between uptown and downtown life. But it was not the humor of a world apart. Small-time vaudeville was, for fans and performers, a kind of minor league—closer to home in its origins, but ultimately defined by its status as a modest version of the big time.

By 1910, it seemed, vaudeville theatres and the neighborhoods they served were being incorporated into national networks of culture with little or no resistance on the part of their inhabitants—which is not to say that vaudeville was part of a massive culture of consensus. There were too many kinds of people lured into the vaudeville audience for all to think alike, and too many potholes in the road to the big time for performers to feel sanguine about success. In light of demanding audiences and sharp-eyed managers, vaudevillians appear less like avatars of a culture of personality and abundance and

nature," encouraged me to relate vaudeville to urban pat-
terns of culture and geography.

"The city," Park wrote, ". . . always shows the good and
evil in human nature in excess." So too the vaudeville in-
dustry. Its industrial character—right down to its union
and its strikes—is profitably analyzed in the judiciously
applied light of the Frankfurt School—even though their
emphasis on "mass culture" can be misused to slight the
heterogeneity of the vaudeville audience. Vaudeville's
great characteristic was not that it reduced people to a
uniform mass, but that it spoke to and with a highly var-
ied public that was divided by class, ethnicity, and gender.
Nevertheless, as writings from the Frankfurt School re-
mind us, culture industries are one of the powerful and
characteristic elements of life in the twentieth century.

The best correction to the distortions created by using
the Frankfurt School's concept "mass culture" without a
sense of nuance come from cultural studies, particularly
the writings of Stuart Hall and James Carey. As the histo-
rian Daniel Czitrom once reminded me, people have
their own ways of creating the meanings of cultural prod-
ucts. Indeed, this ability redeems cultural industries'
products—and saves the audience becoming a passive
mass. Moreover, if we think of culture as communication,
in Carey's phrase, and if we properly locate vaudeville at
the center of the culture of early twentieth-century New
York, we see that the vaudeville house was more than a re-
flection of its time—it was an organ of communication
that focused and amplified the voices of New York City. In
the conversation of culture, the lessons, diversions, sur-
prises, and disciplines that people found in vaudeville
shows powerfully shaped their understanding of their city
and their times.

Since the publication of *The Voice of the City* in 1989, sev-

more like Albert Murray's blues heroes, "affirming life in the face of adversity."

From critical theory I expected to find in vaudeville the birthplace of the passive audience, endlessly consuming the products of a culture industry that fostered cultural conformity. Instead I found audiences that were strikingly demonstrative and a vaudeville industry that was national in its scope— but whose theatre managers were deeply attuned to local preferences.

Vaudeville is too often viewed nostalgically as the benign but corny theatre of "the good old days." Show business memoirs are partly to blame. When I began my research I expected to find a polite and refined vaudeville that was, after its early days of bawdiness and scruffiness, cleansed of all references to sex and sin. Instead, after reading scripts, song sheets, gag books, and managers' reports, and interviewing former performers and audience members, I found a vaudeville that unraveled Victorianism even as it bowed to it. Vaudevillians catered to an audience that was born to Victorianism but headed for a more libertine era, and they learned to acknowledge old mores while opening up opportunities for new ones.

The challenge was to make sense of vaudeville without flattening its intrinsic contrariness. A good place to start was with the Chicago School sociologists, with their concern for the organization of urban life, its social relations, and changing metropolitan identities. Ernest W. Burgess's interest in the relationship between local and metropolitan institutions of recreation, and Robert E. Park's injunction to see the city not just as "a physical mechanism and an artificial construction" but as a place "involved in the vital processes of the people who compose it . . . a product of nature, and particularly of human

eral scholars have produced works that have added to and complemented its analysis. Kathryn J. Oberdeck, in her study of the theatre manager Sylvester Poli, has shown how one showman juggled the clash of cultural values that swirled around and in the vaudeville house. David Nasaw has provided an expanded context for understanding vaudeville by situating it within the dynamic, gregarious, public culture of American cities and their amusements in the first half of the twentieth century and reminding us of the poisonous element that bound together this culture: racist stereotypes onstage and segregation in the seats. Daniel Czitrom has demonstrated how Tammany chieftain Tim Sullivan exploited the connections between urban entertainment and urban politics, forged in partisan fights over the regulation of amusements, to profit in both realms and become a proprietor of the Sullivan-Considine vaudeville circuit. M. Allison Kibler has illuminated the combustible cultural negotiations between definitions of male and female, rough and refined, and high and low culture that occurred in vaudeville houses. All of these suggest that the complexities of vaudeville will remain a fruitful subject of historical analysis for years to come. The present, however, is another story.

In 2000 the relationship between city life and popular culture is not what it was a century earlier. The local, public, and participatory popular culture of the vaudeville years, as Kammen notes, has given way to a global, privatized, niche-marketed, consumer culture. This transition has not been absolutely uniform. Crowds still walk through Times Square. Media moguls still pursue massive audiences. Most heartening, rap and Latin music in New York City are invigorated by local creativity. Merengue provides a sound track for Dominican neighborhoods,

much in the way that Tin Pan Alley tunes animated immigrant streets a century ago. And the multiracial audience for rap music, which undermines the sharpest distinctions between black and white, and urban and suburban, recalls vaudeville's challenge to the binary categories of Victorian America.

Nevertheless, measured against the standard of the vaudeville years, we are in a new age. Times Square has gone from being an intersection in New York to being a national entertainment center to being a global district for media, commerce, and entertainment. While the best acts that graced the Palace often had a style and vigor born of New York City origins, today many Broadway hits are revivals or extravaganzas that could be from anywhere. The bright lights of Times Square today illuminate the conglomerate Disney, the financial firm Morgan Stanley Dean Witter, and the vast Korean firm Samsung.

The niche audience has replaced the mass audience. Of course, some niches can be huge—like the international audience for violent movies packed with bulging biceps and mammoth explosions. But large niches are not the same as the heterogeneous mass audience of vaudeville. Vaudeville showmen attempted to serve a variety of people in one theatre. What was pleasing and familiar to one segment of the crowd was new and unsettling for another, making vaudeville a lively forum for introducing people to new realms of emotion and expression. Such encounters helped to break down some of the binary categories that defined American culture in the nineteenth century—rough and respectable, maternal and sensual, high and low. After vaudeville, more people could recognize that they, like a good vaudeville show, contained a bit of both.

Going to vaudeville meant going out. Vaudeville was

the last time when inexpensive, live theatre was available across the face of New York City. People still trek to Times Square, but today they are more likely to find their entertainment at home, on a television screen or computer monitor. As schools for sociability, David Nasaw reminds us, vaudeville and the popular culture of the early twentieth century had their limits: racism and racial segregation. Nevertheless they taught white Americans of vastly different origins how to get along together in public. Today New York City, with the exception of the subway, lacks such a school. The city is poorer for it.

And going to vaudeville meant being part of the show. The dialogue between artist and audience reached people individually and collectively, as an old vaudeville fan once told me. In small-time houses with boisterous gallery gods, and even in more polite houses like the Palace, vaudevillians learned to play to the crowd and the crowd learned to judge them. It could be a rough school, but all were enriched by the experience. Performers learned to play to every kind of person, while audience members acquired a vocal and discerning temperament that encouraged them to insist on the best. It was the knowing and demanding audience, and not the artists' talents alone, that made vaudeville great theatre.

If vaudeville helps us to measure the distance that New York and popular culture have traveled in the twentieth century, it will also help us to assay the popular culture of the twenty-first. The Internet may resolve popular culture's contradiction of democratic origins and oligarchic distribution, but commercial forces could also undo the Internet's utopian possibilities. But from vaudeville, some things are clear. Popular culture is most vivid when it is rooted in the rhythms and languages of a particular place. It is most vital when it is nourished by energy and creativ-

ity that flow from the bottom up. And it is most powerful when it brings together different people who discover—in shared tears, jeers, cheers, and laughter—that a public life is more rewarding than one lived at home alone.

The Voice of the City

1

TAMING THE

BOWERY BOYS

But here in the Bowery people enjoy themselves
just when they feel like it. They don't care a curse
for what others may say, for that's the custom.

TONY PASTOR, 1874

Take a walk in lower Manhattan on an evening in the
1860s to check out the concert saloons, from fancy Broad-
way establishments to tough dives on William and Chatham
streets and the Bowery.[1] Enter one through a long flight of
steps that leads down to a basement. The first thing that
hits you is the smell: the dense fumes of liquor and the
smoke of pipes and cigars. Then the noise: clinking glasses
play falsetto to the bass line of a piano player thumping
on a dilapidated instrument. Then the walls of a long
room: garish patches of red, green, and yellow paint to
represent a garden. Finally the crowd itself: men packed
so tightly that the pressure of their bodies shoves aside the
furniture. The crush breaks only for the passage of laugh-
ing and bantering waitresses.[2]

Or try the more elaborate New Oriental on Broadway. The outside is colorful: an arched, illuminated canvas about ten feet square, painted with a reclining Turkish woman attended by a servant with a sunshade. The inside is even gaudier: brilliant gaslights shine on illuminated walls and colored cut-paper ceiling ornaments. Pretty waitresses in fancy costumes flit up and down the aisles between merrily boisterous customers. A brass band and piano pump out a lively Irish jig.[3]

Ask a waitress for an impromptu poem and she responds:

> Who comes here?
> A Brigadier.
> What do you want?
> A pot of beer.
> Where's your money?
> I forgot.
> Get you gone, you drunken sot.[4]

You have just seen the New York concert saloon, ancestor of the vaudeville theatre. Concert saloons, like so many of the institutions that have influenced American popular culture, flourished on the margins of polite society. They were part of the socially stratified theatre world of mid–nineteenth-century New York, where immigration and industrialization had created audiences divided by race, class, gender, and ethnicity. Vaudeville entrepreneurs attempted to reverse this fragmentation and create a kind of theatre that could appeal to all New Yorkers and gather them together under one roof. The challenge was not just providing acts that would amuse profoundly different groups of people, but fitting into one building people with profoundly different cultures and ways of behaving.

The problem had reached explosive proportions in the Astor Place Riot of 1849. Superficially, the riot was a dis-

pute about whether an American or an Englishman should be allowed to perform Shakespeare. But the roots of the outburst lay much deeper; in the anger of workingmen, Irish immigrants, and American nationalists against the city's Anglophile economic elite. The conflict reached a climax when troops fired into a crowd of immigrants, workingmen, and nationalists attacking the Astor Place Theatre: eighteen died on the spot, and four more died of their wounds within a week. More than one hundred were seriously wounded.

The volleys at Astor Place marked the end of the years when New York's diverse peoples could gather easily under one roof. A single theatre could no longer house a people who were becoming increasingly different culturally and economically. The differences between mid–nineteenth-century urban theatres increasingly expressed the social differences between New Yorkers, with drama and opera houses for the rich, cheap Bowery theatres for the poor, and foreign-language theatres for immigrants.[5]

Vaudeville drew deeply on the plebeian expressions of these divisions, all of which flowered on the Bowery. As early as the 1830s, the street was well on its way to becoming the city's center for lower-class pleasures, an earthy counterpart to polished Broadway. Crowds of workingmen and workingwomen paraded on its sidewalks, drawn by dance halls, oyster houses, grogshops, gambling dens, bordellos, ice cream parlors, and, as much as anything else, theatre: blackface minstrelsy, melodrama, variety, music, and comedy. All contributed to vaudeville.[6]

In the blackface minstrel show, which first appeared in the 1830s, New Yorkers found song, dance, comedy, sketches, topical repartee between the minstrels, and a complex social ideology steeped in the culture of working and middling New Yorkers. Minstrels affirmed the worth

and dignity of ordinary white Americans by creating inferior blacks to whom whites—no matter how down or confused they were—could always feel superior. They also generally opposed temperance, affirmed egalitarianism, and portrayed slavery as a benign institution that cared for childlike blacks. Minstrel shows also tended to portray immigrants and foreigners in an oversimplified, stereotyped style.[7]

Also found on the Bowery was melodrama, which used the same characters as the minstrel show: the shrewd Yankee, the exuberant Irishman, the happy, good-hearted black, and the heroic Bowery Boy and firefighter Mose. Melodrama avoided moral ambiguity, and saw wrong as the result of character flaws, not situation or society. At its core was a vision of the total goodness and extreme weakness of women. It equated virtue and superiority, and saw love as the destroyer of all barriers of rank. Melodrama was, however, serious about common people and their emotions. It wrestled with the conflict between good and evil, the hopes and fears of the time.[8]

The melodramatic formula gained new levels of significance on the stage of the Bowery Theatre, where the audience was as much a part of the show as the actors and actresses. Journalist George G. Foster wrote extensively about the house, which was built for an affluent audience in 1826 but was taken over by a broader crowd by the 1830s.

The interior of the theatre, as he described it in the 1850s, had its own geography. The dress circle was occupied by "the more quiet and respectable families and children of the east end of the city." The upper tiers and galleries were "a bad and dreadful region" filled with "rowdies," and "fancy men" (the gallery gods), "working girls of doubtful reputation," and "the lower species of public prostitutes, accompanied by their 'lovyers,' or such

victims as they have been able to pick up." From the "punch room" of the section issued "a continual flood of poisoned brandy, rum and whiskey" that fortified the denizens for their debauchery.[9]

Foster noted that the Bowery Theatre was usually associated with "peanuts, red woollen-shirts, tobacco chewing, and rowdyism." But its performers, he explained, had real merit. Their style was perhaps "a little broader and stronger" than that of players in more fashionable theatres who obeyed "the laws of a fastidious criticism," but they were "never dull."[10]

They couldn't be, given the challenge of their audience. On a good night—New Year's or Christmas Eve—the packed house with its habitués in multichrome dress looked like "a hot-bed of exotic and high-colored plants and flowers." The crowd's cheers and jeers, their "noisy lung-exercises," as Foster put it, swelled into a "merry and riotous chorus." "Compared with the performances in the audience," he concluded, "the ranting and bellowing and spasmodic galvanism of the actors on the stage are quite tame and commonplace."[11]

As an alternative to melodrama and minstrel shows, theatre-seekers could also visit dime museums, like P. T. Barnum's establishment on Broadway, which frequently augmented their curiosities with variety shows. From the 1840s on, Barnum, for example, featured animal acts, acrobats, ventriloquists, melodramas, panoramas, notable persons, and men and women clad in revealing tights—dubbed "living statuary." Aware of the theatre's reputation for immorality, and perhaps of the prurient interpretations of living statuary, Barnum claimed that he purged his shows of sin, and banished drinking and prostitution from his hall.[12]

Vaudeville drew inspiration from all of these Bowery

staples, plus the concert saloon. Of all of them, the concert saloon was perhaps the single most important—and certainly the most problematic—of vaudeville's forebears. Turning the boozy, licentious variety theatre of the concert saloon into vaudeville meant confronting and bridging many of the social divisions that had divided the nineteenth-century theatre audience since mid-century.[13]

Much of the problem was alcohol. Drinking was a complicated and controversial social issue in nineteenth-century city life, one that often pitted working-class, immigrant "wets" against middle-class, native Protestant "drys." Nowhere was this conflict more influential in shaping commercial entertainment than in the transformation of the concert saloon.[14]

Concert saloons were taverns that offered alcohol and entertainment—such as bands, piano players, dancers, and singers—for largely male audiences. The smallest had a platform for performers at one end of the barroom; the largest had regular auditoriums. Possibly patterned after the English singing saloon that was the forerunner of the English music hall, concert saloons gained a foothold in New York City by the early 1850s, and were soon common in the Bowery and along Broadway.[15]

The Civil War brought to the saloons swarms of men with money to spend, including soldiers on furlough, army contractors, and recruiting officers. In 1861 the New York press carried daily advertisements from some forty concert saloons. Their variety shows, a New York journalist wrote years later, might include acrobats, female vocalists ("the costume being thought far more important than the voice"), and "a wind up of some outrageously absurd farce, replete with patriotic soldiers and comic Negroes, and screeching devotion to the flag, closing with a grand transparency of General McClellan or of President Lincoln."[16]

Moral reformers condemned concert saloons—with some accuracy—as scenes of crime, prostitution, and drunkenness. A *New York World* report called them "the most abominable nuisance and vilest disgrace of the metropolis." In April 1862 the New York State legislature passed a law to shut them down: it required licenses for all places of amusement and prohibited the sale of alcohol and the use of waitresses in concert saloons. The fees collected for licenses went to support the Society for the Reformation of Juvenile Delinquents. The Society traced its roots to a body founded by the city's mercantile, religious, and political elite in 1817 to make New Yorkers a more sober, industrious, chaste, and thrifty people. By the 1860s, it was concentrating on the reform of the world of theatres, concert saloons, and public amusements, which it deemed to be breeding grounds of vice and lawlessness among the city's young people.[17]

The *New York Times* noted that the reaction to the law "was not exactly a general suppression of the business, but a general compliance in one way or another; in part or altogether; fractional, if not total." The subterfuges included shows without beer, beer without shows or waitresses, openings only for private friends, and waitresses scattered through the audience in the camouflage of street dress. Such ingenuity, combined with the inadequacies of police enforcement, subverted the efforts of the legislature. After an initial fanfare, the law was ignored.[18]

The end of the war brought a downturn in business, but not enough to erase the saloons from the metropolitan scene. In 1872, there were some seventy-five to eighty concert saloons in New York City, thriving amongst diverse pleasure palaces on the Bowery, Broadway, and the side streets of lower Manhattan. "Vice wears a fair mask at every corner," Junius Henry Browne wrote of this period,

"and Art smiles in a thousand bewitching forms. Hotels and playhouses, and bazaars, and music halls, and bagnios, and gambling hells are radiantly mixed together; and any of them will give what you seek, and more sometimes."[19]

At either end of this spectrum were establishments with a more thoroughly upper-class or working-class clientele. Many, however, attracted men from all classes. Browne noted the concert saloon's tendency to draw the "laborer and mechanic, the salesman and accountant, the bank-clerk and merchant"—many from curiosity, more from relish of what they found. Most patrons, he observed, were out-of-towners, often surprisingly middle-aged. The mixture was potentially volatile. On Houston Street, Harry Hill's enforced a strict code of conduct, creating an atmosphere that one visitor described as a state of friendly, drunken confusion. In other houses, conviviality collapsed. And "the proximity of a well-dressed young man to a crowd of hoodlums in jeans pants and braided coats," John Joseph Jennings noted in the early 1880s, "often precipitates a row."[20]

Such saloons became the destination of slumming voyeurs out to see what they thought to be the sinful side of city life. Writer James D. McCabe, Jr., noted these men's tendency to see the foreign-born women working in these saloons as fair sexual game, made somehow exotic and desirable by the setting—the beginning of an erotic treatment of black and imigrant women that has a long history in American popular culture.

> If they were told to go into their kitchens at home and talk with the cook and the chambermaid, they would consider themselves insulted. Yet they come here and talk with other Irish girls every whit as ignorant and unattractive as the servants at home—only the latter are virtuous and these are infamous. Thus does one touch of vileness make the whole world kin.[21]

The respectability of the concert saloons was most likely very much in the eye of the beholder, for barrooms were not automatically prone to depravity. In the city's German resorts, immigrants showed native-born Americans that drink, fun, entertainment, and the mixing of men and women didn't automatically lead to vice. As early as the 1850s, the Little Germany east of the Bowery between Houston and Twelfth streets boasted a "Volkstheater" and inns featuring beer, comedy, and music for German men and women—even on Sundays, despite Sabbatarian laws. At the Atlantic Beer Gardens in the early 1870s, McCabe found three to four thousand people, mainly Germans, enjoying music, light Rhine wine, and above all else, beer. He wrote:

> The consumption of the article here nightly is tremendous, but there is no drunkenness. The audience is well behaved, and the noise is simply the hearty merriment of a large crowd. There is no disorder, no indecency. The place is thoroughly respectable, and the audience are interested in keeping it so. They come here with their families, spend a social, pleasant evening, meet their friends, hear the news, enjoy the music and the beer, and go home refreshed and happy. The Germans are very proud of this resort, and they would not tolerate the introduction of any feature that would make it an unfit place for their wives and daughters.[22]

The German beer hall was a product of immigrants' relaxed and tolerant attitude towards leisure and drink. But their culture was a long way from that of the native-born middle class. When middle-class reformers contemplated the issue of drinking, they saw the concert saloons, whose bawdy atmosphere contradicted middle class ideals of self-control and self-improvement. And as fundamentally male institutions, they were an affront to the middle-class ideal

of family-centered leisure, with mother, father, and children gathered comfortably in their over-furnished parlor.[23]

Although the saloons accommodated crowds of middle-class and working-class men, they did not attract a similar mixture of women. Working-class women might be found as patrons of German beer gardens, but the women found in concert saloons were most likely to be waitresses, performers, or prostitutes. If showmen were to attract middle-class women and families, they would have to change the content, or at least the reputation, of their shows, to divorce themselves from the image of the concert saloon.

Transforming the variety theatre of the saloons into vaudeville meant more than changing a name. Structurally, the two were virtually identical: a series of individual acts strung together to produce a complete bill of entertainment. The name had a more complex origin. According to a standard interpretation, "vaudeville" was originally a French term, referring to either pastoral ballads from the valley of the River Vire or urban folksongs: *voix de ville,* or "voice of the city." By the eighteenth century, "vaudeville" meant entertainments of music and comedy. But vaudeville, as turn-of-the-century Americans understood it, was variety theatre that entrepreneurs made tasteful for middle-class women and men and their families by removing the smoky, boozy, licentious male atmosphere.[24]

Yet the showmen who engineered this metamorphosis could not completely bowdlerize variety and hope to be successful. Some elements of raciness had to be maintained to keep the old variety crowd and also attract those middle-class people who were chafing at the restraints of Victorianism. In this complex juggling act, the vaudeville theatre was born.

A nineteenth-century showman who was instrumental in achieving this transformation was Tony Pastor, who took

vaudeville out of the Bowery without entirely taking the Bowery out of vaudeville. Although he was not alone in such efforts, he was particularly successful.

Pastor was born in New York City in 1834, according to the best available account. His father, who was of Italian descent, ran a fruit store and later a barber shop. For more than ten years after the elder Pastor's death, Mrs. Pastor ran a saloon. Around 1843, Tony sang at temperance meetings. At the age of twelve, he gave his first paid performance ever at P. T. Barnum's museum, singing and playing the tambourine as a blackface minstrel. Early in 1847 he sang again for the temperance movement, toured with a menagerie, and then embarked on a circus career. Trim and athletically built as a young man, he learned acrobatics and worked his way from prop boy, to equestrian, to ring master. But he was primarily a clown and singer.[25]

Eventually Pastor grew tired of the touring circus performer's life. In 1860, he began to appear as a comic singer; in 1861, he opened a four-year run singing in a saloon at 444 Broadway between Howard and Grand Streets. During his years there, Pastor established himself as a writer and singer of popular songs. Attuned to trends in popular taste, he was noted for topical pieces on the Civil War, labor, and women's fashions.[26]

Pastor's songs, written by himself and songwriters, were published in books called "songsters," with titles such as *Tony Pastor's 'Own' Comic Vocalist* and the *New Union Songbook*. The songsters recalled the chapbooks and broadsides that circulated popular songs in Renaissance Europe: printed lyrics accompanied by the name of a well-known tune to which the song was performed. No musical score was written out. Singers did not have to read music to learn the song: like eighteenth-century ballad-mongers, Pastor and his audience assumed a shared knowledge of tunes.

Songsters in hand, New Yorkers could sing along at the sa-
loon and afterwards take Pastor's songs home with them.

Some of the compositions sustained elements of an older
Anglo-American lyric culture. The *New Union Song Book*
contains "The Monitor and Merrimack," a reworking of
older ballads on sea battles between the *Constitution* and
the *Guerriere* and the *Shannon* and the *Chesapeake,* and
"The New Ballad of Lord Lovel," a song about the Ameri-
can Civil War, which trades on the name of a piece cen-
turies older.[27]

Although Pastor performed some sentimental songs, his
pieces published in the 1860s and early 1870s were gen-
erally vigorous and humorous—and sometimes racy. His
dialect songs were peopled with a throng of nineteenth-
century stereotypes, such as shrewd Yankees, rowdy Irish-
men, and childlike blacks.[28]

Pastor's portrayals of the Irish were crude but basically
friendly. He praised Irish courage in the Union war effort
and noted that despite anti-Irish discrimination, "when
they want good fighting men, the Irish may apply."[29]

In contrast, his depictions of blacks were unrelievedly
racist. In "The Contraband's Adventures" he tells the story
of a slave freed by the Union army. When he is taken to
an anti-slavery meeting, abolitionists unsuccessfully try to
scrub, paint, and sand off his blackness. The song concludes
with the slave saying:

. . . de nigger will be nigger
till de day of jubilee
for he never was intended for a white man.
Den just skedaddle home—leave de colored man alone;
For you're only making trouble for de nation;
You may fight and you may fuss,
But you never will make tings right
Until you all agree

For to let de nigger be,
For you'll neber, neber, neber wash him white![30]

Although never radical or revolutionary—an 1879 song-
ster included a ditty titled, "Don't Crush the Poor People,
But Give Them a Show"—Pastor published many songs
with a consistent theme: we live in an exploitative world
where each must endure and fend for himself as best he
can, always remembering that the real repository of cour-
age is the honest working man. Pastor's "We Are Coming,
Father Abraham," parodied a popular recruiting song to
attack the Union policy of allowing men to buy their way
out of the draft for $300—a policy that contributed to the
eruption of the 1863 Draft Riot in New York City.

> We are coming, father Abraham
> Three hundred dollars more;
> We're rich enough to stay at home,
> Let them go out that's poor.
> But Uncle Abe, we're not afraid
> To stay behind in clover;
> We'll nobly fight, defend the right,
> When this cruel war is over
>
> . . .
>
> We are coming, Father Abraham,
> Three hundred dollars more
> But I think, before a year goes round,
> We'll all feel mighty sore;
> For when our soldiers all return,
> Cheered by each friend and neighbor,
> The defenders of our union are
> The honest sons of labor.
>
> Chorus: Whack fol de dow!
> Their names shall live forever;
> Whack fol de dow!
> And we'll forgotten be.[31]

One of Pastor's compositions, "The Upper and Lower Ten Thousand," sketched out New York City's inequities in verses that were both class-conscious and nationalistic:

The Upper Ten Thousand in mansions reside,
With fronts of brown stone, and with stoops high and
 wide
While the Lower Ten Thousand in poverty deep,
In cellars and garrets, are huddled like sheep.
The Upper Ten Thousand have turkey and wine,
On turtle and ven'son and pastry they dine.
While the Lower Ten Thousand, whose meals are so
 small,
They've often to go without dinner at all.

If an Upper-Ten fellow a swindler should be,
And with thousands of dollars of others make free
Should he get into court, why, without any doubt,
The matter's hushed up and they'll let him step out.
If a Lower-Ten Thousand chap happens to steal,
For to keep him from starving, the price of a meal,
Why the law will de-clare it's a different thing—
For they call him a thief, and he's sent to Sing Sing.

And now, when rebellion o'ershadows the land,
And the nation sends forth each brave volunteer band,
Who is it in battle the valiantest proves—
Is't the Upper Ten Thousand that wears its kid gloves?
Or is't the Lower Ten Thousand, that's found
(Whose hands have by labor been hardened and browned)
With his steel in his hand and a fire in his eye,
Rushing into the battle to conquer or die?[32]

There were limits to the audiences that heard such songs: they were composed almost entirely of men. "During my stay at 444 I studied the situation closely," Pastor said in an interview in the 1890s, "and determined that if women

could also be induced to attend, the patronage could be materially extended."[33]

From 1865 to 1875, Pastor staged and starred in variety shows at 201 Bowery, where he made the tentative beginnings of efforts to attract an audience of the lower 10,000 and slumming upper 10,000 types—and women. For starters, he cleaned up his acts somewhat so they would appeal to more than the traditional male saloon crowds. He also moved his halls to remain part of the city's main theatre district, which progressed northward along with the center of Manhattan throughout the nineteenth century, from lower Broadway at mid-century to Union Square around 1870, to Times Square after 1900.[34] Pastor apparently relocated to keep himself on the edge of the respectable theatrical section and win part of its audience.

A program from the opening of Pastor's 201 Bowery Opera House reveals Pastor's attempts to attract a broader audience, even though it may say more about hopes than achievements. "Triumphant and universal success of the great family resort," proclaims the bill. "Universal acclamations of delight from a crowded and fashionable audience. . . . The manager wishes to return his thanks for many favors previously bestowed upon him in this city, and takes pleasure in announcing the opening of his beautiful Temple of Amusement, which he designs making The Great Family Resort of the City where heads of families can bring their Ladies and children, and witness unexceptionable entertainment,—one that will please the most fastidious. . . ."[35]

An 1865 review of a 201 Bowery show condescendingly appraised the theatrical difference between the decorous Broadway and boisterous Bowery. The critic conceded the "respectable character" of Pastor's audiences, but claimed that they were composed of the sort of people who

would be out of their element in many of the Broadway establishments, where fixed rules of etiquette, hackneyed old plays and flat new ones, often represented by worn out stock companies, would be but small attraction to them. They want something hearty, genial, racy, and above all, varied in its character, such as they find, and evidently appreciate at Tony Pastor's Opera House in the Bowery. The drama, whether legitimate or absurdly sensational, such as the theatres produce, is not the kind of performance best suited for the class who frequent the Bowery establishments. They require something congenial to their own natures, which love mirth in its broadest phases and passion delineated by its strongest dramatic agencies. The patrons of Bowery amusements have little time for sentiment, but just enough time for fun and that relief from the exacting obligations from everyday life which an establishment like that of Tony Pastor's affords them. Variety, above all this, is a necessity with this class. They must have histronic art and music and the ballet combined, in order to spend an evening profitably, for they have neither the leisure nor the means to enjoy them in any other way. It is by this combination that the Opera House of Tony Pastor has attained its great success. . . .[36]

Pastor walked a narrow and twisting path between providing "hearty, genial, racy" entertainment and attracting women and families. "Best quality of ales, wines, liquors and cigars, to be had at the saloon inside the theatre," proclaimed an 1873 program, which also advertised that on Friday nights "ladies" accompanied by "gentlemen" would be admitted free. It does appear, however, that Pastor banned drinking in the auditorium and confined it to an adjoining saloon.[37] In short, Pastor was moving from running a saloon that presented variety theatre to running a variety theatre that served drinks on the side. For those

who disliked sharing theatres with crowds of drinking men, the difference probably appeared significant.

Other attractions to lure the family trade included the necessities of life, a possible indication that Pastor was still attracting working-class audiences. "Extra! Extra! Extra!" screamed one bill from the Opera House years. "60 hams given away Monday evening 10 barrels of flour given away Wednesday 10 tons of coal given away Saturday evening 80 prizes."[38]

"In the Bowery," a song from *Tony Pastor's Songs of the Flags & C.*, published in 1874, emphasized his rough-edged class consciousness and praised workingmen who "never live on other folks, but earn the cash they spend." In a spoken part Pastor expounded on the theme, and touted the rowdy Bowery style.

> Yes, you may talk about your Broadway belles, your Fifth Avenue swells, your exquisitely-dressed creatures, with their lavender kids, and their la-de-das, now what do they know about enjoyment? They are afraid to go in for a little fun for disarranging their toilets: and then what would Mrs. Grundy say? "Charles Frederick Augustus is getting decidedly vulgar; Serephina Emelia is positively shocking!" But here in the Bowery people enjoy themselves just when they feel like it. They don't care a curse for what others may say, for that's the custom.[39]

In 1875, Pastor moved further uptown to 585–587 Broadway. Despite the change in location, his shows remained much the same. A December 1878 bill featured fifteen acts, including "Miss Kathy O'Neil, the champion lady jig dancer"; "Ferguson and Mack . . . original and eccentric Irish comedians"; Dutch acts; and "the French twin sisters . . . in splendid execution jig, clog and reel dancing." It is not clear whether smoking or drinking were allowed

at this theatre. However, Pastor's advertisements asserted that his shows were free from vulgarity, with special matinees for ladies and children.[40]

Such efforts gained significance against a backdrop of recurring fights between concert saloon managers and reformers. In January 1872, New York City police raided three concert saloons that mixed music and alcohol, but the complaints against the saloons were eventually dismissed because the authorities could not prove that acts of a disorderly nature had occurred at the establishments. Boys were serving the drinks, and the controversial waitresses were found seated at tables talking with friends. In the spring of that same year, the state legislature passed a new concert saloon law, which reaffirmed the existing licensing procedures and established the mayor's power to grant licenses. The Society for the Reformation of Juvenile Delinquents, grown larger and more powerful, was joined by other reform organizations, such as the Society for Prevention of Cruelty to Children. In 1877, police used the old 1862 law to justify another wave of crackdowns.[41]

Pastor remained at the 585–587 Broadway theatre until 1881. His next move established him as New York's premier vaudeville showman of the 1880s and 1890s, with a mixed audience of men, women, and children, and middle-class and working-class people. In October 1881, Pastor opened a season at a theatre in the Tammany building on Fourteenth Street and Third Avenue, which had previously featured Dan Bryant's minstrels and variety shows. He remained there until 1908, when the uptown movement of New York's theatre district left him isolated in an economically changing neighborhood. Pastor's tenure on Fourteenth Street was a major step in making vaudeville theatre a meeting place for cultural exchange.[42]

Pastor succeeded on Fourteenth Street because he skill-

fully packaged and presented old-time variety shows for a new, broader audience. His shows were popular partly because he presented so many good acts in a setting free from smoking, drinking, and carousing. An 1885 police report noted that there was a bar in the Tammany building, but not in Pastor's (although a door did connect the two). Police reports of 1890 and 1892 emphasized that Pastor's theatre had no connection with any place where liquors were sold.[43]

Such evaluations were critical in a time when reformers prowled the city's concert saloons, attempting to distinguish dens of vice and unoffending establishments. But compliance with the law did not by itself guarantee a broad appeal. The core of Pastor's bills, house policies, ads, and philosophy did not change radically from the Bowery to Fourteenth Street. What did change was the location of his theatre, and that made all the difference.[44]

Established in the heart of the Union Square theatre district nicknamed the Rialto, with department stores nearby, Pastor assumed the respectable mantle of his new surroundings. There, he was no longer a showman from the shady precincts of the Bowery. He was at the crossroads that cradled the emerging world of mass entertainment and shoping (or, to use scholarly terminology, consumption: the practice of people defining their identity and culture through the things that they buy).[45]

Metropolitan newspaper advertisements, a key element in Pastor's publicity campaigns, told people about his theatre. Mass transit systems brought them to his door. An 1884 Pastor program includes a map showing the theatre's proximity to streets, street car lines, elevated trains, and trollies to the Hoboken ferry—a testimony to the wide net he cast for his audience. "Notice!" it exclaimed. "How convenient to horse cars, elevated railroad stations, and re-

member, good reserved seats, 50 cents a new show every week matinees Tuesday and Friday."[46]

Combining his downtown audience and the new one he found at Union Square, Pastor established the beginnings of an entertainment that would reach across class lines. Located in the Tammany building, he was literally under the roof of a political organization that was itself a quintessential interclass institution. Bowery toughs, newsboys, middle-class women, and Tammany's "Boss" Croker all found a home at Pastor's.[47]

Pastor attributed his success to talented acts and the rising popularity of refined vaudeville. And when he asserted that he had "labored industriously to make the variety show business a successful one by disassociating it from the cigar-smoking and beer-drinking accompaniment," he was telling the truth—more or less.[48]

Even on Fourteenth Street, Pastor retained elements of the Bowery. He called his entertainments "variety," and avoided the pretentious-sounding word "vaudeville." The kiosk outside his theatre in 1881 was pure Barnum in its appeal to the viewer's curiosity. "How can we do it?" asked the sign. "See this big show. Read the names." Although a placard backstage warned against taking God's name in vain, Pastor apparently kept some links with the world of vice. Albert E. Smith, a former Pastor employee, claimed that his boss once used prostitutes dressed as "respectable" women to attract patrons. Seated about the theatre, their conservative dress and polite manners lured customers seeking a refined atmosphere. According to Smith, the decoy worked.[49]

All the while, Pastor starred in his theatre, toured with his troupe, and sang. He drew comic songs, he said, from "the fads and the ultra-fashions of both men and women" and themes such as "a fellow's best girl, the old man's boot,

the mother-in-law, the scolding wife and so forth." Across the years, his Bowery raciness remained. A review of a December 1891 show at Pastor's noted that "Mr. Pastor presented his usual budget of songs in touch with the times, his chief topic being the propensity of married men to stay away from home late at night."[50]

To stay "in touch with the times," Pastor exploited themes raised in newspapers. "I believe not only in the power of the public press," he said, "but in its utility."

> It is the most valuable agent the vocalist has ever had for securing subjects for popular songs. The comic vocalist must be quick to perceive the peculiar topic or phase of human life which is liable to interest the amusement-going public, and must be a little ahead of time.

In a city too big and diverse for the face-to-face shared experiences that foster a sense of community, newspapers created the common knowledge that made Pastor's songs of roguish politicians and newfangled electric lights appealing.[51]

At the same time, he featured vigorous, appealing acts in the best variety style. No one personified the approach more than Maggie Cline, the "swaggering, bragging, good-humored Irish 'Mag'," who inspired audiences to sing along in what a journalist called an "earthquake obbligato." Her Irish appeal and working-class sensibility, all pure variety, were appreciatively noted by a *New York Times* reporter who caught Cline at Pastor's in 1891. The reporter wrote that Cline was warmly greeted by a crowd waiting in "feverish expectancy."

> She was a splendid sight in her handsome evening dress, and looked every inch an Irish Queen. She was greeted with cheers, tigers, and vocal rockets. She handed her fan to the leader of the band, asked him to be careful of it as

it cost $3, and performed a song called, "When Hogan
Pays the Rent," which is a misleading title because it is
divulged that Hogan never pays the rent and hence the
excitement in his neighborhood on rent day which Miss
Cline sets forth with photographic accuracy.[52]

Cline's roistering performance epitomized Pastor's
achievement: all the vigor of an old-time variety show, but
an audience broader than the concert saloon. Vaudeville
was becoming the scene of a rich and complicated dialogue
between sexes, classes, and ethnic groups.

By the 1890s, Pastor's was a critical link in the cultural
circularity of vaudeville. Songwriter Edward Marks ex-
plained the process without scholarly terminology. Marks
plugged his songs in New York music halls, hoping that
audiences would buy sheet music for the compositions they
heard. "It meant a lot to have our numbers carried out to
the sticks in the subconsciousness of a tipsy country cousin,"
he said. "The train of associations whereby 'Annie Rooney'
eventually appeared on the piano in a small town banker's
house would have shocked many a fine community."[53]

The route out and around, Marks revealed, ran some-
thing like this.

> [W]ith its initial break in the beer hall, a song might
> work up to the smaller variety houses, and finally to
> Tony Pastor's, on Fourteenth Street, or Koster and Bial's,
> whence some British singer might carry it home to Lon-
> don. If it scored there, it might come back here as a so-
> ciety sensation.[54]

From beer halls, to Pastor's, to society sensation: here
was a major element of circularity. Yet Pastor's influence
on the New York theatre world was not overwhelming.
There were still plenty of dives whose reputation colored
the vaudeville scene with variety's old reputation. In 1892,

a moralizing observer of the city scene could still describe the variety theatre as a place of "vulgar songs," "wretched music," beer and cheap liquor, a "low and vile" haunt of disreputable women and dissolute men.[55]

Throughout the 1880s and into 1890, reformers denounced concert saloons and theatres throughout Manhattan. In a typical case, they threatened Koster and Bial's music hall at 115–117 West Twenty-third Street with lawsuits and charged that it was a center for prostitution.[56] Koster and Bial proposed a solution in 1893: a new theatre, with no bar on the premises, glass see-through doors on boxes to facilitate the surveillance that would prevent illicit assignations, and a ban on "objectionable persons" and "ladies without male escorts."[57]

Koster and Bial's was a launching pad for hit songs that made their way into middle-class homes. But middle-class husbands and wives were not likely to be found there together when the songs made their debut.

The transformation of variety to vaudeville was still incomplete. In his own house, Pastor did much to remove variety from its "cigar-smoking and beer-drinking accompaniment," but other theatre operators were still vulnerable to legal difficulties.

Pastor would die in 1908 acclaimed as the grand old founding father of vaudeville. By the early 1890s, he was already a portly veteran of three decades on the New York stage, and past his youthful prime. But the key questions remained: how to clean up the atmosphere and keep the energy that made variety shows so compelling? And how to attract a broad audience in a diverse and divided city? In 1893, the answers seemed to arrive in the form of two gentlemen from New England, B. F. (Benjamin Franklin) Keith and Edward F. Albee.

2

VAUDEVILLE, INC.

> What Henry the Eighth was to English history
> and Torquemada was to the Spanish Inquisition,
> the theatre manager was to vaudeville.
>
> GROUCHO MARX, 1959

While Tony Pastor had one foot and the better part of his heart in the Bowery, two entrepreneurs emerged who would carry vaudeville far beyond its origins: B. F. Keith and Edward F. Albee. They came out of the same world of circuses and dime museums that produced Pastor, but unlike him, they were never showmen at heart. They were businessmen. Where Pastor was basically a show-business version of a local Tammany boss, they were kingmakers with national aspirations. When they opened a theatre on New York's Union Square in 1893, the city met the men who would do more than anyone else to make vaudeville a nationwide industry.[1]

Keith and Albee were both New Englanders. Albee, born

in Machias, Maine, in 1857, ran away with Barnum's circus in 1876 to work as a tent boy.[2] Keith was born on a Hillsboro, New Hampshire, farm in 1846. After a rural boyhood, he worked as a mess boy on a coastal freighter, spent the 1870s working and traveling with circuses (where he first met Albee), and in 1880 went into business making and selling brooms in Providence, Rhode Island.[3]

In 1883, Keith rented a vacant store in Boston and opened a Barnum-style museum, with attractions like a baby midget and a mermaid. He prospered, took in a silent partner, and added a second room with a stage for performances. Their attractions included a chicken with a human face, the Circassian beauties, a beast that was allegedly the biggest hog in America, and two young comedians, Weber and Fields, who would go on to become vaudeville stars.[4] To beat the stigma attached to the word "variety," Keith christened his performances "vaudeville" and worked to keep his museum "clean and decent." In 1885, he began holding continuous performances from 10:00 a.m. to 10:00 p.m., hoping to fit more audiences into the 300-seat theatre. But even this innovation failed to turn the museum into a thriving operation, and in 1885 Keith was facing difficulties.[5]

With business bad, Keith teamed up with the man he had met in his circus days—Albee. Keith was troubled that the "right people" did not visit his theatre. Albee proposed that they might come to see light opera at variety theatre prices, so they staged a pirated version of Gilbert and Sullivan's *The Mikado* five times a day, with vaudeville acts between performances, for the inexpensive price of ten cents a seat.[6] The shows were a hit. Keith and Albee followed with a season of condensed versions of operas. They were so successful that by 1886 they could afford to lease a regular theatre.[7]

After a year of staging popularly priced plays, Keith and Albee found the best formula: continuous, completely respectable vaudeville.[8] The new arrangement was so profitable that they opened another theatre in Providence in 1888, one in Philadelphia in 1889, and theatres in Boston and New York in 1893.[9]

Keith's Union Square house, opened in September 1893, was a redecorated theatre that boasted a lighted stained-glass exterior and costumed employees, like ushers dressed in Turkish style. The early bills were a combination of vaudeville and mediocre opera, and they were less than a triumph. Reasoning that the operas were unpopular because audiences could already find first-rate opera in New York, Keith's manager switched to an all-vaudeville bill. Success followed.[10]

Whatever Keith's motivation for expanding his theatre holdings, his official line was that he only did it to create better shows for his customers. "It was not my original intention to start a circuit," Keith wrote in a 1912 reminiscence. "The houses accumulated and then it became necessary to join hands with others, in order to give the public the best kind of show."[11] Such professions of modesty and concern for others were typical of the cloak of morality that Keith draped around his enterprises.

Money was probably more important to Keith and Albee than morality. But money came only with an expanded audience that accommodated women and families. Keith and Albee lured them by offering shows that were allegedly free from the concert saloon's rough fun. Pastor brought the spirit of the Bowery to Union Square. Keith and Albee tried to bring refined vaudeville to far-flung cities. The Keith theatres were nicknamed "the Sunday School Circuit." In 1899, Edwin Royle noted this sign in a Keith vaudeville house:

You are hereby warned that your act must be free from all vulgarity and suggestiveness in words, action, and costume, while playing in any of Mr. _____'s [note: the name was withheld in a thinly veiled attempt to conceal the theatre's ownership] houses, and all vulgar, double-meaning and profane words and songs must be cut out of your act before the first performance. If you are in doubt as to what is right or wrong, submit it to the resident manager at rehearsal.

Such words as liar, slob, son-of-a-gun, devil, sucker, damn and all other words unfit for the ears of ladies and children, also any reference to questionable streets, resorts, localities, and bar-rooms are prohibited under fine of instant discharge.[12]

Keith attributed his shows' virtues to his churchgoing country boyhood, and the knowledge gained in his travels and early show-business years.

In those dáys I learned without knowing it, that catering to the best would cause the multitude to follow. So that when an undesirable word or line was spoken that would seem perfectly proper to many, I could at once have it eliminated, much to the surprise many times, of the party who had spoken it and supposed it must be all right because he or she had said it elsewhere without protest. Erroneous impressions are often formed of the character of an audience. I made it my business to visit entertainments in the poorest quarters abroad and, while many in the audience had learned to pass over objectionable sayings and doings, it was perfectly apparent to me that they did not want to see or hear them, but visited the entertainment for the good things they contain because circumstances would not allow for them to go elsewhere.[13]

In such pronouncements, Keith claimed to be refining variety for the sake of his audiences. He virtually described

his cleanup as a public service. Like impresarios before him, such as P. T. Barnum, Keith mastered and exploited a rhetoric of cultural refinement and moral elevation to legitimate a new kind of theatre. In a time when legal restraints and regulations still shadowed the stage, the "Sunday School Circuit" reputation could soothe the anxieties of moral reformers and attract family audiences. Self-censorship meant bigger audiences and bigger profits.[14]

Yet "objectionable sayings and doings" were only part of the issue. The concert saloons and cheap dime museums were known for rough music, rough humor, and rowdy men. The songs and jokes could be toned down backstage, but out front were rowdy audiences that could make a middle-class woman feel very uncomfortable. If Keith and Albee wanted her patronage, and they certainly did, they had to quiet the crowd. And that put them on a collision course with the "gallery gods."

By the 1880s, the gallery gods' territory was tamer than during the 1850s. In legitimate theatres, at least, owners seeking to establish the propriety of their houses had banished prostitutes from the gallery.[15] Their influence endured, however, and was captured in Stephen Crane's *Maggie: A Girl of the Streets,* published in 1896.

In the hero's erratic march from poverty in the first act, to wealth and triumph in the final act, in which he forgives all enemies that he has left he was assisted by the gallery, which applauded his generous and noble sentiments and confounded the speeches of his opponents by making irrelevant but very sharp remarks. Those actors who were cursed with the parts of villains were confronted at every turn by the gallery. If one of them, rendered lines containing the most subtle distinctions between right and wrong, the gallery was immediately

aware that the actor meant wickedness, and denounced him accordingly. . . .[16]

When Keith and Albee arrived in New York in the 1890s, the gallery gods remained a formidable presence, particularly in vaudeville houses.[17]

Such conduct contradicted Keith's ideal.[18] Alcohol and smoking might be banished from a theatre located on the smartest street corner in the city, but all could still be lost with an outburst from the gallery. If Keith were to realize his ambitions, the gallery gods had to be subdued.

Keith took the offensive like a high school teacher trying to subdue an unruly homeroom. He approached the gods armed with his self-justifying argument that refined vaudeville was what people really wanted. He once recalled that he purchased a New England theatre with a traditionally demonstrative gallery, and how

> during the first performance in this new large house, the gallery commenced its usual demonstrations, mostly complimentary, but in a very noisy way, so I stepped out onto the stage and explained to this portion of the audience that it would not be allowed to continue these demonstrations any longer. I said, "You can't do that here. You know you did not do it in my other house, and while I know that you mean no harm by it, and only do it really from the goodness of your hearts, but others in the audience don't like it, and it does not tend to improve the character of the entertainment, and I know you will agree with me that it is better to omit it hereafter." As I walked off, I received a round of applause from the whole house, including the gallery. And that was the last of the noise from the gallery gods.[19]

Keith's story is too pat and smug to be fully credible, but it shows his seriousness. And his theatres' reputation as the

"Sunday School Circuit"[20] make it reasonable to assume that similar episodes—successful or unsuccessful—took place in others of his theatres.

In one theatre, employees carried cards printed with the following requests:

> Gentlemen will kindly avoid the stamping of the feet and pounding of canes on the floor, and greatly oblige the Management. All applause is best shown by the clapping of hands.

> Please don't talk during the acts, as it annoys those about you, and prevents a perfect hearing of the entertainment.[21]

Other Keith cards carried admonitions against laughing too loudly or smoking.[22] A Keith program for a Brooklyn theatre, printed in 1915, requested that, "If patrons will return to their seats as quietly as possible during the intermission it will be appreciated." A 1916 program for the Palace, Keith's flagship theatre, requested that patrons report to the management any "inattention and misdemeanor" by theatre employees. He even took aim at the middle-class women who were his cherished customers, and established an elaborate protocol for asking ladies to remove their hats so they would not block the audience's view.[23]

By the turn of the century, the cleanup was paying off with an increased attendance of women and children at his shows. Robert Grau noted that by around 1894, Keith's theatres were popular with shoppers, who certainly would have included a number of women. Other vaudeville theatre owners who aspired to respectability noted a similar trend in their own houses. In 1903, the manager of Keith's Union Square noted that his matinees were "largely composed of females."[24]

Indeed, some acts were recognized for their ability to draw women. Among them was Ethel Levey, who in her "gorgeous" costume was apparently the big attraction that drew a crowd "composed principally of women" to a Harlem Opera House matinee in 1907, according to a theatre manager's report. Eugene Sandow, a muscleman, also attracted women—a hint at a possibly sexual interest among some of those females who flocked to refined vaudeville.[25]

That women flocking to vaudeville houses might seek both the prim and the prurient was a phenomenon that would have lasting and increasing significance for vaudeville. Yet it was only one of many contradictions that distinguished New York's most popular form of theatre. A how-to-run-a-vaudeville-theatre manual by Edward Renton, published in 1918, instructed theatre managers to expect "all classes of people" and plan accordingly.[26]

> The clientele should be sufficiently well known to the treasurer to enable him to avoid seating persons of questionable repute next to those of high social standing; he should be careful not to seat the mechanic in overalls, who now and then strolls up to the window, in a section where he may be conspicuous to his own discomfort or to the displeasure of those about him. A drunken man or woman should be absolutely refused a ticket. This individual falls asleep during the show and snores; or he insists on talking to the persons seated next to him, or becomes ill. In any event the chances are a hundred to one that he will spoil all or a part of the show for all or a part of the audience.
>
> Passes which call for seats in the best sections should not be issued to individuals who are likely to smell "garlicky" or be poorly dressed.[27]

Such a vaudeville house offered a place for all New Yorkers, as long as they stayed in their places. But in vaude-

ville, no one stayed in their seat for very long. The spirit of the gallery gods was never completely suppressed. Nor could it be, if shows were to retain the electricity that was a hallmark of both the variety stage and the new vaudeville.

"The manager minds the gallery very much;" journalist Hartley Davis noted in 1905, "in fact he has more respect for its critical judgement than for that of the orchestra."[28] As much as they shaped vaudeville, Keith and Albee were also catering to a heterogeneous audience that wanted both a cleanup and a jolly good time. In seeking a broad audience, such entrepreneurs were compelled to recognize the conflicting aesthetics of those who did not share in the canons of gentility. If there were contradictory elements in their creation, it was because their audience was of at least two minds in its expectations of the vaudeville theatre.

Yet in Keith and Albee's plans for vaudeville, theatre behavior was only half of the equation. They were entrepreneurs—not the only ones, but the biggest—who established a show-business empire. Although the cleanup of vaudeville was underway in earnest in the 1890s, the economic organization of the vaudeville industry waited until the early years of the twentieth century. The key instrument in Keith's efforts was the establishment of a huge booking agency, which regulated performers' access to theatres and theatres' access to performers. Through it, he controlled who could perform, where they could perform, how much they were paid, and (to a less certain degree) what they could do onstage.

This empire-building, with its emphasis on bureaucratic organization and enormous scale, marked vaudeville as a part of America's second industrial revolution. It was the era of the robber barons, when John D. Rockefeller and colleagues created Standard Oil and reaped enormous profits by imposing central direction on an unruly industry.[29]

The Keith-Albee organization attempted a similar coup in vaudeville and succeeded. And with that, glittering vaudeville became, at its core, as bureaucratic and bulging with paper files as a national bank.

The precedent for the systematic organization of vaudeville was set in the 1890s, when a group called the "Syndicate" came to rule the legitimate theatre by controlling booking. As Alfred Bernheim observed in a study published by the Actors' Equity union, their efforts constituted an "industrial revolution" in the theatre.[30]

The Syndicate was formed in 1896 by six entrepreneurs— including Marc Klaw and A. L. Erlanger, two of its most prominent members—who had already developed extensive interests in theatre ownership, booking, and producing. The rise of touring combination companies (troupes organized to present a show on the road) had placed a new emphasis on booking and routing. From about 1880 to 1895, booking offices rapidly grew in size and power. Simultaneously, theatres organized into circuits, or chains, to better deal with booking offices and touring performers.[31]

The Syndicate capitalized on these developments by establishing a monopoly over booking, compelling producers to stage shows in Syndicate theatres, and pooling profits from theatres owned or leased by the Syndicate.[32] Their efforts were largely successful. In 1904, a competitor estimated that the Syndicate controlled more than 500 major and minor theatres, including all but two or three of the first-class theatres in New York City. In many other major cities, and hundreds of smaller communities, theatres were completely Syndicate-controlled.[33] Despite the efforts of competitors, the Syndicate dominated American legitimate theatre from 1896 to 1910 and remained a power until the Depression.[34]

Before the arrival of the Keith and Albee system, the

economic structure of variety theatre resembled that of pre-
Syndicate legitimate theatre. There was little bureaucracy.
Theatres were owned either individually or in small
groups, and owners secured their acts by dealing directly
with performers or negotiating with agents. Fifteen to
twenty independent booking agents worked in New York
City in these years. They booked acts with any theatre or
group of theatres they could connect with, in exchange for
a percentage of an act's salary.[85] Theatre businessman Grau
recalled how they clustered around Union Square in the
1870s.

> The most prominent players, including the stars and
> their respective managers and agents, could be found pa-
> rading the sidewalks, their date books in their hands.
> Those were the days of the barn-stormer, when the "fly by
> night" manager was in his element. All classes of show-
> men congregated here, and here the plans of the most
> important stage providers were matured for many years.[86]

Performers who wished to avoid agents could contact
theatres independently. In the years before Keith and Al-
bee arrived on the booking scene, dancer Pat Rooney
established his own bookings by writing each theatre he
wanted to play, which allowed him to plan and control his
work. Vaudevillians who displayed such diligence could
pocket the money that normally went to an agent's com-
mission, but self-booking was a difficult chore for people
who were already busy with touring and performing.[87]

Keith and Albee took the wheeling and dealing off the
pavements of Union Square and set them down in a mid-
town office. In an effort entirely separate from the Syndi-
cate, they established a vaudeville circuit and booking
offices that eventually dominated vaudeville, much as the
Syndicate dominated legitimate theatre. As in their efforts

to make vaudeville more acceptable to middle-class audiences, they were not alone. Keith's vaudeville circuit was only the largest and most influential of some twenty-two circuits established in America by the 1920s. Competing vaudeville entrepreneurs included the Shuberts, F. F. Proctor, Percy Williams, Marcus Loew, Martin Beck, and William Morris. Some of them were successful, some failed, and some were absorbed by Keith-Albee. Yet it was the Keith Circuit, working with the generally cooperative Orpheum Circuit west of Chicago, that dominated big-time vaudeville.[38]

The growth of a centralized vaudeville empire, like its legitimate theatre counterpart, began with the creation of circuits that hired acts through a booking office. The acts then toured the circuit along a prearranged route. The first vaudeville circuits of note appeared in New York during the late 1880s under the direction of F. F. Proctor, but they did not become significant until 1900.[39]

In May of that year, vaudevillians were startled to learn of plans to form a vaudeville managers' association that threatened to monopolize vaudeville the way the Syndicate had monopolized legitimate theatre.[40] Called "The Association of the Vaudeville Managers of the United States," the organization united vaudeville entrepreneurs nationwide into cooperating eastern and western branches under the direction of president B. F. Keith. In an official statement, the Association claimed that it was not a trust, but a body that sought to give vaudeville "sound business principles," regulate performers' salaries, create more compact routes for touring acts, and end damaging competition between theatres.[41]

Not emphasized in the official statement, and critically important to working performers, was the Association's plan to collect five percent of each performer's salary in

exchange for each booking in an association member's theatre. Previously, performers had paid this five percent to the agents who had arranged for their performances in theatres. Under the Association plan, agents would be eliminated, and acts could perform only by booking through the managers for the five percent fee.[42] Although the new plan might not initially cost performers more, they recognized that it gave the managers increased power over setting booking conditions. And performers estimated that the five-percent payments to the managers added up to $1 million a year.[43] The figure may be an exaggeration, but clearly everyone thought big money was at stake.

The artists responded to the Association initiative with the White Rats, an organization that was part union and part fraternal order. As in other industries with a transatlantic work force, British union principles influenced these American workers: the White Rats traced their lineage to the Grand Order of Water Rats, a society of British music hall artists. The Water Rats made their connection to America through George Fuller Golden, a curly-haired actor who had worked his way up through the theatrical ranks and eventually set down his version of the Rats' story in a florid memoir titled *My Lady Vaudeville and Her White Rats*. Once, when Golden was out of work in London, the Water Rats paid his fare back to America and provided for his wife until he could send for her. Now, their American counterparts would attempt bigger things for America's vaudevillians.[44]

The Rats held their first meeting in early June 1900 in the cafe of the Parker House on Broadway. In an apparent imitation of the restrictive membership policies of craft unions of the period, membership was at first limited to 100 members, with an additional 100 members slated to join afterwards. They took their name partly from the British

music hall organization that had aided Golden and partly from a joke about one performer's white hair.[45] Their emblem was a white star, their motto was "one for all and all for one," and their official song was a variation on the London Water Rats' anthem:

> And this is the emblem of our society,
> Each member acts with the greatest propriety
> Jolly old sports to us they raise their hats!
> A merry lot of fellows are the real White Rats.
> Rats! Rats! Rats! Rats! Star![46]

Once established, they gathered at a fraternal hall above Koster and Bial's Music Hall on Twenty-third Street, between Sixth Avenue and Broadway. Golden devised an elaborate induction ritual that, as he put it, "made it clear to all members, once and for all, that they were organized not *only* for social purposes or to temporarily protect their salaries, but to beautify their lives, uplift their profession, and their own enterprises." Membership quickly grew to 600, including many stars.[47]

The Rats unveiled plans for a cooperative circuit, controlled by performers and funded by a five-percent contribution from their salaries. What emerged in the fall of 1900 was something less: an actors' booking agency, which was apparently conceived as a first step in amassing the capital to establish a circuit. Operating out of the Savoy theatre building on Thirty-fourth Street, the agency sought jobs for Rats in theatres independent of the vaudeville managers' association. The office charged performers a five-percent commission, but the money went to the Rats. By running their own booking office and supporting independent theatres, the Rats hoped to break the managers' hold on vaudeville bookings.[48]

The Rats held organizational meetings called "scampers"

in New York and throughout the country. Within several months, they were ready to confront the managers. The first skirmishes occurred in the form of sick-outs in mid-February. Then, on February 22, 1901, the Rats walked out of theatres across the East and Middle West. Theatre managers retaliated with strikebreakers. Not just the usual suspects, but new ones of an automated kind: movies. To bolster their treasury, the Rats held a benefit at the Academy of Music on February 24 that featured a monologue by ex–heavyweight champion James P. "Gentleman Jim" Corbett. According to the union, the show netted $10,000 in two performances.[49]

The walkout was effective, and the western branch of the vaudeville managers' association quickly capitulated. The eastern branch held firm for two weeks, but the Rats won there when B. F. Keith announced that he no longer favored the commission system of booking. There was a catch, however. As Golden noted in his memoirs, "If the members of the Managers' Association will tell the New York press that commissions have been abolished, this is as good as an agreement, because they could break any agreement with as much impunity as they break their word. Whether they keep their word or not is a matter for individual performers to attend to in signing with them." In other words, the Rats were powerless to enforce the settlement. They relied on nothing more than the managers' good faith.[50]

At a testimonial dinner for Golden at Koster and Bial's Music Hall, almost one hundred vaudeville stars crowded onstage to rejoice. Golden received a loving cup containing several thousand dollars in gold. Tony Pastor, originally a member of the managers' association, joined in the festivities.[51]

What little success the White Rats enjoyed was short-

lived. Although Rats were supposed to book through their union's cooperative booking agency, some undercut its power and authority by booking through the managers. Why can only be imagined. The managers may have offered higher pay, or performers may have preferred to stick with the managers out of fear of offending them. And since both the Rats' booking office and the managers were charging commissions, the managers may have seemed a safer bet for no extra cost.[52]

Within the union, dissension broke out over the Rats' goals and purposes. Some members were skeptical of the feasibility of pursuing the original cooperative idea. Others thought the Rats should become a kind of club for actors. Management difficulties at the cooperative led the union to hire professional agents from the very vaudeville managers' association that the Rats had just struck against.[53]

Over the months that followed, the managers reintroduced the detested commission system. Actors drifted away from the union, and membership dropped to seventy-five members. Although the Rats regrouped as the Star Legion, the new organization was not really a labor union, but more a limited membership fraternal fund that attempted to invest in independent vaudeville theatres.[54]

The vaudevillians' assault on the entrepreneurs had failed. But as strong as the vaudeville moguls might be backstage, up front they needed the performers who made vaudeville come alive. Without them, their scheming was worthless.

3

THE PLAYERS

AND THEIR WORLD

Here genius not birth your rank insures.
Billboard, 1915

Maggie Cline, the lusty-voiced "Irish Queen" and darling of the gallery gods at Tony Pastor's theatre, was the daughter of a shoe factory foreman. James "Jimmy Vee" Bevacqua, a blackface singer and dancer, was the American-born son of immigrants from Calabria, Italy. Dancer and singer Capitola DeWolfe belonged to a theatrical family; as a child in California she performed in a small theatre her father had built in a cigar store. Eddie Cantor, an immigrant's son from the Lower East Side, grew up "on the sidewalks of New York with an occasional fall into the gutter." Eubie Blake—ragtime pianist, composer, and son of former slaves—started out playing in a Baltimore brothel.[1]

All of them appeared on New York vaudeville stages be-

tween 1900 and 1925. Their presence testifies to an important point: vaudeville was created largely by people from immigrant and working-class backgrounds who supplied both its talent and audiences. Together, they participated in a series of cultural transformations. They helped fashion new ethnic identities formed more from American popular culture than from Old World ways; they gave big-city popular culture much of its buoyant, egalitarian style; and they challenged and subverted the genteel Victorianism of middle-class, native-born Americans.

Although vaudeville's creative roots lay largely in a world of tenements, immigrants, and street-corner wise guys, the enterpreneurs' drive for a broad audience led performers to serve more and more communities. At virtually every step of their careers, vaudevillians chose a mass audience over a local audience, a multiethnic audience over their own group, an interclass audience over an audience of one class.

The mainstream of popular culture clearly had its lures for the vaudevillians, but not because they were in a rush to become bland articulators of a homogenized mass culture. They flocked to vaudeville because it was a capacious arena that could accommodate and reward many different performers.

Just how diverse they were was sketched out in a magazine article by Frances Peck Smith.

In vaudeville there are six different types. There are the people from the "legitimate"; musical comedy people who have been trained by competent managers; the old-time variety actors; young boys who have procured most of their training on the streets, learned a song and dance from some source or other and graduated on the stage as "Musical Comedy Fours," etc.; rathskeller stars, who after

a number of years of cafe singing came out as vaudeville artists; and the specialty people, among whom may be included acrobats, divers, prize fighters, and animal trainers. . . . And practically all nationalities are represented.[2]

Whatever their origins, one factor united the vaudevillians: one way or another, all of them were beyond the pale of native-born, middle-class society. In his book *Vaudeville U.S.A.,* historian John DiMeglio asserts that the majority of New Yorkers who entered vaudeville were from "undeprivileged circumstances." Bill Smith, a writer who covered the vaudeville scene as a journalist, asserts that "most performers came from working-class families." Biographies, interviews, correspondence, and newspaper clippings confirm this point. Vaudevillians often seem to have been from an immigrant, ethnic, or working-class background. Blacks were also present, although the widespread practice of putting only one black act in a show limited the extent of their opportunities. The remainder were generally the native-born children of show-business families, which also put them beyond the pale of the middle class.[3]

Into the early twentieth century, middle-class Americans believed that performers lacked religious, ethical, and social values, and kept them at a social distance. Harpo Marx recalled that when he and his brothers toured the vaudeville houses of the Midwest and South from 1910 to 1915, stage people were commonly viewed as being "in a class with gypsies and other vagrants."[4]

But becoming a vaudevillian did not mean becoming a pariah. Over the course of grueling careers, the stage offered artists social, economic, and emotional rewards. Psychological theories suggest that performers are motivated by one or more factors: desires for attention, approval and

display, and needs for self-expression and a life of non-conformity.[5] Perhaps, but a Yiddish expression does just as well. As Bunny Berk put it, her father-in-law Sam Berk became a vaudevillian because he had "the dybbuk" for show business: a desire to perform possessed and even consumed him. In Russia, he was an acrobat and a dancer. When his family immigrated to America and settled on New York's Lower East Side, he worked out in gyms, danced, and eventually developed a big-time dancing act with his wife. (His family was uncomfortable with his career because they did not see vaudeville as a respectable occupation.)[6]

Other vaudevillians showed a similar tendency. As a child, Jewish Belle Baker was fascinated by the music hall near her Lower East Side home. Irish Maggie Cline, born in Haverhill, Massachusetts, ran away from home to appear in a dime museum.[7]

Such individual traits were colored by ethnic culture. Among Eastern European Jews, as Mark Slobin has shown, Yiddish theatre, folk music, and cantorial singing gave people musical experience that prepared them for the American stage. Jews also held dual attitudes about music: in the hands of women it could be a tool of seduction or corruption; yet it was simultaneously seen as a positive, worthy, life-sustaining art. The more positive attitude prevailed among Jews in America because it fit more with the new reality of American life.[8]

Ethnic artists could have gratified all of these desires on the immigrant stage, such as the Yiddish or Italian theatres of New York City. Big-time vaudeville attracted them by offering something more: national stardom and money. By 1915, big-time stars earned as much as $2,500 a week. Such highly paid performers were a small minority of all vaudevillians, but their riches were an enormous magnet.[9]

Belle Baker, who grew up on the Lower East Side and worked in a shirtwaist factory as a child, recalled that when she broke into vaudeville

> a new world dawned. I ceased to be Bella Becker and became Belle Baker. From the Yiddish theater at $5 a week I stepped into vaudeville at $100 a week! It sounds ridiculous. In fact, I felt ridiculous when they offered me that much money. I couldn't believe it. My parents threw up their hands in horror. They didn't know there was that much money being minted every week. But they soon awakened to the truth. For with that first week's salary I moved the whole family from the East Side—father, mother and six brothers and sisters were set up in a fine little flat.[10]

Minnie Marx, mother of Groucho and his brothers, put it more succinctly when she was asked why she sent her children into show business: "Where else can people who don't know anything make so much money?"[11]

The prospect of becoming a vaudeville millionaire was partly an illusion. According to one estimate, there were some 20,000 vaudevillians in America in 1919, but there was work for only 8,000 to 9,000. Performers filled out slack periods with things like appearances at social clubs and song-plugging. Pat Casey, who worked for the managers, claimed that "ninety per cent of them are just four days ahead of the sheriff. . . ."[12]

"Hard Luck," a poem in the White Rats' *Player*, captured the gulf between the celebrated and the struggling.

> I wonder if Walker Whiteside, Edeson or Johnnie Drew
> Pawned their overcoats in winter
> 'Cause their hall room rent was due.
> I wonder if Dave Belasco ever beat the Santa Fe,

Or passed the hat in bar rooms, singing "Kill it Babe,"
In "G". . . .[13]

A *Player* cartoon, published in 1910, showed performers
climbing up into a water tank labelled "The Goal—Big
Time," and then falling straight through it onto rocks
labeled "smalltime," "$25," "8-a-day."[14] It was these has-
beens or never-wases whom Kate Simon recalled from her
childhood in the Bronx: the old men in baggy pants who
told lame jokes that no one laughed at and "the too-jolly
women in tight pink dresses, like swollen frankfurters"
who "sang in harsh, flat sounds."[15]

Among vaudevillians who did find work, wages varied.
In 1918, Loew's Royal theatre in Brooklyn paid a single
performer $20 a week and a duo $40 a week.[16] In the Keith-
dominated United Booking Offices, New York small-time
acts booked in January of 1919 were paid an average of
$93 a week (although salaries ranged as low as $30). Big-
time acts booked at Keith theatres in New York in Feb-
ruary of 1919 averaged $427 a week.[17]

For working-class people the more substantial Keith
salaries would have been enticing. In 1919, a small-time
Keith performer earning a low salary of $75 a week, but
fortunate enough to work a forty-two-week season, brought
in $3,150 a year. Even allowing for agents and booking
deductions, plus the expenses of life on the road, costumes,
scripts, makeup, and props, that was more than the average
annual national manufacturing wage of $1,293 and the
average domestic worker's $538.[18]

Winning such prizes was neither easy nor simple. The
road from street-corner hoofing in hard-pressed immigrant
neighborhoods to big-time vaudeville and national star-
dom could take years, and it frequently passed through

rough and confusing terrain. The hardships of show-business life and the challenge of performing before diverse and demanding audiences all took their toll. The path was blazed largely by the Irish, who appeared on the variety stage in the 1880s and 1890s.[19]

A newspaper discussing the earliest variety acts noted that "from the poorer and uneducated class . . . there was a sort of mania among young working lads to play banjos or bones, or do a jig, and the youngster you'd meet rattling the bones as he went along the street, or you'd see dancing 'some steps on a cellar door,' and so forth were the kind who supplied the variety ranks."[20] Among them were many sons, and daughters, of Erin.

In the 1880s and 1890s Irish acts—performed either by Irish people or people pretending to be Irish, according to nineteenth-century theatrical conventions—were a striking presence on the vaudeville stage. They were followed in prominence by blackface and Dutch (meaning German) dialect comics, reflecting the three groups' visibility in American society.[21] Tony Pastor featured Kitty O'Neill, a jig dancer, and John W. Kelly, "The Rolling Mill Man" who told humorous stories of his days working in the sheet metal mills.[22] Maggie Cline, "The Irish Queen," rocked Pastor's audiences with "Throw Him Down, McCloskey," an epic ballad of a boxing match. In the 1880s, the Jerry Cohan family—including young George M.—toured, presenting sketches that included "The Irish Hibernia" or "Hibernicon."[23] All pioneered the path from ethnic origins to national stardom that would become so important in vaudeville.[24]

Succeeding generations of ethnic vaudevillians followed in a continuum. The Jews, who arrived later than the Irish, gained sway in the early twentieth century. Black artists, who in most respects had it harder than their white

counterparts, established in vaudeville a beachhead that helped make possible their extraordinary contributions to twentieth-century popular culture.

They learned their craft in countless settings. Jimmy Vee learned dance steps from Julius "Ricey" Williams, a black janitor at a women's club in Westchester County, New York. Growing up in the Yorkville section of Manhattan, Jimmy Cagney learned his first moves from a boy at the Lenox Hill Settlement House.[25]

The candy stores of the turn-of-the-century Lower East Side nurtured abundant talent, as a University Settlement House report observed in 1899. The typical store had a long counter decked with cheap candies, shelves for cigars and cigarettes, a soda water fountain, and, if it had style, a back room "ice cream parlor" with bare tables and chairs. As long as the kids bought soda—and sometimes as long as they rented playing cards and paid the proprietor kickbacks on their winnings—they could use the "ice cream parlor" as a lounge or clubroom. Or theatre.

> Occasionally a dozen or more youngsters are entertained here by a team of aspiring amateur comedians of the ages of sixteen or seventeen, whose sole ambition is to shine on the stage of some Bowery variety theater. The comedian or comedians will try their new "hits" on their critical audiences (and a more critical one can not be found), dance, jig, and re-tell the jokes heard by them in the continuous performance or vaudeville theatres.[26]

From such settings came Jewish Eddie Cantor, who followed vaudeville from the streets to stardom. His memoirs convey a sense of rising like Horatio Alger from rags to riches, of literally moving from one world to another. He interpreted the changes he passed through as living five different lives.[27] However you count them, they show how

the promises and possibilities of popular culture—both true and false—lit up the streets of the Lower East Side.

Born on Eldridge Street in 1892, Cantor was orphaned at the age of two and then cared for by his grandmother. His childhood saw frequent moves from one overcrowded apartment to another, tight money, gang fights, petty crime, strike breaking, short-term employment as a clerk, and nights spent sleeping on the roof.[28]

On street corners and at play, Cantor was always "on." At the Educational Alliance summer camp, he entertained his fellow campers with imitations of Polish servant girls. He roamed the streets of New York as a most versatile stump speaker: one night he supported the socialists, another night their opponents, and another night the Democrats. When he was beaten up after speaking against the Democrats, he switched his line and championed Al Smith.[29]

Cantor's autobiography, complete with regrettable racial stereotyping, captures his drive:

> I grew up lean, big-eyed, eager, eating from grocery barrels, singing in back yards, playing in gutters and on the roofs of houses, and combining with it all the smattering of a public school education. I was not introspective—whatever that is. I simply took to life as a darky takes to rhythms, and vibrated with it. In short, I was a typical New York street boy who, by a peculiar and deft twist of fortune, eventually lands either in the Bowery Mission or in a bower of roses.[30]

He made his first attempts at show business with his friend Dan Lipsky. Together they played weddings, bar mitzvahs, club socials, and local theatricals. But success eluded them. The act broke up when Lipsky left the stage for a job in an engineer's office.[31]

Cantor continued on his own—"hopelessly befuddled

and sinking fast," according to a memoir. But he perse-
vered. He first appeared on what he called the "regular"
stage in 1908—broke and wearing borrowed pants at a
Miner's Bowery Theatre amateur-night show. The audi-
ence was rowdy, and unpopular performers were being
given the hook. Cantor took the stage and impersonated
vaudeville stars—in itself a testimony to how big-time
vaudeville had permeated the Lower East Side. When he
won the contest and a prize of five dollars, he celebrated
with a meal in Chinatown. But that night he again slept
on a roof.[32]

For the next nine years, Cantor worked his way to the
heights of vaudeville. His itinerary reads like a catalog of
small-time vaudeville and its sidelines: more amateur con-
tests, a job in a touring burlesque revue—alternately play-
ing a tramp, a comic Jewish character, and a bootblack—
for $15 a week. He spent the summer of 1909 in Coney
Island working as a singing waiter in a saloon and as a
boardwalk shill. At about the same time he appeared as a
master of ceremonies at Lower East Side wedding halls in
what was apparently an American application of the tra-
ditional European Jewish role of badkhn, or wedding
jester.[33]

Then followed small-time shows in theatres scattered
around metropolitan New York—at salaries ranging from
two dollars a show to $20 a week. A break came around
1909, according to Cantor, when Roy Arthur of the big-
time juggling and travesty act "Bedini and Arthur" re-
turned to Jefferson Street on the Lower East Side to visit
his friends. People on nearby Henry Street became jealous
of all the attention being lavished on Arthur as he paraded
around, and they asked Cantor to perform in response.
Arthur was impressed. He hired the youth as a valet at $30
a week.[34]

As they toured the big-time, Cantor gradually worked his way up to being an assistant in the act, then a juggler. His salary was $35 a week when he left the act for two seasons with Gus Edwards' "Kid Kabaret" and subsequent appearances in England and California in 1914 and 1915. Behind the glamour, Cantor and his wife still lived in a sublet single room in her sister's flat. In 1916, Cantor landed a job at a posh cabaret, and in 1917 he finally joined the popular and lucrative Ziegfeld Follies, increasing his salary from $200 to $400 a week.[35]

Cantor's stardom was singular, but his general path was common. Oral histories, newspaper accounts, and performers' memoirs hint at thousands of others who followed the same route—a few to fame, most to the endless grind of the small-time theatres and an eventual shift into another career.

Despite the odds against success, vaudeville was egalitarian in a competitive way. Vaudeville was far more open than the formal professions: the key criterion for success was the ability to put an act over. The start-up costs were minimal. Performers invested their ability to sing, dance, tell a joke, or do somersaults in midair. Their capital was in their bodies and their craftsmanship. Family lineage or formal education meant little. In 1899, Edwin Royle observed that "whatever or whoever can interest an audience for 30 minutes or less and has passed quarantine is welcome." As the 1915 *Billboard* noted under its reviews of acts at the Palace, "here genius not birth your rank insures."[36]

There were limits to these opportunities. Even the best-acclaimed and highest-paid black vaudevillians faced discrimination that took some of the sweetness out of their victory. Still, the popularity of black musicians in the early twentieth century gave them some advantages. In 1914, an upstate New York amusement park manager asked a Man-

hattan booking agency about the availability of white and "colored" bands. The agency replied that

> [t]he demand for colored musicians is so great in the big city now that there is little likelihood of our being able to supply capable colored musicians for your place at anything like a reasonable salary. We can supply high-class white trio at a flat weekly salary. . . .[37]

Black artists had at least this much in common with their white counterparts: they honed their acts on the fringe of the big time. U. S. Thompson, acrobatic dancer, singer, comedian, and husband of the musical comedy star Florence Mills, worked in myriad settings, including medicine shows, Patterson's World Carnival, Heger and Hopper stock shows, the Gentry Brothers Dog and Pony Show, the Hagenback and Wallace Circus, the Ringling Brothers' Circus, and a United States Army band in World War I France. Thompson went on to star on the Keith Circuit and in a variety of revues.[38]

And so the outsiders looking for a chance to become insiders flocked to vaudeville. Billy Glason, immigrant son of a Jewish house-painter, sold newspapers as a child in Boston. He then plugged songs, played parties and free dates, became the house singer at the Beacon Theatre, and finally started touring on the Poli circuit in New England. Comics Weber and Fields started out at Harry Hill's concert saloon on Houston Street, performing for drovers who came into New York City from Long Island before dawn. Jimmy Cagney got a job in a chorus line at Keith's Eighty-first Street vaudeville house around 1918, but went to work as a brokerage house runner when the act closed. Eubie Blake's preparation included stints playing in medicine shows, minstrel shows, saloons, and Atlantic City. His partner, Noble Sissle, appeared with the celebrated black band

leader James Reese Europe. Comedians Smith and Dale started out in the saloons of Manhattan's Lower East Side, then toured vaudeville houses in the Catskills.[39] George Burns appeared in a child act, and performed on street corners, at parties, and at amateur nights. As a teenager, he developed an act in which he danced on roller skates.

> We played a saloon at Fort George and we were the only act. The guys would get full of beer and fall asleep. The minute they'd fall asleep, we had to go on, and the noise of the skates woke them up. So that's the job we had— waking up drunks. Big future there.[40]

However hard and precarious such a life might be, it offered unique opportunities for one group: women. Whatever the obstacles working-class or immigrant men faced, women confronted all of these plus sex discrimination. In vaudeville they could see the possibility of an independent career and wages that were virtually closed to them in other fields. Maggie Cline, teenage daughter of a shoe factory foreman, twice ran away from home pursuing a stage career before she found work performing at the Boylston Museum in Boston for six dollars a week. The pay was better than at the shoe factory, and she was allowed to stay. Twenty years later, in the 1890s, she was known as "The Irish Queen," the darling of the gallery gods at Tony Pastor's. Mary Irish, the Swedish-born daughter of midwestern farmers, began performing at fourteen in 1901 because her parents needed the money to support their family. Dancer Ruth St. Denis and singer-dancer Eva Tanguay were both raised in rural poverty; they used vaudeville to achieve wealth and fame. A turn-of-the-century newspaper article on the vaudeville world concluded, "A woman is as free and independent as a man. Generally she needs no protector, for she is usually able to take care of herself."[41]

Dancer Frances Poplawski recognized vaudeville's offer of economic security and cultural expression. Poplawski, the Massachusetts-born daughter of a Polish longshoreman, studied ballet as a girl. But she saw that there was little work for her there.

Most people who belonged to ballet companies were children of rich people. I could not afford ballet. In other words, my love for vaudeville was for the lucrative place where you knew for a year where you were going to be and you worked all year long and you prayed for a layoff so you could have a rest.[42]

Like Poplawski, Sophie Tucker also found a living in vaudeville. But where Poplawski left the ballet, Tucker left the Yiddish theatre. As a woman, Tucker found money and independence virtually closed to her elsewhere. As a Jew, she followed earlier artists who used vaudeville to achieve stardom far beyond their original communities, without entirely erasing their older ethnic identification.

Tucker grew up in Hartford, Connecticut, where her immigrant parents ran a delicatessen restaurant with a rooming house upstairs. Sophie sang to attract customers.[43] Most of their patrons were working men, but occasionally Jewish theatre companies visiting Hartford stopped in her parents' establishment. Sophie waited on stars of the Yiddish stage such as Jacob Adler and Boris Thomashefsky, and she was thrilled to take an order from Bertha Kalich. But when Adler and Thomashefsky asked Tucker's family to allow Sophie to tour with them, she was against it. "I wasn't keen for it," she recalled in her memoir.

I had seen how hard it was to make the Jewish plays a success even for one night. It used to be up to Papa to sell the tickets. Many times he was left, holding the bag, with hundreds of seats, meals, and sleeping rooms given

free because of no business. I had noticed that this sort of thing didn't happen with the regular American shows.[44]

Despite her love for the Yiddish theatre, Tucker was also at home with the "American shows" that outdrew Yiddish productions. She sang Tin Pan Alley hits to attract customers into her parents' establishment, and performed at amateur concerts at Hartford's Riverside Park. No stranger to mainstream show business, she visited Saturday matinees at Poli's Vaudeville Theatre and the Hartford Opera House, where her favorite performers were "American" musical comedy acts.[45]

Tucker married in her teens and had a child, but the marriage soon failed amidst financial troubles. She left Hartford in 1906 to find work in New York City. In New York she did not go to the Yiddish stage of her youth, but to the Von Tilzer songwriting house of Tin Pan Alley, armed with a reference from vaudevillian Willie Howard. (The sequence was a testament to the increasing Jewish presence in American popular music. Howard and the Von Tilzer brothers Albert and Harry were all Jews.) Soon she was singing at Manhattan beer gardens and cafes, avoiding the prostitution that tempted similarly struggling women. She earned $15 a week plus tips for singing fifty to one hundred songs nightly at the German Village beer garden on Fortieth Street, off Broadway.[46] It was the beginning of an international career. And it was a long way from being thrilled at waiting on Yiddish players like Bertha Kalich.

Similarly, Belle Baker performed in the Yiddish theatre as a child and then crossed over into vaudeville. Although her passionate rendition of "Eli, Eli" had great meaning for Jews, she was also fluent in other styles. In an interview, she described Sarah Bernhardt as her "inspiration"

and asserted that she worked at using melody to "portray pathos and drama" like Bernhardt. A Keith program of 1915 called her "The Bernhardt of Songs."[47]

From Bella Becker to Belle Baker to "The Bernhardt of Songs" was a journey followed in some form by every performer who moved from an immigrant neighborhood to the big-time stage. Those who made the trek did not necessarily lose the mark of their origins. But their birthmarks combined with new influences. One of them was the world of show business.

The vaudevillians inhabited a new world of popular culture, one that they shaped as much as it shaped them. Especially in small time, they developed a subculture based on performing, wearying schedules, and living out of a suitcase. Its significant dimensions were listed annually in *Julius Cahn's Official Theatrical Guide:* theatre sizes, managers' names, ticket prices, local newspapers, hotels, railroad stations, costume shops, theatre critics, holidays, and theatre services.[48]

Its potential for quiet desperation was noted by George Burns: "Even though the jobs were few and far between, I always put a little makeup on the edge of my collar so that everybody would think I was working."[49]

As Groucho Marx recalled it, "The average vaudeville actor led a lonely life. The townspeople regarded him with suspicion and contempt." Some towns on the circuit were noted for their xenophobia—especially towards Catholic and Jewish performers. None endured more, however, than black vaudevillians. Segregated restaurants and hotels forced many artists—including stars such as Bert Williams— to seek inferior accommodations apart from their white counterparts.[50]

Despite these rigors, vaudevillians established their own kinds of domestic stability. Journalist Marian Spitzer as-

serted in 1924 that all vaudevillians aspired to playing the
Palace and owning their own home.[51] When this couldn't
be done in a house or apartment, they fashioned their own
homes on the road. A vaudeville dancer interviewed in
1926 recalled, "I slept in the tray of a trunk, for I, just like
my little son, accompanied my parents on all their tours
and so realized when I grew up how necessary it is to keep
a little family together and make a home even in our
travelling."[52]

In the slack summer months, unemployed vaudevillians
often settled into show-business communities that sprang
up around Chicago and New York, the centers of western
and eastern vaudeville. Bayside, Queens; Bensonhurst,
Brooklyn; and Freeport, Long Island, housed well-known
summer colonies of vaudevillians. A performers' social
club, the Long Island Good Hearted Thespians Society
(LIGHTS), held a Christmas celebration in July, when
members could expect to be at leisure—and out of work.[53]
But during the working year, life centered on the thea-
trical neighborhoods of New York City.

In turn-of-the-century New York, the vaudevillians' com-
munity clustered around Union Square. A contemporary
newspaper article described it as a "little world" with its
own customs, manners, morals, and beliefs. Performers
found essential services in obliging neighborhood shops
and barrooms. The news that mattered most to them was
in the pages of the show-business newspapers. "The rest of
the world, to the variety actor," the article asserted, "is one
large audience, valuable from a professional standpoint,
but to be left to itself after the curtain has gone down on
a performance."[54]

When the show was over, performers frequently retired
to theatrical boarding houses. A reporter described them
in an article written around 1900.

Anything livelier than life in one of them it would be hard to imagine. It is one constant fight between the landlady and the tenants, and the monotony is occasionally varied by fights among the tenants themselves. Night, of course, is turned into day. No one is ever in time for a meal, and the pets of the boarders, specially the women, make the house a bedlam for the greater part of the time. Every variety actress, when at home, has at least one pet. It is a dog, a cat, a parrot, a white mouse, a pigeon, or some other living beast or bird. She is very fond of these pets, and any one who attempts to molest them is apt to get in trouble with the mistress.[55]

At the turn of the century, more and more vaudevillians lived in small apartments carved out of buildings near Union Square. Like the boarding houses, they catered to performers' need for a convenient place to stay. The furniture might be battered, but to the residents that meant that they didn't have to be careful with it. Setting up housekeeping involved little more than arriving on the heels of a departing tenant, moving in trunks and an oil stove, putting out a few photographs and toilet articles, and cooking meals with utensils supplied by the landlord.

Nothing more democratic than the life that the tenants of these apartments lead can be imagined. Beer comes in through the front door and wash day is any day a tenant selects. The wash is hung out of both back and front windows and left there until it dries. No one complains of appearances because no one cares.

When disputes or excitement arose, they tended to be about salaries (vaudevillians were forever exaggerating their own to impress their colleagues), acts (performers were forever stealing good ones from each other), and superstitions (whistling or passing another performer on the stairs meant disaster).[56]

The vaudevillians carried their ways with them as the theatre district moved uptown to Times Square. The centerpiece of their community was the Palace Theatre, located at the northeast corner of Forty-seventh Street and Broadway. Hangouts were the St. Regis Café next door and the Somerset Coffee House around the corner. The sidewalk in front of the theatre was nicknamed "Panic Beach" for the unemployed performers who gathered there waiting for work. "In front of the Palace," one actress recalled, "you saw everyone you knew as you walked down the street."[57] They milled about, chatting in their special slang: a bad act was a "fish," a theatre doing poor business was a "morgue," and a good singer had a "swell pair of pipes."[58]

Vaudeville's subculture nurtured stagecraft. A good performer, dancer Hal Leroy asserted, was always learning. "It takes twenty years to learn how to walk on with class, and twenty years to learn how to talk with class, and twenty years to learn how to walk off with class," he said. Vaudevillians studied each other. George Jessel and Eddie Cantor watched Will Rogers to pick up tips. A young Sophie Tucker visited Hammerstein's Victoria to study the stars. As Jimmy Cagney said of his early dancing, "All we ever did was steal from each other, modify the steps to suit ourselves and in that way develop our individual styles."[59]

In a business where novelty meant money, emulation could turn into plagiarism. Performers fought bitterly to establish their title to an act. Sometimes they argued out their claims in theatrical newspapers. Critic George Jean Nathan reproduced the following exchange in 1918:

DEAR EDITOR:
Please print this letter as I want to denounce to the world the action of Flo D'Arcy, of The D'Arcy Sisters, who has deliberately pinched my one-armed back spring

which was invented solely by me as can be proven by my personal agent for years as well as the agent for the Three Bounding Allaires of which I am the personal agent and manager. My one-armed back spring has made a sensation wherever displayed in America or Europe and I want to warn Flo D'Arcy, of The D'Arcy Sisters, that if she don't cease it I will prosecute her to the full extent of the law which I have already asked our lawyer, Mr. Isadore P. Klein, to take steps towards. Thanking you, I am, yours, Aug. Allaire of The Three Bounding Allaires.

DEAR EDITOR:
I dislike to be unlady-like, as my conduct as a member of the famous team of D'Arcy Sisters who have played successfully in all parts of the world is well known to all my dear friends in vaudeville always to be strictly ladylike, but I can't let the remarks of one, Aug. Allaire, of The Three Bounding Allaires, go by unnoticed. I want to say to Aug. Allaire that if he claims I stole the one-armed back spring from him he is a liar, as I copied the one-armed back spring from Oscar Delarmo, of Delarmo and Astor, with his kind permission. Mr. Oscar Delarmo has used the one-armed back spring for twenty years and twenty years ago Aug. Allaire of The Three Bounding Allaires, was probably still sweeping out some Baltimore Lunch place on the Bowery. Faithfully yours, Miss Flo D'Arcy, Of the D'Arcy Sisters—booked solid for one year.[60]

There was pride and even vanity in such exchanges. There was also the drive to find an act that would lift you out of the grind of the small time and into the glitter of the big time.

Small-time performers put on at least three shows a day. Unable to leave the house between performances, they had to be satisfied, as one observer noted, "with whatever they can arrange to have delivered to them in the theatre—a cup of coffee and a sandwich, perhaps, which they eat in some

dingy, dirty corner, lucky if they can find an old box to use as a table." Big-time Keith theatres boasted lounging space and dressing rooms with a shower and bath. Acts appeared twice a day; between shows performers could leave the theatre to do whatever they pleased. For big-time performers, lunch could be a relaxed meal at a restaurant.[61]

Small time, which usually catered to the neighborhood immediately surrounding a theatre, was the branch of vaudeville most intimately a part of the working-class or immigrant world. But performers understood that the best pay and performing conditions lay elsewhere. "There was never a performer in show business who never wanted to make it into big time," said dancer Hal Leroy in a 1984 interview. Interviews, memoirs, contemporary accounts, and letters from ex-vaudevillians all back him up. For performers, small time was a place to develop before moving on to more prominent and lucrative stages; a minor league in which to prepare for the big leagues. As Richard Osk, a vaudevillian and (briefly) a press agent put it, "The acts that played small time were, of course, on their way down or on their way to the big time. No one played it by preference."[62]

For some, the Yiddish theatre had a similar status. Jewish productions were the first love of Belle Baker and Sophie Tucker, but they wanted fame and money. And fame and money were in the mass-market English-language vaudeville that appealed to audiences across New York City and the rest of the country. Although performers like Tucker and Baker went on to become significant cultural figures for Jews, they did so from the stages of big-time vaudeville, not the Yiddish theatres of the Lower East Side.

Stardom did not mean a denial of ethnic identity. Vaudeville won the allegiance of diverse New Yorkers because it presented enough of their culture to affirm their impor-

tance. This affirmation, however, was bound up with the new kinds of fame and popular culture.

Witness the Jewish Ross Brothers of Cherry Street on the Lower East Side. They played Keith's Jefferson on Fourteenth Street under their slogan, "hitting home runs on the fields of song." Crowds flocked from their old neighborhood nearby—and they received top billing over the better-known Belle Baker, to her displeasure.[63] They were Lower East Siders who had made good in the outside world, and their old neighbors loved them for it. The aura of vaudeville made them something special.

Artists like the Ross Brothers were among the many vaudevillians who explored the route from ethnic neighborhood to cultural mainstream. The journey transformed everyone involved: vaudevillians, the Lower East Siders they left behind, and fans who never ventured near Cherry Street but encountered it through the Ross Brothers.

The journey out of the old neighborhood was not necessarily a one-way path. Some, like Fanny Brice, kept a foot in Yiddish theatre even as they became mass-market stars. And even those who returned to their home streets singing Tin Pan Alley numbers instead of songs of the *shtetl* were not so much abandoning their identity as constructing a new one. In vaudeville, ethnic groups like Jews would come to create new American identities out of popular culture.

But there was an economic dimension to all of this, and some who ventured onto the circuits found themselves on a tricky and treacherous road. Vaudeville was highly competitive, and it had a hard underside: the Keith-Albee booking system.

4

THE KEITH-ALBEE
OCTOPUS AND
THE RETURN OF
THE WHITE RATS

I learn with great satisfaction of your effort to
bring the Vaudeville Trust to book. This is the
most merciless and autocratic organization that has
ever arisen in the theatrical business. All those
concerned richly deserve to be locked up for life.
"An Old Timer" writing to the
Federal Trade Commission, 1918

The years around 1915 found Edward F. Albee in circum-
stances far different from when he featured the chicken
with a human face and the biggest hog in America.[1] In
their place was a show-business empire that dominated big-
time vaudeville in New York City and much of the eastern
United States. The performers who negotiated their salaries
with Albee understood his power. "The Ol' Massa would
really put it on for you," Groucho Marx recalled in his
memoirs.

When you were eventually ushered into his august presence, the stage would be all set. In his private lair the carpet was thick and silent. His desk was about eighty feet long, or so it seemed, and on it there would be nothing but an expensive vase containing a single rose. The only chair in the room would be one occupied by the master. The poor actor, trembling with fear, would stand before him, shuffling his feet like a schoolboy who had just been caught redhanded swiping the teacher's lunch. In this setting the actor would humbly listen while Albee informed him what his salary would be for the coming season.[2]

Albee exercised his power through the Keith-Albee organization, which combined with the Orpheum circuit to rule eastern and western vaudeville respectively before the two consolidated in 1928. Other booking systems challenged them, some with a degree of success, but none ever supplanted them.

Like the Klaw-Erlanger syndicate, the Keith system was based on booking. As theatre observer M. B. Leavitt noted, through such organizations vaudeville moguls "had things systematized in a manner not surpassed by a national bank." Although the Keith interests owned their own circuit of theatres, they controlled many more by becoming the middlemen who charged a fee for bringing together performers and theatre managers. Keith's operation was incorporated in Maine in 1906 as the United Booking Office of America (U.B.O.). In subsequent years, but for several minor name variations, it changed little. Keith died of heart failure in 1914; he was replaced by his son, A. Paul, who died of influenza in 1918. The Keith system endured. And after 1918, Albee was at the top of it. Vaudevillians villified him, journalists skewered him, and the Federal Trade Commission investigated him. He outlasted them all.[3]

The centerpiece of the operation was the U.B.O., the switching house that linked managers and performers and ultimately directed acts around the circuits. Its operations generally followed a basic pattern.[4]

Managers sometimes bid for well-known acts without advance viewing. But the steps in booking a big-time act typically began with a tryout, usually for small pay, in an obscure theatre where a failure would not attract attention. Acts sometimes used false names to dodge bad reviews.[5]

An act might play four or five weeks in tryout houses before attempting a big-time booking.[6] When the act was deemed ready, an agent went to the sixth floor of the Palace Theatre building, center of the Keith-Albee booking system.

Within wooden walls topped by a metal grille, the agent found an open trading floor holding some twenty desks. At the desks worked booking managers, or bookers. Each represented specific theatres: a cluster of houses in New York City, for example, or New England. The bookers drew up the bills for each show at their respective theatres.[7]

To an outsider, the sequence of acts looked as random as the scenes glimpsed from a trolley car on a busy city street. Their selections were actually based on established principles of vaudeville. Bookers weighed each act's appeal, cost, and staging requirements, and then judged how it would fit on a bill that would satisfy the audience and build to a climax. While theatre managers had a say when the players arrived at the theatre, it was the booker who took the critical first step in creating the show. In 1916, George Gottlieb, who booked shows for the Palace, described his techniques in the book *Writing for Vaudeville*.[8]

First: a "dumb act," possibly dancers or trick animals,

to make a good impression that "will not be spoiled by the late arrivals seeking their seats."[9]

Second: anything more interesting than the first act; perhaps a man and woman singing, to "settle" the audience and prepare it for the show.[10]

Third: something to wake up the audience, perhaps a comic dramatic sketch that builds to a "laughter-climax," or any act distinct from the preceding turn, to keep the audience "wondering what is to come next."[11]

Fourth: an act to "strike home," ideally a name performer who will rouse the audience to expect better things from the show.[12]

Fifth: another big name, something the audience will talk about during the intermission.[13]

Sixth: the first act after intermission and a difficult slot to fill, because it had to sustain audience interest without overshadowing the remaining acts. A famous mime comedian to get the audience seated with few interruptions of stage action might work well. But most of all, Gottlieb noted, the sixth act had to begin a buildup that was "infinitely" faster than that of the first half, one that would quickly put the audience in a "delighted-expectant attitude."[14]

Seventh: an act stronger than the sixth to set up the eighth act. Usually a full-stage number like a short comic play, or, if the performers were good enough to warrant it, a serious dramatic piece.[15]

Eighth: the star that the crowd was waiting for, typically a solitary man or woman.[16]

Ninth: the closing act, preferably a visual number—trick animals or trapeze artists—that sent the audience home pleased.[17]

Such principles were applied with an eye to the likes

and dislikes of each theatre's audience. An act might be too refined for a house whose patrons had rough-edged tastes, too dependent on topical political jokes for a placid municipality. Bookers and theatre managers tried to pick acts that would be popular with their own audience, mindful that what was successful in one theatre might not work in another. In a 1907 report on singer Bessie Wynne, theatre manager H. A. Daniels noted that she was a hit in New York but a comparative flop in Cleveland. "Personally, I like her work immensely," he wrote. "She is dainty, clever and artistic. But as I do not pay to see the show, it's not good policy to force my likes and dislikes on the Clevelandites."[18]

As attentive to local preference as these principles might be, they were applied in a setting that had much in common with a brokerage office. With money and jobs at stake, and bookers and agents in full swing, the booking office vibrated with arguments, excited gestures and haggling— "you will find yourself wondering what the panic is about," one writer noted.[19] The agents tried to get their acts top dollar and a good touring route, one that touched many theatres without traveling long distances between them. The bookers tried to bargain them down and, at the same time, construct solid shows.

If the agent and booker agreed on a salary, the booker sent for a contract that was signed by all parties. Contracts were signed for one theatre at a time, and each house paid the salaries for the performances it presented. In at least some cases—exactly how often it is impossible to determine—the bargaining over salaries was a charade because the bookers met to fix them.[20]

Sometimes acts that rejected a salary offer were black-lasted from the Keith circuit, and thus banned from virtually all of big-time vaudeville. They might also be banned

from Keith theatres and booking facilities if they appeared for Keith competitors, failed to book through the Keith offices, or refused to play for free at benefits for Keith's company union. Such measures were used most vigorously to thwart vaudevillians' union efforts in 1910–1911 and again in 1916–1917, but even when they were not invoked they remained a sword over performers' heads.[21]

Once an act was booked, the Keith exchange made deductions that paid the cost of the booking system and more. Given Keith's dominance of the market, these deductions amounted to performers' paying for the right to work. And multiplied by the number of acts the Keith exchange booked—7,917 in 1917–1918, for example—their sum reveals the lucrative nature of Keith's middleman position.[22]

Assume, for example, that an act was being paid $250.00 a week, exactly what Fred and Adele Astaire received in 1917–18.[23] Before they received their check from a theatre, five percent, or $12.50, would be deducted to pay for the services of the United Booking Office. An additional five percent would be deducted to compensate the Astaires' agent for his services, making a total of $25.00 in deductions. This deduction was processed by the Vaudeville Collection Agency, a Keith firm, which collected, for this service, half of the agent's fee, or two-and-a-half percent of the act's salary. Keith's justification for the Vaudeville Collection Agency was twofold: it prevented agents from charging the performers more than the five percent commission allowed by law, and it guaranteed that the agents would receive their fee from the actors (although minus the Vaudeville Collection Agency's own deductions). To offset this loss, the agents sometimes charged actors for additional services—real or imagined. The performer's paycheck then suffered an even deeper cut.[24]

U.B.O. attempts to control performers didn't stop at

the booking office. A typical contract of 1909 limited the theatre's obligations to the performer and made the most of the performer's obligations to the theatre. It also compelled the performer to book through Keith's United Booking Office and allowed management to censor or cancel the act at will.[25]

Such arrangements had their attractions for theatre owners. In a letter written around 1907, Keith representative Jule Delmar attempted to sell the Keith system to the operator of an upstate New York amusement park vaudeville house. He listed the following benefits: through the commission system, the acts paid for the bookings, not the theatres; theatres gained the drawing power of the Keith name; publicity and advertising were handled in advance by the Keith office; acts were booked on a route and were virtually guaranteed to appear (no small consideration, given managers' concern that acts would break contracts to pursue more lucrative offers) because cancelling one engagement meant cancelling all of them; and finally, acts were forbidden to reduce their novelty by appearing near Keith-booked theatres because "we virtually control the booking field and the various acts would not play other places than ours if we so directed."[26]

Yet the system was not foolproof. From the manager's perspective, both the booking office and performers posed problems. The bookers might sign acts whose salary or style of performing were inappropriate for a particular theatre, as the manager of Keith's Union Square complained in 1907.

> I think a few people ought to come down from the office and look at some of these acts and they would be convinced that a good genuine variety show with plenty of comedy and good acts is 100% better than four or five of these tremendous big acts that do not seem to please

the audience, and makes the show cost about $2500 when I can do just as well with a $1800 or $2000 show.[27]

The manager of Keith's Union Square hinted at another problem he confronted: the need to control the cost of his bill. The fixed expenses of staff and physical plant were high in a big-time house, which had to earn $7,000 a week in 1907 to show a profit, according to journalist Hartley Davis. By 1919, when Keith theatres presented the Federal Trade Commission with the costs of their bills for the week of January 28, 1919, new heights were appearing: $3,600 at the Colonial, $3,500 at the Alhambra, $4,445 at the Orpheum, and $4,700 at the Riverside. Salaries offered one opportunity for cutting costs.[28]

But the problems didn't stop with dollar signs. Performers, with their complicated schedules, professional jealousies, and contract demands, confronted managers with many difficulties. This 1909 report from a Boston theatre manager on the Keith circuit describes the potential for chaos in the organization of just one vaudeville show. For starters, there was the need to coordinate the acts' arrival.

This proved to be our fifth successive "tempestuous" Monday. This time it is the Pissiutis who are in trouble. Through the stupidity or negligence of the people in the Pennsylvania baggage room in Philadelphia, combined with ignorance and a seeming desire to save a few dollars on the part of Pissiuti, his baggage was too late to make the steamer from New York last night. However, the Pennsylvania people on this end, made arrangements to have the stuff put on the 1 o'clock limited from New York so that it will be here in ample time for the evening show. Under this stress of circumstances we pressed into service the Sutcliffe Troupe, who played here last week and are to sail for Europe in the morning.

Then there were unreliable performers.

> To add to our troubles one of the young ladies of the
> Pianophiends went strolling around the streets looking in
> the shop windows and finally showed up at the stage door
> at the time the act was scheduled to go on. Fortunately
> Miss Bergere was ready and we were able to go along
> without any wait.

And rivalries and contract disputes.

> Outside of these few mishaps everything was lovely until
> after the Hawaiian Trio had been on, when "Toots" sent
> for me and said that her guitar player and she had had
> trouble and they couldn't get along. While she was mak-
> ing her explanation, he came on the scene with his guitar
> and grip, saying she had fired him. I finally straightened
> this matter out by fixing it so they are both going to work
> the week out as a favor to me,—so they said, although I
> think they have done the same stunt in other houses.
> Hence, I do not feel all swelled up on my prowess as a
> diplomat. I trust Pat Casey will be able to use the salve
> so that they will play out the rest of their contracts. The
> guitar player is a hit and knows it, while "Toots" is jeal-
> ous of his success, thinking her Hula dance should be the
> big feature. Here endeth the story of my troubles.[29]

From the manager's point of view, the Keith system pro-
vided an element of stability in a volatile industry. It also
facilitated both the control of the acts' content and the
collection of records of the acts' popularity. Part of the
motivation behind this, as we shall see, was the censor-
ship of ribald or socially controversial performances.[30]
But records of popularity also pressured performers to be
consistently successful. An anonymous vaudevillian's letter
printed in *The Morning Telegraph* in 1915 complained
of this rating system.

This vaudeville has gotten to be too hard a game. Every Monday you go on trial. Every week a report goes in and you wonder what it says. You have stood the test of every kind of audience and yet you must constantly show your wares all over again. . . .[31]

And the U.B.O. didn't just squeeze performers. It also squeezed managers. As "An Old Timer" wrote anonymously in a 1918 letter to F.T.C. investigators examining whether the U.B.O. violated the Sherman Anti-Trust Act, the U.B.O. had "a double edged sword. Against the theatre owners it cuts by refusing him the best and the vitally necessary acts if he does not give it the exclusive booking privilege, and against the acts it cuts by refusing them work in the best and vitally necessary theatres."[32]

The Keith-Albee interests used access to their booking exchange and grants of regional booking monopolies to encourage or dissuade theatre development. Around 1905, Bernard A. Myers was building a theatre in Bayonne, a town on the New Jersey side of New York Harbor, when he sought a franchise to book acts through the U.B.O. The theatre was to be a low-priced house, with ticket prices ranging from fifteen cents to fifty cents. The U.B.O. refused him a franchise because it feared competition with its existing Jersey City theatre eight miles from Bayonne. Unable to present U.B.O. acts, Myers instead offered dramatic shows. In 1918, he again applied for a U.B.O. franchise. Albee replied that since he had survived so far without U.B.O. vaudeville, he ought to be able to continue on his own.[33]

Such dealings also surfaced in the opening of the famous Palace Theatre. Located at Broadway and Forty-seventh Street, the Palace was built by Martin Beck, head of the Orpheum Circuit, which dominated vaudeville in the western United States. Albee resented the competition, but

there was no simple way to get rid of it. He could take over the house, but that wouldn't end his troubles. Oscar Hammerstein I had an exclusive franchise to book U.B.O. vaudeville acts in the Manhattan theatrical district from Forty-second Street to Fifty-ninth Street. Albee would have been unable to use his own booking office to serve his own theatre.[34]

In a series of murky moves, Albee gained control of the Palace, and left Beck with only twenty-five percent of its stock. Albee also paid $200,000 to Hammerstein to buy back his U.B.O. booking rights.[35]

Vaudevillians were understandably suspicious of moguls who could make such deals. The performers had struck in 1901 to limit the vaudeville managers' power, but defeat left them in a weak position. Apathy, internal splits, and the intimidating power of the Keith-Albee regime all weakened the union. According to one estimate, within four or five years of the 1901 strike, membership plummeted to twenty-eight members.[36] They had nowhere to go but up. And they did.

The Rats' resurgence began in 1907, when Harry Mountford, an English music hall performer who had been the blacklisted chairman of the National Alliance of Actors, Stagehands and Musicians, emigrated to the United States. He continued his union activities in America and became the leader of the White Rats despite bribe offers and threats from Albee. Mountford was an energetic and enthusiastic organizer working in a New York of insurgent labor. The years of the Rats' revival also saw the shirtwaist makers' and bakers' strikes of 1909, and the cloakmakers', bakers', and express drivers' strikes of 1910.[37]

In June 1910 the New York state legislature passed a bill supported by the Rats which made it illegal to charge any performer a gross commission of more than five per-

cent, regardless of the number of agents involved in book-
ing the act. Although an apparent victory for vaudevillians,
the law was easily evaded, and levying of unfair commis-
sions continued. A bigger gain came later in the year. In
November 1910, the Rats merged with the Actors National
Union: together they received a charter from the American
Federation of Labor (A.F.L.) as the White Rats Vaudeville
Union of America.[38]

A.F.L. charter in hand, the Rats' organizing drive broad-
ened. They published a journal, *The Player*, whose motto
was a quote from Gilbert and Sullivan, "The enemy of one
the enemy of all is." When *The Player* proved unprofitable
in 1913, the Rats switched to publishing union news in the
theatrical newspaper *Variety*. They purchased an interest
in the Mozart Circuit—small-time houses in New York
State and Pennsylvania—and used it to offer performers
thirty weeks of bookings without going through the Keith
offices. They established a large clubhouse on West Forty-
sixth Street in Manhattan. They reached out to the rest
of the labor movement, and performed at strike benefits.
And in 1911, they threatened a strike to establish a closed
shop for vaudevillians.[39]

Despite these efforts, the Rats also maintained some of
the conservative characteristics associated with A.F.L.
unions. Although a "Colored" branch for black performers
was eventually established, a 1911 ad in *The Player* iden-
tified Japanese and Hawaiian branches, and a 1913 adver-
tisement in *Variety* stipulated that the union was open to
"any white player of reputable standing." Women were
initially barred from the union, but in September 1910
they were admitted to the Associated Actresses of America,
an auxiliary that otherwise carried the same benefits and
privileges as membership in the White Rats.[40]

Conflicts within the union revealed further divisions.

Mountford was deposed from 1911 to 1915 by what *Billboard* said were forces more conciliatory to the managers, and disputes festered over the wisdom of purchasing the clubhouse.[41]

The membership gains from all this are uncertain. Alfred Bernheim, who analyzed the theatre business for Actor's Equity, estimated that within a few months of receiving the A.F.L. charter, Rat membership grew to 11,000. But without concrete gains, membership dropped to 600 in 1915, according to Bernheim. The Keith interests, using the Rats' figures, reckoned that in 1916 the union embraced 16,000 of America's 20,000 vaudevillians— a figure that Bernheim thought an exaggeration.[42] Whatever the actual numbers, such fluctuations must have played havoc with the union's ability to plan for a showdown with the managers.

For the Rats, the final conflict came in 1916. When stagehands went on strike in Oklahoma City, the Rats struck in their support and then followed suit in Boston and New York. When the stagehands settled and returned to work, the Rats remained on strike from December 16 to January 17, primarily fighting to establish a union shop.[43]

The vaudeville managers struck back with a three-pronged attack: they activated the Vaudeville Managers' Protective Association (V.M.P.A.) to coordinate their actions, formed a company union called the National Vaudeville Artists (N.V.A.), and established a blacklist.[44]

The V.M.P.A., founded in 1911 in anticipation of a Rats' strike, was revived for the 1916–1917 confrontation. According to the Keith interests' attorney, Maurice Goodman, its 211 members represented 422 of the 907 vaudeville theatres in America. A self-described trade organization, the V.M.P.A. was apparently most oriented towards

fighting performers' strikes. Although dues were normally five dollars a week, a special levy was established when the 1916–1917 strike threatened, graded progressively according to theatre size and city. Pat Casey estimated that it raised "about a couple hundred thousand dollars," which paid for strikebreakers, police protection for theatres, and the spy's nest of a room that Casey rented across the street from the Rats' headquarters.[45]

The N.V.A., a company union, was established in 1916 by Albee and the V.M.P.A. In the months closest to the strike, the N.V.A. was used to stiffen the managers' blacklist and break the White Rats.[46] Keith contracts of 1916–1917 contained the following clause: "The artist warrants and agrees that he and the members of his act are members of the National Vaudeville Artists, Incorporated, in good standing, and that they are not nor are any of them members of the 'White Rats Actors Union' or the Associated Actors and Actresses of America and in the event that this warranty or representation shall be found untrue the manager may forthwith cancel this agreement without any liability to the artist whatever."[47] Join or you could get fired: such was the incentive used to recruit members for the N.V.A., whose rolls were monitored by theatre managers and the Keith central office.

With the Keith bureaucracy already in place, the blacklist was simple and effective. Spies in the union and among unaffiliated actors and careful readings of the Rats' publications provided the V.M.P.A. with a list of Rats. Many were then banned from the Keith booking offices.[48]

Union busting, the managers said guilelessly, had nothing to do with it. At an F.T.C. hearing in 1919, Casey of the V.M.P.A. claimed that banned actors were guilty of flaws in "character." "To my mind," Casey said, ". . . they were irresponsible, and could not be depended upon to

fill any contracts that they made or might enter into."
Under cross-examination, however, he admitted that the
blacklist was tied to the strike.[49]

At its height the blacklist incorporated the names of
300 of 15,000 Rats, according to Goodman, the Keith-Albee
attorney. Goodman claimed that the list shrank to twelve
after the strike ended. Whatever its scope, it was a threaten-
ing and shadowy measure, and it was hard to fight. As one
observer noted, ". . . the U.B.O. can say of any single
act, 'we do not think it meritorious.' This can conceal
blacklisting without any way of beating it."[50]

A V.M.P.A. announcement in *Variety*, the vaudeville
trade newspaper, said it with arrogance.

> Who's Bluffing? . . . Those few White Rats who have
> not yet got their cancellations must not feel slighted. The
> Managers are merely rearranging their bills to meet the
> conditions, and the balance will be reached in a few days.
> No act too big to be cancelled.[51]

Despite the managers' arsenal, the strike dragged on for
some two months. Some theatres' earnings, according to the
Keith interests, plummeted from up to $1,800 a day to
less than $100.[52]

Although it would take the managers several months to
recoup their losses, the Rats were beaten. In the aftermath,
the union was virtually destroyed. The Rats collapsed and
their membership scattered. Albee purchased their club-
house in 1919 and turned it over to the N.V.A. Their dues-
paying membership dwindled, and the few Rats left were
forced underground. When the Depression arrived, they
gave up their charter.[53] But for all practical purposes, the
obituaries were long overdue. The union had been mori-
bund since losing the strike in 1917.

Without the White Rats, the V.M.P.A. and N.V.A. dom-

inated vaudevillians' working conditions in a style that was paternalistic at best and coercive at worst. Thus, Albee wrote a letter to theatre managers in November 1921 extolling cooperation between artists and managers.

> The old ways, the bitter hatred, the impulsive demonstrations on the least provocation, both by the artists and the managers, are a thing of the past. Each is getting acquainted with the other, and the vaudeville business, notwithstanding the unfortunate business condition at the present time on account of the reaction of the war, is a lesson to all the peoples of the world. Strife, antagonism and hatred bring forth nothing but the rankest weeds, while kindness, consideration, the teachings of the great Master put into practical operation, brings forth a condition of happiness, order and respect which cannot do other than prosper and grow to the everlasting benefit of all who participate in the latter principle.[54]

At least part of Albee's peace was purchased through his company union, the N.V.A., whose leadership he and the V.M.P.A. approved. Albee asked audience members to contribute to the N.V.A., but the real support came from the 12,000 to 15,000 members who paid dues of ten dollars per year. Albee, who retained the threat of the blacklist, also had performers appear without pay in N.V.A. benefit shows. A special feature of such events was their printed programs, which included advertisements that Albee made the performers buy.[55]

After 1919, U.B.O. contracts stopped asking performers to attest to N.V.A. membership and dropped the clause giving managers the right to cancel contracts with members of the White Rats. An N.V.A. membership application of 1922, however, made an implicit reference to the Rats when it asked applicants about membership and standing in other theatrical organizations. As late as 1924, a union

investigator wrote that while failure to join the N.V.A. did not automatically lead to blacklisting, it often led to difficulty in obtaining bookings.[56]

There were some plusses for performers. N.V.A. members received sickness and death benefits, and had use of a registry service that enabled artists to determine who held first rights to disputed material. The V.M.P.A. and N.V.A. also operated an arbitration service that handled contract disputes and disagreements over acts' material. A "play or pay" policy was instituted, under which acts were paid the full sum of their contract even if their performance was cancelled.[57]

N.V.A. members also got to use a New York clubhouse with accommodations, a cafeteria, a billiard room, and a barber shop. It was located in the White Rats' old building. Albee held the lease, which included a clause forbidding labor union meetings on the premises.[58]

The N.V.A., V.M.P.A., and U.B.O. became the dominant business force in big-time American vaudeville. By the early twenties, Keith and Orpheum theatres covered the entire United States. Keith-Albee interests owned, leased, or operated five small-time theatres in New York City, and their subsidiaries controlled twelve theatres in New York and its suburbs. Their system booked as many as 300 theatres east of Chicago. Orpheum covered Chicago and points west. Other circuits of varying size and profitability—Pantages, Fox, Fally Markus, Shubert, and especially Loew at the small-time level—provided a degree of opposition to Keith and Orpheum. The Federal Trade Commission investigated charges that the U.B.O., V.M.P.A., and N.V.A. were guilty of blacklisting and other offenses, but concluded that they had not violated Federal regulations. In the end, rival businessmen and the Federal

government were not enough to supplant the house that Keith and Albee built.[59]

Although the vaudeville entrepreneurs were out for profits, their efforts had unintended cultural consequences. Their booking offices were the starting point for theatre circuits that sent performers into New York neighborhoods as different as Times Square and the Lower East Side. Once the acts went out on tour, they became show-business emissaries who traversed the cultural mosaic of New York City. Who knew what they might accomplish out there?

5

BIG TIME, SMALL TIME, ALL AROUND THE TOWN

Vaudeville makes a wider appeal than any other form of entertainment, and that is the fundamental reason for its success.

HARTLEY DAVIS, 1907

The vaudeville theatre belongs to the era of the department store and the short story. It may be a kind of lunch-counter art, but then art is so vague and lunch is so real.

EDWIN ROYLE, 1899

Imagine an aerial photograph of the New York City vaudeville scene taken at its height, around 1915: a picture of a cultural nerve system, with vibrant stations all around the city and vigorous messages pulsating between them.

The center is at Times Square in Manhattan, site of the prestigious Palace Theatre, the United Booking Office, and the Loew vaudeville offices. Secondary centers appear in the major business districts of the outer boroughs: at "The

Hub" at 149th Street in the South Bronx, home of the Royal and National theatres; and the Fulton Street area of downtown Brooklyn, home of the Orpheum Theatre. Farther afield in the most localized business districts of the city, often in working-class or immigrant quarters, are neighborhood small-time theatres, such as Loew's Avenue B on the Lower East Side of Manhattan, and Fox's Folly Theatre in Williamsburg, Brooklyn. On the city's fringe at the seaside cluster summertime vaudeville houses, catering to crowds at resort and amusement areas: the Brighton Beach Music Hall in Brooklyn; the Terminal Music Hall at North Beach, Queens; and Nunley's Casino at South Beach, Staten Island.

Although our photograph is imaginary, New York's networks of vaudeville activity were real.[1] Vaudeville was everywhere in New York during the first two decades of the twentieth century because profit-seeking vaudeville entrepreneurs attempted to sell it everywhere. In their economic empire building, they wove city- and nationwide circuits of vaudeville theatres that made possible vaudeville's many-voiced communication. Critics of the Keith-Albee organization correctly likened it to an octopus, with a Times Square booking office brain and theatre circuit tentacles.[2]

Circuit building was motivated by economics, but it was also part of New York's social and geographic evolution. Vaudeville houses followed mass transit lines out into the city—performers joked about touring on the subway circuit—and entrepreneurs relied on proximity to transit and stores to draw patrons. Their theatres became central to new business districts for shopping and entertainment.

Yet vaudeville did not bridge the city's different cultures by shoehorning diverse peoples into standardized, homogenized theatres. Showmen fit their houses into a compli-

cated city. They recognized and often accommodated their audience's enormous diversity. High-priced theatres clustered around central business districts; cheaper houses proliferated in immigrant and working-class neighborhoods.

There was a vaudeville theatre for practically every kind of New Yorker. Middle-class women out shopping could seek a refined Keith-Albee theatre. Working-class Jewish immigrants on the Lower East Side found vaudeville at Loew's theatres on Delancey Street or Avenue B. Again, there were racial limits to the situation: segregated theatres limited blacks' entry into vaudeville houses. But for whites, at least, vaudeville reached people from different classes and ethnic groups because for each of them it appeared in familiar surroundings, smoothing their entry into a heterogeneous cultural network.[3]

The distinctions between theatres and their surrounding districts were partly a function of the contrast between big-time and small-time vaudeville. Big-time vaudeville meant two shows per day; small-time, four to five shows a day or continuous performances. The big time featured star performers, whose high salaries compelled higher ticket prices. Small-time acts were paid less, allowing for lower ticket prices (although small-time entrepreneurs made money by presenting more shows). Small time generally appealed to local neighborhoods, often those of working-class or immigrant New Yorkers. Big-time vaudeville, higher-priced and located at major shopping and entertainment districts, sought city- or borough-wide audiences, and consequently a broader mixture of people. The big time often aimed more at the middle class; but remained open to working-class patrons who could afford higher ticket prices.[4]

The cultural dialogue that distinguished vaudeville was the sum of many conversations, conducted from the elite

stage of the Palace Theatre to the small-time halls of Brooklyn. Its center was at Times Square, twentieth-century hub of New York vaudeville.

Throughout Manhattan's history, the theatre district—along with the commercial district—had moved steadily uptown, staying just ahead of the ever-northward movement of the city's core. Theatre owners built on the fringe of the city's central business district, apparently to take advantage of lower land prices.[5] The theatres were shadowed by two trades: Tin Pan Alley, home of song writing and publishing, which relied on the theatres to disseminate its songs;[6] and the vice district, which after the 1850s moved uptown from the Bowery. By the 1870s and 1880s, Manhattan's red-light district ran along Sixth Avenue between Twenty-fourth and Fortieth Streets.[7]

From the 1880s into the early 1890s, vaudeville's center had been on Fourteenth Street near Union Square. Then the hub moved north to Twenty-third Street, home of Koster and Bial's music hall and Proctor's Twenty-third Street Music Hall (its slogan for continuous vaudeville: "After Breakfast go to Proctor's, after Proctor's go to bed"). Near to both were the Keith offices at Twenty-sixth Street and Broadway, off Madison Square.[8]

Within a few years real estate trends were converging to create Times Square. Such developments were described by the *New York Morning Telegraph*.

The erection of a theatre invariably means a big increase in land values for the property surrounding the site of the theatre, and this frequently happens with land that has been unoccupied, or property that has been desolate for years. A theatre means light, and light is one of the best advertisements in the world. Other property owners bask in the light shining from the theatres and reap rich profits with very little sowing. . . .[9]

Showmen sought to draw crowds with the right com-
bination of mass transit, busy streets and sidewalks, and
distance from vice districts—a distance often mostly psycho-
logical. "Be careful to locate on the right side of the
street," a guide to would-be vaudeville theatre owners
noted, "for there are a right and a wrong side of every
street, a popular and an unpopular side."[10] By the turn
of the century, the right side of the street was nearing
Forty-second Street and Broadway, an intersection then
known as Longacre Square.[11]

In November 1895, theatre entrepreneur Oscar Ham-
merstein I opened the mammoth Olympia Theatre on
Broadway between Forty-fourth and Forty-fifth Streets.
The Olympia heralded Longacre Square's emergence as
a theatre center. At the Olympia, a fifty-cent ticket bought
admission to a pleasure palace incorporating a music hall,
a theatre, a concert hall, bowling alleys, a billiard hall, a
two-story rathskeller, lounges, smoking rooms, and a Turk-
ish bath, all capped by a roof garden. The interior, with
its stucco and statues, was decorated in styles attributed to
French kings. The music hall was in the mode of Louis
XIV: a white and gold motif, with ornamented walls,
paneled ceilings decorated in floral designs, and a massive
chandelier hanging from a rosette surrounded by dancing
cupids.[12]

But behind this bold façade was Hammerstein's flawed
business management. The Olympia failed to turn a profit.
In 1898, the building was mortgaged to Klaw and Erlanger
of the legitimate theatrical syndicate, who eventually sold
it to vaudeville magnate Marcus Loew. But Hammerstein's
decision to build, and other entrepreneurs' willingness to
follow him, showed that something was happening.[13]

The biggest boost for the area's theatrical fortunes came

in 1904, when New York City opened its first subway line. The new Interborough subway line proceeded north from the Brooklyn Bridge along Manhattan's East Side, then headed west on Forty-second Street before turning north at Broadway to continue uptown. When the *New York Times* opened a new office building at the spot where the subway turned north, the intersection acquired a new name: Times Square. Mass transit brought millions to the Square, and in less than ten years, it was Manhattan's new center of theatre and entertainment.[14]

Times Square used electric lighting and a concentration of attractions to create the fantastic environment described by author Stephen Jenkins in 1911.

> Broadway from Thirty-fourth to Forty-seventh street has been for the last few years the locality where the gay life of the metropolis has been most readily seen. Here are congregated great hotels, famous restaurants, and theatres; and the brilliant illumination at night by countless electric lights has caused this section of the avenue to be called the "great white way"; and no stranger has seen New York who has not traversed it.
>
> When we cross Forty-second street we are in the very heart of the "great white way" . . . and the owners and purchasers of property seem to be imbued with a perfect mania for tearing down and rebuilding.[15]

By 1913, the bright lights illuminated vaudeville houses, which included Hammerstein's Victoria at Forty-second Street and Seventh Avenue, and the Palace at Broadway and Forty-seventh Street.[16]

Big-time theatres could be lavish, with marble entrances and columns, statues, and color schemes such as gold, cream, and pale blue. The Palace was no exception, with its richly decorated box seats resting beneath sculpted wall

ornaments, and its proscenium arch outlined in bas-relief designs.[17] It all anticipated the movie palaces of the thirties.

Such theatres were not, however, enormous and cavern-ous. They were moderate-sized houses—usually of about 2,000 seats—that allowed a considerable degree of direct contact between audience and performer. The Palace, New York's premier vaudeville theatre, had 1,736 seats. (In comparison, the Hippodrome, home of immense spec-tacles, had 6,100 seats. The quintessential movie palace of the thirties, Loew's Paradise in the Bronx, had 3,884.)[18]

There was a purpose to this opulence. As Renton noted, vaudeville house decor fed working-class dreams of luxury and middle-class ideas of status.

> It should never be forgotten that the theatre draws peo-ple from all sorts and conditions; in particular does the vaudeville house draw from both the classes and the masses. A theatre should represent to the less favored of its patrons, something finer and more desirable than their ordinary surroundings; and to the better class, it should never present itself as inferior to the environment to which such persons are accustomed.[19]

This balance between price, design, location, appeal, and inclusiveness was critical to a theatre's success. The Palace opened March 24, 1913; it initially failed to attract many customers, possibly because of its relatively high ticket prices, ranging from twenty-five to fifty cents for gallery seats to two dollars for boxes. Other vaudeville houses nearby were less expensive: the average ticket to Hammerstein's Victoria cost one dollar, and front-row seats at Loew's American cost twenty-five cents. However, ap-pearances by Ethel Barrymore in April and Sarah Bern-hardt in May attracted patrons and helped make the

Palace the premier vaudeville theatre in New York City.[20]

Times Square, like the districts that preceded it, encompassed different levels of vaudeville. Such hubs served both middle-class and working-class, native and immigrant, male and female audiences—sometimes under one roof, sometimes in different theatres. Consider Norman Hapgood's description of the different audiences a woman performing in vaudeville might encounter in New York City in 1901. The street he describes is almost certainly Fourteenth or Twenty-third Street.

> Usually she sees before her one of two species of audience, roughly speaking. If it is a continuous house, or a house with two performances every day, in the shopping district, the audience may be extremely respectable. . . . There are two continuous houses on a certain street in New York, within a block of each other. A knowledge of the two would be enough to suggest the differences in the lives of various "artistes" in the same general world, both artistically and professionally. Sometimes the same person will appear at both places, but in the main the whole personnel is unlike, the superiority of the performances in tone and ability at one house corresponding to the superior quality of the patrons. The same contrast holds between the most respectable "continuous" and the ordinary music hall, which has its exhibitions in the evening and is supported as largely by "sporty" men as the other is by the steady bourgeoisie.[21]

In 1914 *Variety* noted that this diversity persisted in Times Square. "In New York . . . ," Andre Charlot wrote, "Hammerstein's and the Palace are only a stone's throw from one another and the atmosphere of both is absolutely different. . . ."[22] The Palace was the embodiment of Keith and Albee refinements; an observer once called it their theatre for "the silk stocking trade."[23] Ham-

merstein's Victoria recalled the Barnum Museum of the mid–nineteenth century.

Manager Willie Hammerstein, Oscar's son, attracted crowds in hot weather with vintage humbug. In the lobby he placed a thermometer that purported to indicate the temperature inside. The thermometer actually rested on an exposed cake of ice. A blackboard behind it recorded seventy degrees on the hottest days, and a message urged skeptics to look at the thermometer if they didn't believe the blackboard. Hammerstein also heated the elevator that carried customers to his theatre's roof garden. When sweltering sufferers reached the roof, they could only conclude that it really was cooler there.[24]

Newsmakers appeared regularly at the Victoria: participants in sexual scandals, prizefighters, wrestlers, bicycle racers, runners, sharpshooters, and suffragists. The Victoria's Woman's Suffragette Week of 1915 was a box office failure but a publicity smash, with suffragettes delivering speeches inside and outside the theatre. Hammerstein presented Jack Johnson, the black heavyweight champion whose affairs with white women were as famous as his pugilism. When chorus girls Lillian Graham and Ethel Conrad were released on bail after shooting Graham's wealthy lover W. E. D. Stokes, the Victoria put them onstage as "The Shooting Stars." They packed the house.[25]

The Victoria's shows also encouraged the rowdy audience participation that was frowned on in big-time Keith theatres, preserving some of the ambience of the old variety theatre. The Cherry Sisters, billed as "America's Worst Act," sang, recited, and performed dramatic sketches behind a net: it protected them when the audience threw vegetables and eggs. A sketch called "Hanged" climaxed with the warden refusing to spring the trap because he opposed capital punishment. A volunteer was then called

from the audience to do the job. "Hanged" evolved into "Electrocution," in which an audience member pulled a switch that sent sparks flying from a simulated electric chair.[26]

The Victoria closed in 1915, partly the victim of competition from the Palace.[27] Yet the nearby Loew's American still offered low-priced vaudeville; vaudeville eventually arrived at the Hippodrome; and there were the houses where star graduates of vaudeville appeared in revues like the Ziegfeld Follies, not to mention the legitimate theatres. The "vast, floating population"[28] that filled Times Square found that there was something for everyone: the gallery god who threw rotten tomatoes at the Cherry Sisters in the Victoria, the middle-class couple who cherished the swank style of the Palace, and the office worker on a tight budget who appreciated the cheap ticket prices at Loew's. Because New York was a city of different classes and cultures, it was impossible to totally integrate the city's population into a few standardized theatres. Vaudeville entrepreneurs were compelled to recognize the differences between New Yorkers and accommodate them.

And Times Square was not the only place in New York for big-time vaudeville. Theatres in the secondary business districts of Manhattan, Brooklyn, and the Bronx also presented top shows at a borough level. The big-time houses of the Upper West Side of Manhattan, The Hub of the South Bronx, and downtown Brooklyn, while not as prestigious as the Palace, all featured nationally acclaimed stars. Without going to Times Square, Brooklynites and Bronxites could see touring big-time performers. Vaudeville thus enlarged the cultural elements these otherwise different people held in common. Keith's Riverside at Ninety-sixth Street and Broadway was some fifty blocks from the Palace, but thanks to performers who toured along the circuits, a

reviewer could conclude that "Riverside clientele, coming from Broadway and the Drive, understand their big time vaudeville. . . ."[29]

Such theatres relied on pools of viewers smaller than those of Times Square houses, but larger than those of neighborhood small time. Witness the aspirations of Proctor's Pleasure Palace, an elaborate continuous vaudeville house on Fifty-eighth Street between Third and Lexington avenues.

> For its support it has many thousands of people to draw from, being the only pretentious place of amusement between Harlem and the lower portion of the city upon the east side. It is between two immense arteries of travel traversed by cable cars and the elevated railway, with ample cross-town communication. Magnificent hotels . . . and the marble palaces of the Fifth Avenue dwellers, are close at hand. Within a stone's throw are luxurious clubhouses of the principal German societies. Upon the north and east is an enormous population that before had been compelled to seek its amusement at remoter resorts. There is much to attract all classes. . . .[30]

Wherever they opened, theatres relied on the same factors: transportation, population, and proximity to a business district. The Sewell brothers, real estate brokers from Port Richmond, Staten Island, took all these into account in 1911 when they announced plans to build a 1,000-seat vaudeville and film house on the south side of Richmond Terrace, near the post office and "handy to the various trolley lines." The local newspaper noted that:

> The plot on which the theatre is to be erected is one of the finest that can be found anywhere on the north shore of Staten Island for such a purpose. It is located right in the heart of Port Richmond, and what makes it so valuable as a site for a modern theatre is that it is easily

reached by the Staten Island Rapid Transit trains, the Bull's Head, Concord, Silver Lake and shore line trolley cars, and the Bergen Point and Elizabethport ferries.[31]

Consider the history of a premier big-time vaudeville theatre in downtown Brooklyn, a neighborhood that, by the end of the nineteenth century, was well established as as Brooklyn center for shopping, theatre, and municipal government. The Orpheum opened on New Year's Eve, 1899, at 578 Fulton Street. The 1,700-seat theatre, built by vaudeville entrepreneur Percy Williams, was one of a chain of Williams vaudeville theatres in New York City.[32]

In 1912, the Keith organization paid $5 million for the Percy Williams theatres in metropolitan New York, including the Orpheum. When they refurbished the house in 1915, they attempted to place it on a par with the Palace (Times Square big time having become the level by which top vaudeville was judged throughout New York). The renovated Orpheum boasted a ventilating system, indirect lighting, Italian marble lining, extensive hangings and curtains, luxurious rugs and carpets, costly bronzes, silk box draperies, and diverse fixtures and pictures.[33]

If the Orpheum's history shows showmen operating in an established downtown district to take advantage of the drawing power of stores, offices, transportation, and public buildings, the growth of Keith and Loew vaudeville in the Bronx shows entrepreneurs following new subway lines to prosperity. Until the late nineteenth century, most of the Bronx was woods, meadow, and farmland, dotted with small villages. From the 1850s to the 1890s, Bronx theatre consisted of local halls presenting concerts, political rallies, traveling shows, and wedding receptions. All appear to have been local institutions, with no pretensions to the citywide audience that places like Tony Pastor's were cultivating at the same time. Eventually, however, the Bronx acquired

two legitimate theatres in and around The Hub, a com-
mercial district at 149th Street and Third Avenue: the
Metropolis, which opened just below The Hub in 1904,
and the Bronx Opera House, which opened at The Hub's
center in 1913.[34]

Population changes ushered in The Hub's vaudeville
years. From 1900 to 1910, the Bronx grew from 200,500
residents to almost 431,000, the greatest rate of growth of
any borough in New York City. This boom, and the real
estate bonanza that accompanied it, were caused partly by
the extension of the Interborough Rapid Transit (IRT)
subway line into the Bronx. The tracks reached the South
Bronx in 1904 and the northern regions of 242nd Street
and Broadway in 1908.[35]

As more middle- and working-class people moved into
the Bronx, the upper classes fled The Hub, just as they had
forsaken areas like Union Square in Manhattan. The Me-
tropolis, already shaken by competition from the Bronx
Opera House, was isolated from its old "society" audience.
Metropolis management tried a variety of offerings, rang-
ing from dramatic stock to vaudeville, films, and Italian
shows. None of them brought lasting success. A fling at
burlesque attracted the police, and the theatre was closed
in 1926. In 1929, the house was sold to Loew's for use as a
scenic studio. The Bronx Opera House thrived longer, but
by the late twenties it was converted to a continuous-show-
ing movie theatre.[36]

The changes in population and transportation that shook
the Metropolis and the Bronx Opera House meant oppor-
tunity for vaudeville entrepreneurs. The Hub, at the in-
tersection of the Third Avenue "El" and the Seventh Ave-
nue and Lexington Avenue subway lines, was the major
shopping district of the Bronx. With more and more new

residents moving into the borough, a more lucrative site for vaudeville could not be imagined.[37]

Keith and Loew houses opened all around The Hub. The first Keith theatre in the Bronx opened in 1909: the Bronx Theatre, a 1,220-seat house at 581 Melrose Avenue and East 151st Street. Marcus Loew responded in 1910 by opening the 2,397-seat National two blocks away at 500 Bergen Avenue. Keith countered in 1913 with the Royal, a big-time house of 2,070 seats. The Keith interests abandoned the Bronx Theatre in 1918, but their Royal continued to compete with Loew's National.[38]

Meanwhile, further north in the Bronx, new businesses, residential districts, and theatres sprang up along the transit lines. Major circuits hurried to open houses on thoroughfares such as Fordham Road and Tremont Avenue. From around 1910 to 1920, the Loew, Keith, and Fox interests built or acquired more than twelve Bronx theatres, each seating more than 1,000.[39]

Many of these new stages were in the most local dimension of vaudeville—the neighborhood small-time houses. In the Bronx and throughout the city, at neighborhood intersections and business districts, small-time theatres injected vaudeville into new middle-class and working-class neighborhoods. Unlike theatres in Times Square or downtown borough centers, they catered to people within walking distance. It was in the small time that immigrant and working-class New Yorkers encountered vaudeville on their home ground. "Who diverts the minds of the great Common People from the beef trust and coal trust and the landlord's union?" asked a magazine writer in 1910. The answer was small-time vaudeville.[40]

Small time was vaudeville's version of baseball's minor leagues. The performers there were usually on their way

up or down the ladder to stardom. The small time was not a haven for established stars.

Some small-time theatres were down-and-out places, the sort of houses where artist Marsden Hartley noticed "the frayed traditions of worn plush and sequin," the "so inadequate backdrop such as . . . the scene of Vesuvius in eruption or the walk in the park at Versailles," and "the very much worn property piano just barely in tune." Some, like Keith's Jefferson on Fourteenth Street, copied the lavish decor of big-time theatres.[41]

The theatre operator most associated with New York small time was Marcus Loew. "The Loew circuit had theatres in every neighborhood in New York City and Brooklyn," vaudevillian Fred Allen noted. "The acts moved from neighborhood to neighborhood. At the Delancey Theatre, on the Lower East Side, Mae West was the star of the bill. At the National Theatre, in the Bronx, there was Harry Jolson, Al's brother; at the Columbia Theatre in Brooklyn, there were Burns and Lorraine."[42]

Loew's first houses, which he experimented with around 1905, were little more than nickelodeons that featured singers between reels. Over the next five years, he acquired a succession of full-fledged theatres in Brooklyn, Manhattan, and the Bronx, and put them into service featuring combination bills of movies and vaudeville.[43]

The new-style Loew theatres presented shows at an inexpensive price—five to twenty-five cents in 1914—at least three times a day. By 1918, Loew operated 112 theatres in the United States and Canada; 32 of them were in New York City. A performer playing Loew houses alone could tour for months without leaving town.[44]

Loew—who was dubbed "the Henry Ford of show biz"— showed that there was no contradiction between cheap tickets and profits. In contrast to big-time Keith houses,

which promised the stars, Loew theatres featured less-famous acts for a less expensive price. There was one basic principle behind his operation: selling five ten-cent tickets is as profitable as one fifty-cent ticket, provided that the cheaper seats are consistently turned over.[45]

Loew's vaudeville was aimed at people who couldn't or wouldn't pay the admission prices at more expensive houses. A 1914 article lauding his theatres called them places where "the man with the wage or small salary looks for an evening's pleasure," houses for "the filling of the poor man's hour with fun" and "helping the strugglers to forget their poverty. . . ." Although Loew theatres ranged from Times Square to local shopping districts, a guide to the 1913–1914 vaudeville season listed three Loew houses in the immigrant Lower East Side, more than any other circuit.[46]

Cheap small-time theatres were most often noted for playing to immediate residential neighborhoods. A 1914 magazine article recognized Loew's local appeal.

> When one of his emporiums of pleasure is opened in any city district, half of the families within twenty minutes' walk are counted on for one visit a week, three persons a visit should be the average. One fourth of the residents in the tributary circle must be inveigled into dropping dimes and quarters into the box office twice a week, for doesn't the complete bill change every Monday and Thursday? A Loew manager must make that change pay.[47]

Even when presented in a more lavish Keith style, the local orientation of small-time vaudeville was noticeable. A 1918 article on the opening of a new Keith house on Fordham Road in the Bronx described a fancy, big-time style interior: roomy lobby, marble stairs, women's rooms furnished with ornate framed mirrors, men's rooms pan-

eled with English walnut, tables decorated with fresh flowers in vases, dressing rooms with tiled bathrooms, and all of it with carpeted corridors and serviced by elevators.[48]

But if the interior was in a big-time style, the intended audience was not. The reporter compared the theatre's anticipated patrons to the "vast floating population" that filled the Palace. "This is strictly a neighborhood house; that is, it draws only on the residents of that immediate region. The same people come week after week. It gives a program of mixed vaudeville and pictures at a low price."[49]

Other small-time theatres, beside Keith's and Loew's, were scattered throughout the city. The Fox vaudeville firm ran small-time theatres all around New York. Independent houses like the Hyperion Theatre, which opened in Corona, Queens, in December 1910, offered vaudeville, films, dancing, and amateur nights for prices ranging from five to fifteen cents.[50] *Variety* noted the orientation of such theatres when it covered the 1912 opening of the Halsey theatre in Brooklyn, operated by M. H. Saxe, who also owned moviehouses at Times Square and 116th Street in Manhattan. "The Halsey," *Variety* asserted, "was built . . . to give the amusement-seeking people of the Saratoga Park neighborhood a chance to spend their rusty dimes without crossing the river."[51]

Neighborhood vaudeville houses were a part of everyday life, "like your local movie," said Harold Applebaum, who lived near the Royal in the Bronx. In the late teens and early twenties, Applebaum preferred the Royal at The Hub to Keith's Fordham Road theatre. The Royal, he felt, was for "the lower element, the ritzier element was for Fordham." For Applebaum, the Keith theatre on Fordham Road, which was fancier and farther from his

neighborhood, was not "home" like the Royal. And Apple-
baum's attachment to his neighborhood vaudeville house
was typical.[52]

At small-time houses, contests and giveaways were com-
plemented by promotions that were designed for neighbor-
hood appeal. In June of 1915, Loew's Avenue B Theatre
was jammed for a beauty contest that featured thirty-one
contestants from the Lower East Side. In February of 1911,
the Hyperion Theatre in Corona, Queens, featured local
Boy Scouts appearing in their own play. The Prospect in
Brooklyn gave a special reception for a Brooklyn-born per-
former, Frank Fogarty, whose catch phrase "Am I right,
boys?" always sparked the crowd. The packed Prospect was
rocked by applause. "From the aspect of the celebrations,"
Variety concluded, "one might have concluded that the
Brooklyn team had won the National League pennant and
that Frank Fogarty was responsible for it. . . ."[53]

Small-time theatres were frequently rowdy places, with
boisterous humor reminiscent of the earliest variety halls.
An act could get big laughs out of flypaper stuck to the
seat of a man's pants or an allusion to the wife of the Tsar
as the Tsardine.[54]

This spirit lived on longest in small-time amateur nights.
There, aspiring stars competed for prizes in rambunctious
events with roaring audiences, anxious performers, and
sometimes "the hook" to pull off the losers.[55]

Eddie Cantor recalled his 1908 appearance at Miner's
Bowery Theatre's amateur night, with gallery gods who
shouted, "take the muzzler off! . . . Go to work, you
bum!" When he won them over, ". . . there was a rumble
of stamping feet, shrill whistling, and a thin shower of
coins that pelted the back-drop and rolled toward the
gutter of footlights. This was their way of applause, with
leather, metal and siren shrieks; they scorned the effemi-

nate clapping of hands." Losers were yanked off with the hook. At the end of the show, the survivors were lined up onstage. The master of ceremonies walked down the line of them, holding a five-dollar bill over each performer's head. The one who received the loudest applause won the money.[56]

There was an honesty and an egalitarianism among audiences at amateur nights, but at their core they were competitions in which audiences measured artists against big-time standards. They cheered them if they measured up, but they were merciless if they fell short. One witness recalled scenes in which

> [h]opefuls walked the plank for applause and some cash and too often got the hook and perhaps left in tears. But when the patrons liked the talent, they would tear the theatre apart and sometimes throw coins. Some thought it funny to heat up the coins with matches.[57]

In contrast, at big-time vaudeville theatres, people behaved more as they did in the legitimate theatre. Popular acts were greeted with applause or cheers. Unpopular acts received the silent treatment, or if they were particularly bad, a walkout. Booing occurred, but it was rare.[58] All of this might be traumatic for the performer, but it was a far cry from the vigorous and vocal assertions of the gallery gods. In big-time vaudeville, at least, the Keith-Albee taming of the gallery gods was largely successful.

Another set of vaudeville theatres was even farther from the center of the city: the seaside vaudeville houses of resorts like Coney Island. Although open only in summer months, they were otherwise much like their landward counterparts: connected to adjacent business districts (in this case, the business being amusements); linked to transit systems that brought audiences from around the city;

claiming to feature only the best big-time acts; and able to appeal to different classes of New Yorkers.

In Brooklyn, seaside vaudeville houses clustered along the Atlantic Ocean between Coney Island and Manhattan Beach. The more notable included the Manhattan Beach Theater (its slogan was "swept by oceans of laughter"), the Brighton Beach Music Hall, and the New Brighton Theater. The New Brighton explicitly promised its customers the same class of shows found at leading downtown theatres.[59]

In Queens, summertime seaside vaudeville was found at North Beach, today the site of LaGuardia Airport. North Beach opened in 1886, the creation of two successful German immigrants: brewer George Ehret and William Steinway, the piano manufacturer and owner of a trolley line that ran straight to the resort. It boasted a large hotel, a swimming pool, a dance hall, picnic grounds, fireworks, movies, amusements, and German bands for Queens' German population.[60]

Reaching North Beach was easy, according to its promoters: boats ran regularly from East 99th and 134th streets in Manhattan, and trolley cars ran from the Queensboro Bridge. North Beach offered free shows performed by what the management claimed were big-time acts at the Terminal Music Hall, McMahon's Big Meriden, and Spivak's Grand Pier.[61]

Recalling early vaudevillians' efforts to attract women and children to their theatres, North Beach entrepreneurs boasted of the many mothers and children who visited their park during the hot days of summer, and planted shade trees to create an attractive atmosphere for them. Their strategy worked—to an extent. By day, North Beach attracted orderly families, union outings, political and fraternal organizations, and Sunday School groups. By night,

it received crowds of young men and women. And although reports of drunkenness, gambling, and corruption attracted the condemnation of moral reformers, the area remained popular until it was undone by Prohibition and the end of trolley service.[62]

North Beach seemed to present one face by day, another by night. Sometimes a seaside pleasure district could present two faces at once, as in the vaudeville houses of South Beach, Staten Island. South Beach emerged as a resort and entertainment area in 1886, when a new train line opened between St. George (an urbanized area of northern Staten Island and the landing for ferries to Manhattan and Brooklyn) and the Arrochar station near South Beach. Pleasure-seekers of a working-class character followed—a "Bowery beer crowd," as one observer put it. Entrepreneurs rushed to build hotels and amusements. By 1890, South Beach boasted hotels, boat houses, dance pavilions, shooting galleries, rides, and a carousel. Equally important for the resort's success, boats began carrying visitors on the forty-five-minute trip from Whitehall, Manhattan, and also from Brooklyn.[63]

In 1892 increased development prompted a railroad extension directly to South Beach. The bustle and crowds that followed prompted comparisons to Coney Island. On summer Sundays, trains and boats brought up to 100,000 passengers, many of them visitors bound for picnic parties in groves where the management sold lager beer. Some rented bathing suits and plunged into the surf.[64]

Two vaudeville houses opened in South Beach in the early 1890s: Nunley's Casino, at the south end of the boardwalk near the railway terminal, and Hergenhan's Olympia, at the north end of the beach. Although there were other vaudeville houses on the beach, the contrast between these two is telling. Admission to both houses was

free. Patrons paid their way by drinking the beer and soft drinks sold to them in thick glasses at double the barroom price of five cents. Both houses featured comics, acrobats, and vocalists left unemployed when other theatres closed for the summer.[65]

The Olympia was apparently something of an island of refinement in rough-edged South Beach; its middle-class patrons seemed to avoid the amusement attractions around it. The Casino attracted more of the "Bowery beer crowd." The visiting habits of soldiers from an artillery regiment stationed nearby followed accordingly. Officers usually patronized Hergenhan's Olympia; enlisted men favored Nunley's Casino, where the audience's behavior was freer.[66]

From Times Square to South Beach, vaudeville entrepreneurs recognized that New Yorkers were not one people who could be easily entertained under one roof. New Yorkers were too divided by class, race, ethnicity, and gender to find satisfaction in one standardized vaudeville theatre. Vaudeville, like the people of New York, spoke in many dialects. The entrepreneurs who sold vaudeville to New York City had to tailor their appeal to a diverse constituency. No other approach was possible, especially in an industry that grew so closely with the city.

Returning to our imaginary aerial photograph of the vaudeville nerve system, we can see artists and audiences moving back and forth between the theatres. Performers on tour were messengers. They brought the brash spirit of the Lower East Side to the stage of the Palace Theatre, and downtown style to the furthest reaches of the five boroughs. Even as they bowed to the distinct personality of every theatre, they took a giant step towards integrating their audiences into a city- and nationwide arena of popular culture.

6

UNFORCED AND

HAPPY COMMUNION

A vaudeville comedian in America is as close to
the audience as Harlequin and Puncinello were
to the Italian publics of the eighteenth century.

MARY CASS CANFIELD, 1922

In 1922, Mary Cass Canfield wrote in the magazine *New Republic* about the "unforced and happy communion" between artists and audiences in the vaudeville house, and the comedian's carefully crafted image of spontaneity. She takes us inside a long-silent theatre to hear a long-gone comedian.

He is . . . an apparent, if not always an actual improviser. He jokes with the orchestra leader, he tells his hearers fabricated confidential tales about the management, the other actors, the whole entrancing world behind the scenes; he addresses planted confederates in the third row, or the gallery and proceeds to make fools of them to the joy of all present. He beseeches his genial, gum-chewing listeners to join in the chorus of his song;

they obey with a zestful roar. The audience becomes a part of the show and enjoys it. And there is community art for you. . . .[1]

Canfield described a vaudeville show produced by a corporate entertainment industry. Yet the comedian's combination of art, empathy, and artifice fostered real and immediate communication between artist and audience. And it was this sense of intimacy, however manufactured, that was central to the way vaudeville won and shaped audiences in New York City. Audiences were not coerced into vaudeville houses, they were enticed. Even if the intimacy of the vaudeville house was as deliberately created as the heterogeneous vaudeville audience, the satisfactions audiences found were real. Their support made vaudeville a popular form of theatre in every sense of the term.

Ordinary New Yorkers embraced vaudeville because it was familiar, because it spoke for and to them more than any other commercial entertainment medium. This direct appeal, plus the variety and accessibility of vaudeville theatres, made vaudeville popular with a diverse audience. The only statistical survey of the New York vaudeville audience, made in 1911, revealed an audience that was 64 percent male and 36 percent female; 60 percent "working" class, 36 percent "clerical" class, and 4 percent "vagrant," "gamin," or "leisured."[2] Even though it did not erase the differences between these people, vaudeville succeeded because it was a uniquely expansive form of theatre that could accommodate them all.[3]

Performers spoke and sang directly to the audience, making them feel that they were a part of the show. Their goal, as they described it, was to put the act over. What the performers said was as important as how they said it. Their songs, monologues, jokes, and short plays were de-

signed to achieve the widest reception possible. The themes of acts, particularly when dealing with ethnicity, were open to a variety of interpretations. Sophie Tucker's "My Yiddisha Mama" examined the pain of Jewish assimilation and mobility, but it was also a sentimental song about mothers with an appeal for non-Jews as well.

Such songs—which were vaudeville mainstays—were an important part of an emerging commercial ethnic culture concerned with both mass-market appeal and ethnic life. Their language was similar to that observed by Stuart Hall in British journalism. It was neither a fabrication nor the actual patter of the city streets. It combined elements of popular culture—Tin Pan Alley—and elements of everyday speech. Without realism, it wouldn't have been accepted. Without artful alteration and a leavening of deliberate mass appeal, it wouldn't have reached the broadest possible audience.[4]

Such creations enabled vaudeville to outflank New York's boundaries of class, ethnicity, and neighborhood and introduce people into a city- and nationwide arena.[5] They spoke to different New Yorkers in a language of popular culture, a voice influenced by both the imperatives of the entertainment industry and the city's many cultures.

Although the taming of the Bowery boys had quieted many of the gallery gods, the dialogue between artist and audience remained critical. As George Jessel recalled of his vaudeville years, "you lived by the reaction of the audience."[6]

Above all, it was a heterogeneous audience. As vaudevillians worked the circuits from the small to the big time, they toured across New York City and ultimately the entire country. They encountered crowds with different kinds of faces, middle- and working-class, immigrant and native-born.[7]

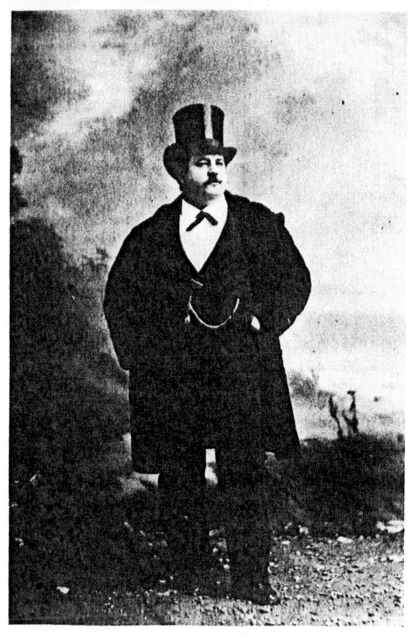

Tony Pastor, who took vaudeville out of the Bowery without entirely taking the Bowery out of vaudeville. (*Harvard Theatre Collection*)

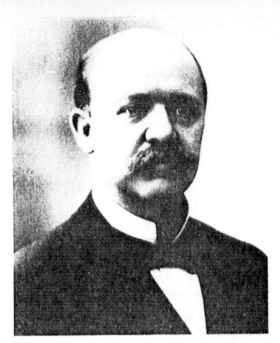

Benjamin Franklin Keith started out in circuses and dime museums, but gave his name to the theatre circuit that defined big-time vaudeville. (*Courtesy of The Hampden-Booth Theatre Library at The Players*)

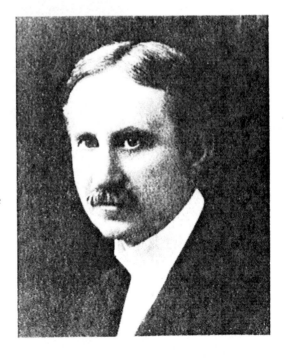

Edward F. Albee, whose ties to Keith went back to their circus days. He ran the circuit and its affiliated operations after Keith died in 1914. (*Courtesy of The Hampden-Booth Theatre Library at The Players*)

George Fuller Golden, founder and first president of the White Rats, the vaudevillians' union that unsuccessfully battled Keith and Albee. (*The Billy Rose Theatre Collection, The New York Public Library at Lincoln Center, Astor, Lenox and Tilden Foundations*)

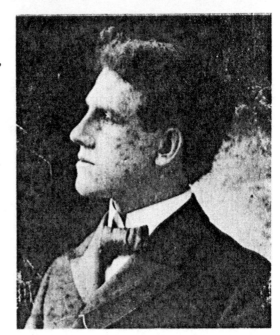

Marcus Loew, whose cheap, mass-market theatres earned him the title "The Henry Ford of Vaudeville." His combination of live shows and films smoothed the transition from vaudeville to the movies. (*Georgetown University*)

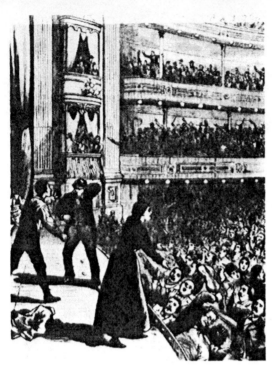

The audience the show-men tried to tame; at the Bowery Theatre, 1878. (*Harvard Theatre Collection*)

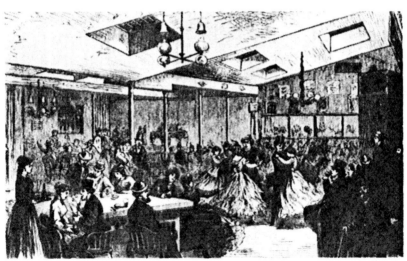

Concert saloon audience at Harry Hill's on Houston Street, ca. 1870. (*United States History, Local History and Genealogy Division, The New York Public Library, Astor, Lenox and Tilden Foundations*)

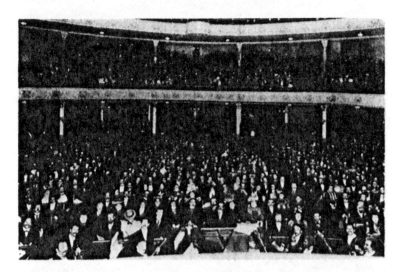

The vaudeville audience at Proctor's Pleasure Palace, late 1890s.
*(United States History, Local History and Genealogy Division, The
New York Public Library, Astor, Lenox and Tilden Foundations)*

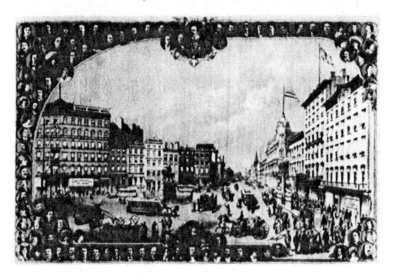

Union Square, cradle of New York vaudeville and home of Tony
Pastor's, in midsummer, 1882. At right, actors, actresses and agents
pound the pavement in front of what would become Keith's Union
Square Theatre in 1893. *(Courtesy of the New-York Historical Soci-
ety, New York City)*

Tony Pastor's Theatre, under the roof of Tammany Hall on Fourteenth Street, at the turn of the century. (*The Billy Rose Theatre Collection, The New York Public Library at Lincoln Center, Astor, Lenox and Tilden Foundations*)

Top of the big time: the Palace Theatre on Times Square in Manhattan opened in 1913. (*Museum of the City of New York*)

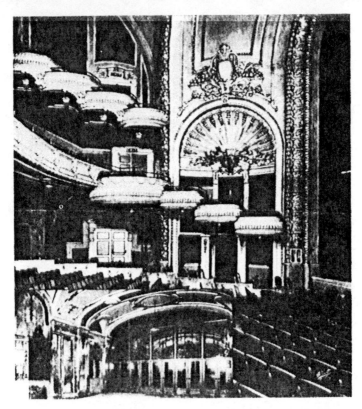

Palace Theatre interior and lobby. (*The Billy Rose Theatre Collection, The New York Public Library at Lincoln Center, Astor, Lenox and Tilden Foundations*)

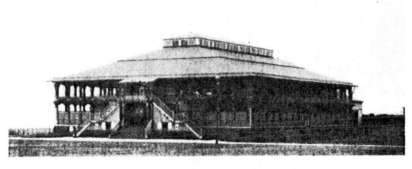

Vaudeville at the seashore: the Brighton Beach Music Hall at the turn of the century. (*Museum of the City of New York*)

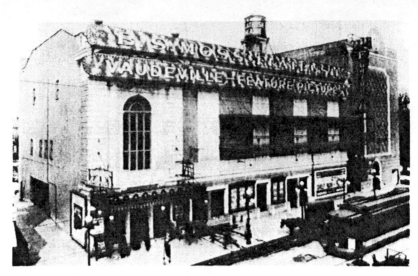

Vaudeville in the neighborhoods: B. S. Moss's Flatbush Theatre in the early 1920s. (*Brooklyn Historical Society*)

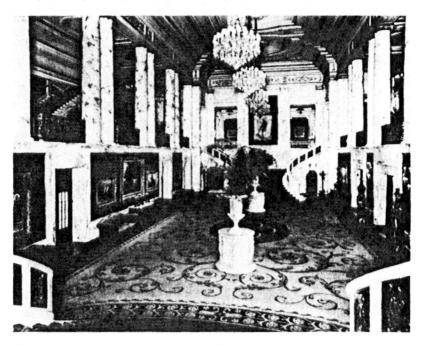

Big-time style in Brooklyn: the Albee Theatre lobby, 1925. (*Museum of the City of New York*)

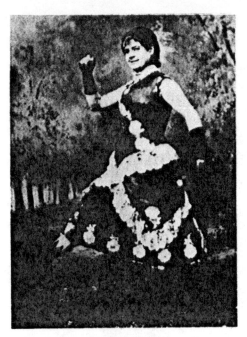

Maggie Cline, "The Irish Queen."
(*Harvard Theatre Collection*)

Pat Rooney, Sr., a vintage
vaudeville Irishman. (*The
Billy Rose Theatre Collec-
tion, The New York Public
Library at Lincoln Center,
Astor, Lenox and Tilden
Foundations*)

Joe Welch in a classic example of the
Jewish stereotype. (*Harvard Theatre
Collection*)

Sophie Tucker: maternal, sensual, and Jewish—all at once. (*The Billy Rose Theatre Collection, The New York Public Library at Lincoln Center, Astor, Lenox and Tilden Foundations*)

Eddie Cantor, a Jewish son of the Lower East Side, was one of many performers who broke into show business in blackface. His career spanned vaudeville, records, radio, film, and television. (*The Billy Rose Theatre Collection, The New York Public Library at Lincoln Center, Astor, Lenox and Tilden Foundations*)

Bert Williams (*left*) and
George Walker (*right*).
Williams, although black,
wore blackface makeup so
his appearance would con-
form to the stereotype.
(*Harvard Theatre
Collection*)

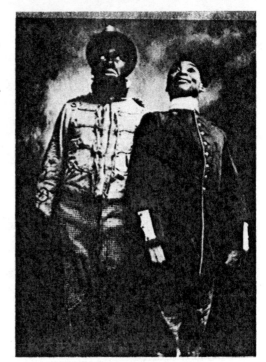

To his last days, Eubie
Blake was proud that he
made his Palace debut in
formal dress, without
blackface makeup. (*The
Schomburg Center for Re-
search in Black Culture,
New York Public Library*)

Eugene Sandow, whose muscular poses titillated many proper middle-class women at the turn of the century. (*Courtesy of The Hampden-Booth Theatre Library at The Players*)

George Burns and Gracie Allen, who joked about the relations between men and women from vaudeville to television. (*Harvard Theatre Collection*)

Eva Tanguay, star of the supposedly puritanical Keith Circuit. (*Billy Rose Theatre Collection, The New York Public Library at Lincoln Center*)

As journalist Marian Spitzer noted in 1924, legitimate theatre audiences were generally alike. Jokes usually went over equally well in one house after another.

> But vaudeville audiences are different all the time. It's almost impossible to set a performance and then play it that way forever. Each town seems to be different; every neighborhood in the city needs different handling. So a vaudevillian has to be forever on the alert, to feel out his audience and work accordingly.[8]

Sometimes the differences were within a single theatre. Managers' reports noted how acts scored with the cheap seats at the back of the house, which most likely contained plebeian types, but failed with the high-priced seats, which were more likely to contain middle-class people.[9]

More than other forms of theatre in late nineteenth- and early twentieth-century America, vaudeville consistently reached out to make its broad-based audience feel like part of the show. Drama and opera, although certainly capable of being enthralling, sought to create their own reality on the stage, which spectators observed from their seats. Then-fledgling musical comedy played to the audience, although not as often as vaudeville. Burlesque also played to the audience, but its reach was narrowed by its risqué reputation. But in broad-based vaudeville, acts consistently spoke to the people beyond the footlights.[10]

The importance of this appeal was reinforced by the economics of the vaudeville industry: bookers and managers hired popular acts because they attracted the largest crowds and made the most money for the theatre. Theatre managers' reports, filed with New York booking agents, helped to determine which acts were hired. Few acts would last long if they generated responses like that of Crimmins and Gore when they performed the telephone scene from

"A Warm Match" at a vaudeville house in Sacandaga Park, New York, in 1910. "Rottem [sic]: 920 Paid admittance All of 500 people left the theatre before act finished completely disgusted with this act. Has killed our business for next two days."[11]

Faced with such pressures, vaudevillians learned to establish a fine-tuned rapport with spectators. Even though they performed the same routine for weeks and even years on end, they had to sound fresh and original. The demands were apparent even to a legitimate theatre star who toured in vaudeville—Ethel Barrymore. "The vaudeville public is an exacting one," she wrote, "and nothing must ever be slurred for them—perfect in the afternoon and perfect at night, over and over again for weeks and weeks."[12]

As Jimmy Cagney recalled it, "Vaudevillians by persistent trial and error and unremitting hard work found out how to please. When they said something, it was generally and *genuinely* funny . . . they spent years perfecting those acts so that they knew their jobs and they did their jobs without slighting either their talent or their audience."[13]

There was nothing rote or routine in their craft. Decades after he played in New York City, singer and comedian Billy Glason recalled the vaudevillian's versatility and connection to the audience.

> If you've been in vaudeville, you have a knowledge of every type, every nook and corner of show business. Dramatics, comedy, timing, pacing, proper and improper. You have your mind and your mouth working together, and you work along with the vicissitudes of the audience. You see they're not going, you go a different way, or you throw in a line. If they're going good, you're sailing. Time, rhythm, pacing, personality.[14]

Caroline Caffin, in a book published in 1914, captured the performers' calculated efforts to establish a feeling of intimacy.

> [I]t is ever the strong personality and the ability to get it across the footlights and impress it upon the audience that distinguishes the popular performer . . . that genial familiarity, that confiding smile which seems to break out so spontaneously, the casual entrance and glance round the audience—all have been nicely calculated and their effect registered, but with the artist's sympathy which informs each with the spirit of the occasion and robs it of the mechanical artifice.[15]

Performers learned to tailor their presentations to the crowd before them. A young Eddie Cantor flopped when he presented an English language act in a theatre where most of the patrons spoke Yiddish. He translated the act into their language and scored a hit:

> We had simply talked to them in the wrong language, and this in a way is every actor's problem in adapting himself to his audience. Drifting as I did into every conceivable type of crowd, I trained myself to the fact that "the audience is never wrong," and if a performance failed to go across it was either the fault of the material or the manner of presentation. By carefully correcting the one or the other or both with an eye to the peculiarities of the audience I could never fail a second time. I proved this to myself on many occasions later on, when in the same night I'd perform at the Vanderbilt home and then rush down to Loew's Avenue B and be a hit in both places.[16]

Cantor, a Jew, appealed to Jews by speaking Yiddish. Yossele Rosenblatt, a renowned cantor who toured in

vaudeville in the 1920s after his financial support of an Orthodox Jewish newspaper drove him into bankruptcy, typically sang one song in English and two in Hebrew. For the Irish, Pat Rooney commented on the Land League, and Maggie Cline tossed barbs at the Queen of England.[17]

But vaudeville's relationship to ethnic culture was not always so sympathetic. Vaudevillians who performed in cities like New York did not often present immigrant culture to their ethnically diverse audiences. Instead, they expressed a synthetic ethnicity formed from elements of immigrant experiences, mass culture, and the stereotyped national and racial characters of the American theatre.[18]

Vaudeville thrived in cities whose size and diversity made their inhabitants strangers to each other. It introduced these city-dwellers to each other, but often through stereotypical characters who would, in Raymond Williams's words, "simulate but not affirm human identity."[19]

Stereotypes provided simple characteristics that roughly explained immigrants to native-born Americans and introduced immigrant Americans to each other. They were identifying markers on a bewildering cityscape of races, nationalities, and cultures. They were also sometimes bigoted and racist, a trait that occasionally roused the aggrieved to protest portrayals of black chicken thieves, Jewish cheapskates, and drunken Irishmen. Sometimes the complaint was as subtle as a rabbi's backstage visit to a Jewish comedian who lampooned his own people; sometimes it was as shrewd as a threat of a boycott; sometimes it was as smashing as the boos, hisses, and vegetable matter that the Ancient Order of Hibernians used to silence the Russell Brothers' spoof of two Irish servant girls. The U.B.O. files contain repeated references to cuts of ethnic gibes and nastier expressions such as "kike," "wop," and "dirty little Greek."[20]

Of course, such portrayals—whether in song, comedy, or sketches—could be mined for more complex and humane meanings than appeared on the surface. And representations of ethnics were bound to be problematic at a time when the stresses of immigration and acculturation left many in a continual state of upheaval. Still, vaudeville was not as generous as it might have been to ethnic culture, and at its worst it set a precedent for the simplistic treatment of race and ethnicity that still pervades American entertainment.[21]

According to the conventions of the period, anyone could play any nationality. All that was needed was a convincing presentation of stock traits (down to skin color: sallow greasepaint for Jews, red for Irishmen, and olive for Sicilians). The Jewish Ross Brothers of New York City did Italian dialect impersonations. Lee Barth advertised himself as "the man with many dialects / I please all nationalities and cater to originality." In 1920 and 1921 a Californian of Spanish descent, Leo Carillo, performed Chinese and Italian dialect stories on the Keith circuit. One of the most bizarre, to late–twentieth-century eyes, appeared at Keith and Proctor's Fifth Avenue Theatre in 1911 under the name of Morris and Allen. "Two Jews singing Irish songs with a little talk and some bag pipe playing," noted manager R. E. Irwin. "This act is a find for any house and is as good an act of the Hebrew brand as has been around in many a day."[22]

These stereotypes were effective and durable because they were widespread and because they evolved over time with their real-life counterparts. Vaudeville characters were based on real people to be found on city streets. Acts that traded in ethnic stereotypes claimed to base their routines on close, careful observation of their subjects.[23] As Jewish Belle Baker asserted in 1919:

You see, a comic song to be truly comic ought to have a true-to-nature touch. If you don't understand the people you are characterizing, your impersonation is just a burlesque and not real at all. Well, I don't have to make a sightseeing tour to get my types. I was born in New York right among them. . . . All my impersonations are real. When I sing an Italian or Irish or Yiddish song, I have a definite character in mind that I've known for years. I present the character from that point of view—not the outsider's.[24]

Baker, a plump woman with large eyes and a strong, rich voice, worked a variety of characters into her act. A typical performance could begin with an imaginary plea from forty-three-year-old Sadie Cohen that her beau Jacob should not let her remain single much longer; then "Come Back Antonio," an Italian-style dialect plea from a wife whose husband "taka the gun, maka the run to Mexico." The woman's chief worry is that if he loses a hand in the fighting he will be unable to work shining shoes. Next would be "My Mother's Rosary," a piece of Tin Pan Alley bathos calculated to appeal to at least some of the Catholics in the audience. Then "Robinson Crusoe," which asks the musical question, "Where did Robinson Crusoe go with Friday on Saturday night?" and answers it with, "Where there are wild men, there must be wild women." Baker might conclude with her signature tune, "Eli, Eli," a passionate, wailing Hebrew lament that always grabbed the Jews in the house.[25]

"Eli, Eli" aside, performers like Baker presented ethnic caricatures. But their portrayals were rooted in reality, and they changed with the immigrants and their children. Without an element of truth—however thinly stretched—their acts would have appeared totally implausible. Without an element of standardization, their acts would have

lacked their requisite mass appeal. Without broad satire, they wouldn't have been funny.

Among the first to experience such stage treatment were the Irish. The typical Irish character of the late nineteenth century appeared in a take-off on an immigrant workingman's garb: a plaid suit, green stockings, corduroy breeches, a square-tailed coat, a battered stovepipe hat with a pipe stuck in the band, a hod-carrier's rig, and chin whiskers. His voice was frequently that of Pat Rooney, who expressed class consciousness—and racism—in his 1880s song, "Is that Mr. Riley?"

> . . . now if they'd let me be, I'd set Ireland free;
> On the railway you'd never pay fare.
> I'd have the United States under my thumb,
> And sleep in the president's chair.
> I'd have nothing but Irishmen on the police.
> Patrick's day would be Fourth of July.
> I'd get me a thousand infernal machines
> To teach the Chinese how to die.
> Help the working man's cause, manufacture the laws;
> New York would be swimming in wine.
> A hundred a day would be very small pay,
> If the White House and Capital were mine. . . .[26]

But Irish characters changed. In 1902 an observer noted how they moved, as they did outside the theatre.

> There was a sudden transition from the Castle Garden greenhorn to the East Side "Mick." This is the Irishman who is either a contractor, a politician or a policeman, and a wonderful amount of cleverness has been expended in personating him by hundreds of performers, scores of whom have become famous in that line. . . .[27]

The dislocation of Irish immigrants' economic mobility and social climbing was captured by Mike Haggerty, who

appeared in a formal frock coat and a laborer's hob nailed boots. Their triumph rang out in songs like "Irish Jubilee," which chronicled a huge party given to celebrate Doherty's election to the Senate. The hallmarks include "invitations in twenty different languages," "a thousand kegs of lager beer" for the poor, dancing, and a menu of "pigs-head and gold-fish, mockingbirds and ostriches, ice cream and cold cream, vaseline and sandwiches."[28]

Equally important was the characters' ability to mean different things to different people. Consider the following exchange between Pat Rooney, son of the man who sang "Is that Mr. Riley?", and Marion Bent:

> ROONEY: What's your favorite stone?
> BENT: Turquoise.
> ROONEY: Mine's a brick.[29]

For an Irishman with calloused hands, it is a wry confirmation of working life; for others, the difference between a hard-working man and an acquisitive woman; for non-Irishmen, a humorous look at how the other half lives.

Such characters were often placed in an urban context that brought the verve of street life to the stage. Rooney and Bent, for example, performed an act called "At the News Stand." In 1912, Charles E. Lawlor and his daughters presented a series of Irish and Italian characters in a routine called "Night and Day on the Sidewalks of New York."[30]

These efforts at urban realism drew on the legacy of nineteenth-century "sunlight and shadow" books that introduced middle-class people and outsiders to city life and the underworld. "The System," a one-act vaudeville play of 1910, covered life, love, thievery, and police corruption on the Lower East Side. The characters include a crook,

Billy "The Eel" Bradley, his sometime girlfriend Goldie, four policemen with Irish last names, a police reporter and his cub reporter sidekick, a drunk named Mr. Inbad, and Mrs. Demming Worthington, "a noted horsewoman."[31]

The play opens with the police investigating the theft of $5,000 worth of jewelry from Mrs. Worthington's home. The prime suspects are two street-wise ex-sweethearts, "The Eel" and Goldie, whose romance soured when the Eel made a mistake and tried to kill Goldie for being a stool pigeon. But Goldie still loves the Eel, and blames all his troubles on Lieutenant Dugan of the police department.

The story that follows, full of intrigue and references to pervasive corruption, leads to the Lower East Side. The journey is punctuated by wisecracks like, he "thinks so much of me, that if he saw me drowning, he'd bring me a glass of water . . ."; and this exchange between Flynn the policeman and Maggie the charwoman.

> FLYNN: I see you've got the paper wrapped around something good.
> MAGGIE: I have that, and it's meself instead of the paper'll be wrapped around it in a minute . . .
> FLYNN: Is he [Maggie's husband] working?
> MAGGIE: He ain't done a tap since the Civil War.
> FLYNN: That's quite a vacation.
> MAGGIE: Vacation? It's a life sentence of laziness.
> FLYNN: There's many a good man layin' off.
> MAGGIE: No, the good men are dyin' off, it's the bums that are layin' off.

Meanwhile, Goldie and the Eel, their love re-established, are planning to go straight and move to Chicago. The Eel leaves Goldie's flat to get the necessary money from a fence.

Dugan then arrives at Goldie's. In the conversation that

follows, it turns out that Dugan himself is a criminal, and that Goldie has aided him hoping he will let up on the Eel.

Dugan threatens Goldie: if she won't become his lover, he will frame her and the Eel and send them to prison. This and a bribe of $20,000 fail to move her. And then the Eel returns from his fence.

Dugan takes the Eel's money and puts it in his own red wallet. The Eel is furious. "Yes, I am a crook and a thief," he says, "and I've robbed a lot of people, but I'm a little bit above you, Dugan, just a little bit above you. Because, I never took money from a woman, and that's part of your graft."

Dugan draws his pistol, the Eel grapples with him, and the Inspector bursts in with a squad of policemen.

Thanks to a listening device on Goldie's wall, the police have uncovered the corruption of Dugan, who is led away in disgrace. The Inspector encourages Goldie and the Eel to go straight and bids them good night.

Goldie considers how Dugan took their money. "Well, we're broke again," she says tearfully, "we can't go West now, so there's no use packing."

With that, the Eel takes Dugan's red wallet out of his pocket. He stole it back in the scuffle and confusion. "Go right ahead and pack!" he tells Goldie, and the curtain closes to her happy laughter.

"The System" offered different things for different viewers. For real-life Lower East Siders, it could be a biting and humorous slice of everyday life, a tribute to their tough virtues and hearts of gold, and a melodrama with a happy ending. They might also enjoy exchanges like the banter between Maggie and Flynn as a prank that violated the norms of middle-class propriety.[32] For middle-class people, it could be a melodrama, an amusing look at the under-

world, and, between the laughs, a display of rough-edged wisdom born in frustration and disappointment.

For vaudeville, which aimed for an audience that was almost always broader than one nationality or class, such an open-ended approach was critical. A mass market theatre could not depend on just one ethnic group. Maggie Cline made much of her Irishness, but she had a broader urban style as well. Once, when she finished the song "Don't Let Me Die Till I See Ireland," a man in the gallery shouted, "Well, why don't you go there?" "Nit!" Cline called back. "It's too far from the Bowery." She swaggered off a stage awash in cheers.[33]

Such appeals also served the Jewish artists who followed the path-breaking Irish onto the vaudeville stage. When Jews appeared in vaudeville, they rarely performed their European folk songs and dances. The audience that vaudeville entrepreneurs were cultivating was too broad to accommodate many acts with a narrowly Jewish appeal. Few could become American entertainers by narrowly following the Old World precedents of wedding jesters and itinerant musicians.[34]

The Jewish performers who surfaced in the late nineteenth century usually appeared as Dutch (meaning German) characters because many thought that their Yiddish accents sounded German. Dutch and Jewish stereotypes were otherwise different, but their similarities to the ear gave Jews an entry point. As Jews became a more visible urban presence in the years after 1900, a full-fledged Jewish character appeared, often a peddler or a confused immigrant.[35]

Julian Rose was one of the earliest and most successful performers in this cultural drama. A Jewish accountant from Philadelphia, Rose appeared widely during the early 1900s and on through the twenties. His most famous mono-

logue was "Levinsky at the Wedding," first formulated in 1899, which explored the confusions and conflicts of immigrants.

> First we had menu, but I didn't get any of that. I guess they ran out of it early. . . .

> The janitor of the apartment, Mickey McCann, calls himself the Superintendent, and he was there too. He gets forty-five dollars a month wages and the neighbors' milk. He got noisy and hit Cone with a bottle. It was a good thing Cone got in the way, or the bottle would have broken a window. . . . A cop walking by called Mickey over to the window and asked what's going on in there. Mickey told him he was cleaning up a Jewish wedding, and the cop shook hands with Mickey and lent him his club. . . .[36]

As with the Irish who preceded them, the Jewish position on the vaudeville stage evolved to reflect Jews' adaptation to the American environment. In the decades after 1900, the second and third generations of Jewish artists aimed at an ever-larger audience, and cast off European traits in their encounter with American culture.[37] Al Jolson, Sophie Tucker, Eddie Cantor, Belle Baker, and others explored the tensions, transitions, and possibilities that flowed from the meeting of a European heritage and the new ways of America. Some of their acts were distinctly Jewish, but they were also as likely to be influenced by popular music and jazz. Many of them started out in blackface.

When Sophie Tucker sang "My Yiddisha Mama," she used the song's multiple meanings to reach Jews and non-Jews. As she explained in her autobiography:

> "My Yiddisha Mama" was written for me by Jack Yellen and Lou Pollack. I introduced it at the Palace Theatre in

New York in 1925 and after that in the key cities of the U.S.A. where there were many Jews. Even though I loved the song, and it was a sensational hit every time I sang it, I was always careful to use it only when I knew the majority of the house would understand the Yiddish. However, I have found whenever I have sung "My Yiddisha Mama," in the U.S.A., or in Europe, Gentiles have loved the song and have called for it. They didn't need to understand the Yiddish words. They knew, by instinct, what I was saying, and their hearts responded just as the hearts of Jews and Gentiles of every nationality responded when John McCormack sang "Mother Machree." You didn't have to have an old mother in Ireland to feel "Mother Machree," and you didn't have to be a Jew to be moved by "My Yiddisha Mama." Mother in any language means the same thing.[88]

"My Yiddisha Mama"—which Tucker sang in both Yiddish and English—was the classic statement of a performer with one foot in the immigrant Jewish community and another in twentieth-century American popular music. Introduced in 1925, the English language version used the conventions of Victorian sentiment and Tin Pan Alley. The song, as Mark Slobin has pointed out, was simultaneously a statement on Jewish Americanization and a sentimental "mother" song for the mainstream American audience.[89]

The song's melody was not genuinely foreign, but its minor mode and tango-style rhythm gave it an exotic flavor. Tucker sang the English version without accent. In the language of the Victorian parlor songs, she assumed the stance of a comfortable, assimilated Jew longing for a special person on the East Side, the sweet angel she called her "Yiddisha mama."[40]

The Yiddish version spoke more directly about assimilation and guilt at leaving aged parents. It also romanticized

ghetto life in a way that reveals the singer's distance from poverty: although her family was poor, their kitchen smelled of roast dumplings, and there was always enough food for the children. It emphasized grief at the mother's impending death, the bitter sorrow and grief of losing her.[41]

"My Yiddisha Mama" addressed Jewish concerns, but the motherhood motif had appeal for non-Jews as well. And the theme of a Jewish child's love for its mother portrayed Jews in a more positive light than the stereotypes of befuddled immigrant or sharp businessman.

If such portrayals of white ethnic groups offered considerable cultural latitude, the blackface image of Afro-Americans was far more restrictive and negative. First developed in antebellum minstrelsy, blackface carried over into vaudeville as minstrel shows declined in the 1890s.

Much of an entire generation of vaudevillians, who started out from the 1890s well into the twentieth century, broke into show business behind burnt cork.[42] For performers from immigrant backgrounds, blackface was a theatrical convention that offered a way of becoming American—at least in appearance.

Audiences knew that white performers in blackface were not really blacks. But they associated blackface performers with a uniquely freer, more expressive style. "They were loose in their emotions," recalled audience member Norman Steinberg; "it was a free thing, they had voices, they could deliver the song." As blackface singer and dancer Jimmy Vee put it, they would "bang the song out."[43]

In blackface, white performers found a liberating mask. Black performers found a straitjacket. No one knew this better than Bert Williams, the black dancer, singer, and comedian, and star of vaudeville and musical comedy. Williams, a West Indian, was compelled to wear blackface

so the reality of his face would fit the stage stereotype. He was one of the great comedians of his day, but he was well aware of the way that stage conventions limited his portrayal of black Americans. "If I were free to *do as I like,*" he noted, "I would give both sides of the shiftless darky— the pathos as well as the fun. . . . But the public knows me for certain things. If I attempt anything outside of those things I am not Bert Williams."[44]

The best that can be said for blackface characters is that occasionally they displayed pathos, or a folksy, sly humor. At their worst, they show an awful process of black characters—often whites wearing makeup—being made to conform to racist white expectations. If blackface acts were supposed to be livelier, it was partly because white racism conceived of blacks as a primitive, and therefore more emotional and expressive, people. In blackface, popular culture expressed the hierarchy that prevailed outside the theatre; whatever the alleged deficiencies of white immigrants, all were held superior to blacks, who were enshrined as the butt of everyone's voyeurism, jokes, hostility, and disrespect.

"McMahon's Water-melon Girls," a holdover hit at Hyde and Behman's in Brooklyn in 1903, mixed blackface and Indian characters in a Dixieland setting. The theatre's manager enthusiastically captured its details in a report to the Keith booking offices.

This is a new act, it opens with . . . two girls in Indian costume, singing chorus, and McMahon and Nevins, dressed in handsome black suits, following with song and dance assisted by the girls, then [*sic*] stage opens in full, girls in watermelon suits, standing on each side of the stage, a large drop curtain in rear representing a steamboat all lighted, coming up to dock. On the dock is an immense water-melon filled with electric lights, which

opens and shows McMahon and Nevins, in black face, re-
clining inside. They come out sing and dance, assisted by
the chorus. It is one of the prettiest and best acts, in that
line, ever seen on our stage. It is a great hit, they are en-
cored four and five times, after each song and dance.[45]

A vicious example of blackface humor is (white) Nat
Wills' 1915 recording, "Two Negro Stories." The short
bit is set in a hotel in Canada that employs black waiters.
A rich Georgia planter walks into the dining room shortly
before mealtime and asks, "I want to find out who's the
head nigger here."[46]

A black waiter replies, "Nigger. You're mistaken, sir,
ain't no niggers here. You're up in Canada now, under the
English flag. You ain't down South. So you see all them
men standing around by those tables? Well, them is all
colored gentlemen. No niggers."

The planter replies that he is a guest and that he has a
twenty-dollar bill for the "head nigger" to ensure good
service.

"I'm the head nigger, boss, yassuh," the waiter replies.
"And if you don't believe me ask any of those niggers
standing over there and they'll tell you I am."

Blackface conventions were applied to Afro-American
performers of the highest caliber. Ragtime pianist Eubie
Blake also understood their insidiousness, and how they
almost marred his entry into vaudeville.

We were supposed to shuffle on stage in blackface and
patched-up overalls. In the middle of the stage there is
this big box with a piano on it. The idea was to look as
if it were from the *moon* and I'd say, "What's dat?" and
Noble would say, "Dat's a py-anner!" And then we'd do
our act. Well, Pat Casey would have none of that. He
told the agents that Sissle and Blake had played in the
houses of millionaires and the social elite and they dressed

in tuxedos and he'd be *damned* if he'd let us go on the stage and act like a couple of ignoramuses.

As "The Dixie Duo," Sissle and Blake went on to be big-time stars. They were one of the first black acts to appear without blackface makeup. When they played the Palace, they wore Palm Beach suits at matinees and dinner jackets in the evening.[47]

Sensitivity—or insensitivity—to the city's many racial and ethnic groups were only two of the factors that performers took into account. Vaudevillians toured through a wide array of New York neighborhoods, not to mention very different cities across the country. To build a rapport with each of the crowds they encountered, they learned to acknowledge audience mood and local custom.

Such appeals were complex, because most vaudevillians worked from standard scripts. They usually purchased acts from professional vaudeville writers. Less successful and therefore less affluent acts could cull routines from the many joke and sketch books produced for vaudevillians.[48]

Sometimes talking to the audience involved references to local geography, which performers could always modify according to the location they were playing. "I went from bad to worse, from Jersey City to Hoboken," said a character in a 1912 sketch. The script explicitly noted that two different localities could be inserted outside the New York area. As New York vaudevillian Frank Rowan observed, "If you're playing Bushwick, you make fun of Flatbush, if you're playing Flatbush, you make fun of Bushwick. That's an old, old game."[49]

Local appeal sometimes involved appreciation of language. Jewish comedian Billy Glason explained that if he played Loew's Avenue B theatre on the Lower East Side, he would give his act a "hamish," or homey, Jewish qual-

ity, with jokes and songs to make the audience feel like "family." If he played the Palace, he would not emphasize Jewish themes, but would use more complicated, sophisticated material.[50]

Acts always needed to balance intimacy and a national appeal. As an author advising vaudeville script writers put it:

> common sense dictates that no theme of merely local interest shall be used, when the purpose of the monologue is to entertain the whole country. Of course if a monologue is designed to entertain merely a certain class or the residents of a certain city or section only, the very theme—for instance, some purely local happening or trade interest— that you would avoid using in a monologue planned for national use, would be the happiest theme that could be chosen. But, as the ambitious monologue writer does not wish to confine himself to a local or a sectional subject and market, let us consider here only themes that have universal appeal.[51]

Jokes and scripts written according to such precepts, enhanced by direct appeals to the audience, helped make vaudeville a powerful vehicle for cultural integration and standardization. Part of vaudeville's appeal was built on the acts' broad-based familiarity. For many acts, the old lines evoked laughter and recognition. Smith and Dale first performed "Dr. Kronkhite" around 1906 and continued to present it successfully for decades, even after vaudeville itself was finished. "Now for the Irish" meant J. W. Kelly, "The Rolling Mill Man." "I luff you Meyer" meant Weber and Fields. "Is everything copacetic?" evoked black dancer Bill "Bojangles" Robinson. "Wanna buy a duck?" meant Joe Penner.[52]

Such lines were complemented by vaudeville's treatment of popular songs. Tony Pastor had followed newspapers

to find timely themes. Decades later, Irving Berlin used the same technique to write popular songs that were carried nationwide over the vaudeville circuits. Tin Pan Alley and vaudeville lived off each other: vaudevillians took songs from Tin Pan Alley, and Tin Pan Alley used vaudeville to boost song sheet sales.[53] Together, they made songs into nationwide hits and singers into nationwide stars.

The stars, and the big-time theatres they played in, became the most compelling face of vaudeville. In interviews, elderly fans who remembered New York vaudeville from 1915 on said the big time was best. Their memories focused on the big acts they saw, like big-game hunters recounting their trophies. The human experience of the shows and their vitality were important also, but they expressed this through their appreciation for well-known routines.[54] The combination of intimate appeals and nationwide performers worked.

Vaudeville was everywhere in New York City. But the effect of this was to point everyone's gaze towards the big time, towards the Palace and similar theatres. Audiences may have been sitting in Bushwick, but their eyes were on Times Square. The big time was the standard by which all vaudeville was judged. Jack Gross remembers that the acts at Fox's Folly in Brooklyn were not first rate, but that the Palace acts were tops. Howard Basler and Harold Applebaum both saw Keith's vaudeville as superior to Loew's, and the distinction between the two was widely seen as the distinction between the big and the small time. Applebaum claimed that a visit to the big-time Royal was a place to mention in conversation, with more "name" acts that made lasting impressions; the nearby small-time Loew's National was just an afterthought. Arthur Kline and Murray Schwartz both described the Palace acts as tops. Kline described the difference between Keith and

Loew vaudeville as being "like going from Tiffany's to Ohrbach's."[55]

Ultimately, magazine writer Charlotte C. Rowett concluded in 1910, it was "degree of showmanship" that distinguished big-time and small-time vaudevillians. The hierarchy of appreciation was implicit at small-time amateur nights, where audiences evaluated artists against big-time standards. They acclaimed them if they measured up, but when they found them wanting, they could be pitiless.[56]

Newspaper advertisements reinforced the big time's dominance. When theatre managers cultivated audiences, they did not dwell on the homey qualities of their theatres, the friendliness of local audiences, or the satisfaction of seeing your neighbors onstage. They stressed their ability to present big-time stars, people with national reputations. In effect, they offered an opportunity for people to step beyond their neighborhood and enter a form of theatre that was city- and nationwide in scope. Acts often used a New York booking as evidence of their superiority, evidence that they traded on as they toured distant states. As vaudeville fan Murray Schwartz said of the stars, "They were out of this world, they were out of our world."[57]

There was a sticking point in all this: theatres routinely promised stars and top-grade acts, but there weren't nearly enough to go around for all the vaudeville theatres in New York City, not to mention America. The solution lay partly in small-timers' imitating name performers, and partly in theatre managers' trading on the U.B.O. reputation for high-class vaudeville. The Keith-Albee seal of approval became a passport to success, and the booking office became a metropolitan arbiter of taste.

When the Sewell brothers of Staten Island announced plans for a vaudeville house in Port Richmond on the

north shore of Staten Island in 1911, a theatre that was very unlikely to become a top house like the Palace, they still proclaimed their connection to big-time vaudeville. "All of the vaudeville artists who are to appear will be booked through the United Booking Offices," they asserted, "which, as every theatre-goer knows, furnishes the highest class talent to all the exclusive vaudeville theatres in the United States and Canada."[58]

The Terminal Music Hall at the North Beach amusement area in Queens used a similar strategy. In its announcements in 1914 and 1915, the management promised "high-class vaudeville," "headliners," "performers who have featured the big houses."[59]

At Keith's Royal in the Bronx, audience members were angered in 1915 when the management switched from big-time to small-time acts. They seem to have resented the loss of the stars. Keith management asserted that the theatre was offering big-time shows at a small-time price, which meant a savings to patrons. No one seemed to believe it. "The public and press of the Bronx are making a concerted effort to have the big time policy restored at Keith's Royal theatre in that section," *Variety* reported. "Manager Egan has been flooded with letters and the press is printing a number of communications from readers."[60] Bronx residents, however, continued to patronize the theatre.

Vaudeville took people out of their neighborhoods and moved them into a world of stars and fans. It created a kind of popular culture community, foreshadowing the day when people would relate to television and movie stars as if they were intimate friends. As ludicrous as it might be for people to treat television characters as real people, in vaudeville they at least had the satisfaction of a real, live person performing before them.

Being vaudeville fans did not make otherwise different

people the same. It did, however, give them vaudeville in common despite all their other differences. And vaudeville did that with a generous, human touch.

For audiences, vaudeville inspired loyalties and filled human needs. In 1915, *Billboard* noted vaudevillians' appearances before prisoners at Sing-Sing and Blackwell's Island. In 1918, doughboys in France amused themselves by imitating Sophie Tucker's hot singing. Van and Schenk were a singing duo from Brooklyn that went from working on trolley cars to the height of big-time vaudeville. As late as 1951, the Van and Schenk Club of Brooklyn was still meeting in their memory.[61]

Sophie Tucker recalled that in New York City and Chicago, the same people attended Monday matinees fifty-two weeks a year. They grew familiar with the performers, and applauded their favorites. Vaudeville became a secular faith for its fans, acted out in what showmen called "temples of amusement." "It was a religion for people to go to vaudeville shows . . ." said performer Glason in 1984. "Every week they'd be in the same seat."[62]

Such qualities were recognized even by people like Michael Davis, a university-trained critic of "commercial recreation" who saw virtually nothing of educational or moral value in vaudeville. He observed the response that illustrated song singers evoked at movies and vaudeville shows, and wrote:

> no warm-blooded person can watch the rapt attention of an audience during the song, and hear the voices swell as children and adults join spontaneously in the chorus, without feeling how deeply human is the appeal of the music, and how clearly it meets a sound popular need.[63]

In a letter written many decades after she attended vaudeville shows, Florence Sinow captured the attractions.

I loved it—I miss it—neither film nor TV has the warmth, the excitement, or the life of vaudeville—it moved you with an emotion quite missing in other entertainment—it reached and touched *you*, individually. And also caught you up in a communal happening—a sharing together of a common wonderful experience. Nothing has taken its place. It moved fast, had a wide range that kept you always absorbed—no one act was on long enough so that you lost interest—the evening shifted from excitement to excitement, but on different levels—high comedy, sophistication, slapstick, dancing, singing—sentimental—jazz—acrobats—animals—a panorama that was gorgeous, funny, tearful, each in turn—a kind of entertainment audiences could lose themselves in, individually and collectively. . . .[64]

Although vaudeville was "a kind of entertainment audiences could lose themselves in," in the contradictory world of the vaudeville house, audiences also found things. Among the most complex was vaudeville's ambiguous, hesitant, but very real challenge to American Victorianism and the codes of gentility the earliest showmen had catered to when they fashioned variety theatre into vaudeville.

7

RESPECTABLE

THRILLS

There must be something for everyone and, though
the fastidious may be a little shocked (the fastidi-
ous rather like to be shocked sometimes), they
must not be offended, while the seeker for thrills
must on no account be bored by too much mildness.

CAROLINE CAFFIN, 1914

When middle-class Americans sang about lost love in the
1840s, they often gathered around their parlor pianos to
warble songs like, "Thou Hast Learned to Love Another,
or Farewell, Farewell, Forever."

> Thou hast learned to love another,
> Thou hast broken every vow;
> We have parted from each other,
> And my heart is lonely now;
> I have taught my looks to shun thee,
> When coldly we have met.
> For another's smile hath won thee,
> And thy voice I must forget.
> Oh, is it well to sever
> This heart from thine forever,

Can I forget thee? Never!
Farewell, farewell, forever.[1]

By 1910, their great-grandchildren gathered in vaude-
ville houses to hear Sophie Tucker and her band belt out
a hot version of "Some of These Days," a very different
song about lost love.

> Some of these days,
> Oh you'll miss me, honey.
> Some of these days,
> You're gonna be so lonely.
> You're gonna miss my hugging,
> You're gonna miss my kissing.
> You're gonna miss me when I'm far away . . .[2]

The difference between the two songs is the difference
between the nineteenth-century world of American Vic-
torianism and the culture of the twentieth century. Ameri-
can Victorianism, a culture of industriousness, self-control,
and moral integrity, was strongest among the northeastern
Protestant middle class.[3] Even at the height of its strength,
Victorianism was never a completely solid edifice. (Other-
wise, how would all the concert saloons have done their
business?) But it had been strong enough to shape the shift
from concert saloon to vaudeville theatre.

Oddly, you wouldn't know this from reading histories of
vaudeville. Historians have been often misled by entrepre-
neurs' claims of cleanups and moral improvement. The re-
sult is that they dwell on vaudeville's purity and whole-
someness, its lack of the risqué.[4]

Such assessments, while off the mark, are understandable.
Many of vaudeville's contemporaries were impressed by its
pretensions to purity. Edwin Royle wrote in 1899, "The
vaudeville theatres may be said to have established the
commercial value of decency." Other contemporary ob-

servers asserted that vaudeville was "all innocent," "clean and respectable," purified, and family-oriented.[5] They had a word for vaudeville: puritanical.

But they were only half right. Such claims were part of an old practice in nineteenth-century show business—that of establishing a show's claims to refinement before going beyond the boundaries of acceptability. In vaudeville, Victorianism was only one element of a complex and volatile cultural equation that simultaneously recognized Victorianism's lingering power and asserted alternatives to it. Witness Brooklyn's New Brighton Theatre in 1919. A program included the joke, "A few words mumbled by a minister constitute a marriage. A few words mumbled by a sleeping husband constitute a divorce." Several weeks later, the same theatre serenaded the intermission with "The Hand That Rocked the Cradle Rules My Heart."[6]

The changes that separate us from the Victorians date to the turn of the century, and they were acted out on the vaudeville stage. The vaudeville show was a kind of theatrical laboratory for experimenting with the new culture that clashed with Victorianism. Vaudeville's often exuberant, irreverent, sensual style of music, drama, and comedy challenged the Victorian code of sentiment and gentility— sometimes directly, sometimes indirectly. As Lewis Erenberg has observed, vaudeville substituted for an older culture of asceticism, hard work, and an endless quest for morality, a new urban vision of success and happiness based on luxury and consumption.[7]

Just as vaudeville lifted countless immigrant and working-class New Yorkers out of the Lower East Side and into a new world of popular culture, so it lifted middle-class men and women out of the restrained world of home and family. Once, urban thrill-seeking was largely a male pastime. But with vaudeville shows open to middle-class women, re-

spectable ladies could also experiment with theatrical titil-
lation.

In the vaudeville theatre, as Peter Bailey has written of
the British institutions of commercial leisure, people passed
from the humdrum routine and subordination of working
life to a man-made fantasy world of amusement and lei-
sure "where life became theatre and new roles and iden-
tities were experimented with."[8] Vaudeville theatre, like
the British comic strip *Ally Sloper's Half Holiday*, which
Bailey has analyzed, was a new arena for adventure and
fulfillment, a special place where people could fashion new
ways of life and live out their fantasies.[9]

The Victorian culture of sentiment vaudeville chal-
lenged was pervasive in early and middle nineteenth-
century America. It was manifested in fashion, etiquette,
mourning rituals, theatre, and music.

Workers adopted some elements of sentimental culture,
but in immigrant cities like New York, the main elements
of working-class culture were derived from a combination
of class and ethnicity. But sentiment combined with a gen-
teel code of behavior to form an important component of
a native-born, middle-class identity.[10]

The cult of sentiment was partly an attempt to evade
painful realities by retreating into a private world of feel-
ings, and partly an attempt to provide socially acceptable
channels for human passions without denying them alto-
gether. Walt Whitman criticized all of this in *Democratic
Vistas*, where he lamented American literature's weakness
and its failure to deal with "real mental and physical facts."
He scorned the cult of sentiment's

> parcel of dandies and ennuyees, dapper little gentlemen
> from abroad, who flood us with their thin sentiment of
> parlors, parasols, piano songs, tinkling rhymes, the five-
> hundredth importation—or whimpering and crying about

something, chasing one aborted conceit after another, and forever occupied in dyspeptic amours with dyspeptic women.[11]

Sentiment was also part of a Victorian ethic of self-control, an attempt to provide an internal compass for middle-class conduct in a fragmented and threatening moral order. In this city of strangers with no fixed central standard of behavior and morality, middle-class Americans used sentimental rituals—from parlor behavior to funeral rites—to establish the identity of the good and sincere. Even in the late nineteenth century, as formalized ritual, these practices remained in place as devices for defining middle-class identity.[12]

A University Settlement report of 1899, written by F. H. McLean, disapprovingly noted the passing of the florid but "essentially sound" ethical teachings of the melodrama. "The tendency is everywhere toward the light, the very light," he concluded. And nowhere was this more pronounced, he asserted, than in variety theatre.

> There is not so much to be said in favor of the cheap variety show, either on the Bowery or elsewhere in the city. It is all of the same cheap and sometimes nasty character. The wit is of a dull and sodden sort, and when it treads on forbidden ground it is brutishly vile in innuendo. There is a healthy mixture of acrobats, gymnasts, jugglers, etc., which give tone to an otherwise stupid and often vulgar performance. Of course, it must be understood that there is no lack of passably nice-looking girls, of bright-colored garments, of pretty dances, of good stage effects, and so on.[13]

For McLean, the sin of variety theatre was that it failed to lift the morals of its audience, and instead pulled them

still further down into the mire. It is realism in art, with the idealistic element entirely expelled, and in its place an exaggeration of the bad, and the flippant, and the silly. Take for instance the comic sketches which have a little plot running through them. The manners and tempers of the characters in the play are of the sort which throw to the winds all thoughts of gentle or truly manly or womanly feeling. Coarseness and vulgarity are added to the horse play, which might be amusing in itself if not so complicated.[14]

Yet McLean concluded that in variety there were also "bright spots in the darkness," like a eulogy for Madame Dreyfus sung in a Bowery theatre, which showed an encouraging "soundness of heart."[15]

McLean hit on a core of vaudeville's appeal: a recognition of sentiment and old standards, even as it experimented with new ways. Nowhere was this clearer than in the 1890s, when there emerged a new kind of music that challenged the genteel songs of sentiment. In its origins, sound, lyrics, and dances, it was rough where the earlier songs were respectable, vigorous where they were syrupy, and direct where they were ethereal. It was ragtime.

Ragtime was born and raised in saloons and brothels in the "sporting" district of St. Louis and the black communities of the South and Midwest—all places well outside the middle-class pale of respectability. Strictly defined, ragtime was a syncopated, polyrhythmic music rooted in Afro-American musical traditions. But the name was also applied to varieties of popular music and Tin Pan Alley pieces that diverged from the classic ragtime style. In all of its variety, ragtime was at the center of American popular music from the 1890s until about 1920.[16]

Ragtime was unmistakably un-Victorian; it offered a

world of pleasures to be enjoyed here and now. The tinkling, syncopated ragtime piano, with its insistent rhythm, had "a powerfully stimulating effect, setting the nerves and muscles tingling with excitement," as a contemporary noted in 1898. Many Americans were appalled by ragtime's associations with the underworld and black America. In 1899 one critic called ragtime "cheap, trashy stuff," part of an "invasion of vulgarity," a "national calamity" for America's "mental attainments." Its accompanying dances, like the two-step, were seen as blatantly sexual and immoral.[17]

If vaudeville were as puritanical as some have claimed, it would have shunned ragtime. Instead, vaudeville featured ragtime musicians and helped popularize the new music. While some of the ragtime presented on the vaudeville stage was diluted and refined in comparison to the original red-light music, ragtime musicians on the vaudeville stage also played the "powerfully stimulating" tunes. Ragtime artists starred at Keith and Proctor vaudeville houses, including the great Scott Joplin, who always saw ragtime as a dignified form of music. Presenting the sheet music produced by Tin Pan Alley, vaudeville spread ragtime across America.[18]

Writing in *The New Republic* in 1915, Hiram K. Moderwell was onto something when he called ragtime "the folk-music of the American city." Despite controversy, by the second decade of the century, ragtime was being played in a variety of settings: red-light joints, vaudeville theatres, select clubs, and the ballrooms of the rich. If elite and ordinary New Yorkers could both enjoy ragtime, then some of the nineteenth-century's cultural divisions between rough and respectable were being redrawn.[19] And the redefinition was being accomplished through more than music.

Ragtime's challenge to Victorian restraint was complemented by new forms of dance. In the 1890s, vaudeville

shows mixed elements of the rough and the genteel in skirt dancing, which combined ballet and folk-style clog dancing. Skirt dancers dressed in costumes that reflected refinement, such as long tutus or flouncy skirts, but their movements were brisk and high-spirited. Turn-of-the-century films of skirt dancers capture the style. The "Betsy Ross Dance," filmed in 1903, shows a young girl in a frilly skirt cut above the knee. As she dances, she kicks her leg, swings her skirt, climbs up on pointe, lifts her skirt and twirls around. The camera catches an occasional glimpse of a garter just above her knee.[20]

In 1903, William Dean Howells wrote about the ambiguous refinement of a similar dance he saw in vaudeville:

> . . . "Twin Sisters;" who, as "refined Singers and Dancers," appeared in sweeping confections of white silk, with deeply drooping, widely spreading hats, and long-fringed white parasols heaped with artificial roses, and sang a little tropical romance, whose burden was *Under the bamboo tree*, brought in at unexpected intervals. They also danced this romance, with languid undulations, and before you could tell how or why, they had disappeared and reappeared in short green skirts, and then shorter white skirts, with steps and stops appropriate to their costumes, but always I am bound to say, of the refinement promised. I can't tell you in what their refinement consisted, but I am sure it was there. . . .[21]

The "Twin Sisters" captured the relationship between the rough and the refined: they used the conventions of silk dresses, parasols, and huge hats to set the stage, and then moved out toward the boundaries of the acceptable. They recognized the genteel tradition's lingering power even as they transformed it.

Slapstick and eccentric or "nut" comics offered resounding diversions from cultivated standards of behavior. Even

though the partial taming of variety reduced the amount of roughhouse comedy that made its way onto the vaudeville stage,[22] slapstick retained plenty of popularity.

From head-bashing to choking and kicking, it all looked excruciating. In 1912, the long-popular stars Weber and Fields enumerated their most effective routines. The list began with a poke in the eye. "We have often tried to figure out a way to do something to the other's kneecap— second only in delicacy to the eye—" they concluded, "but the danger involved is too great."[23]

Weber and Fields asserted that the essence of slapstick comedy was that all involved appeared to risk pain, but escaped unhurt. Yet there is another explanation. The Victorian codes of gentility were intended to order behavior, but slapstick created a world of disorder. Like the "Twin Sisters," the slapstick comedians began with a recognition of accepted standards of behavior, and then pushed beyond them. Their anarchic violence and extravagant behavior ridiculed middle-class ideals of conduct. They appeared almost subversive in their autonomy from genteel norms.[24] Their comedy inverted standards of behavior.

Although less physically violent than Weber and Fields, comedians Smith and Dale perpetuated slapstick's anarchic spirit in "Dr. Kronkhite," which they first performed about 1906. Smith and Dale (their real names were Charlie Marks and Joe Sultzer) were products of the East Side. The sketch opens with a patient entering a doctor's office and becoming nervous at cries of pain coming from the adjoining room. Finally the doctor arrives.

PATIENT: Are you a doctor?
DOCTOR: I'm a doctor.
PATIENT: I'm dubious.
DOCTOR: How do you do, Mr. Dubious

[After a discussion of various symptoms and their significance, the doctor becomes confused.]

DOCTOR: But the way you spoke, I couldn't tell. You see, you make the "v" with the "we," instead of a "woo."

PATIENT: I should eat veal or wool.

DOCTOR: No, no, no. . . .

[A discussion of the patient's family history follows, which leads to questions about the patient's insurance.]

DOCTOR: Do you have any insurance?

PATIENT: I ain't got one nickel insurance.

DOCTOR: If you die, what will your wife bury you with?

PATIENT: With pleasure . . .

[Various attempts at a diagnosis follow, and finally, the visit concludes.]

DOCTOR: You owe me $10 for my advice.

PATIENT: Ten dollars for your advice? Well, Doctor, here's $2. Take it, that's *my* advice.

DOCTOR: Why, you cheap skate! You schnorrer [Yiddish for beggar], you low life, you raccoon, you baboon!

PATIENT: One more word from you, you'll only get $1.

DOCTOR: You . . .

PATIENT: That's the word! Here's a dollar. [Curtain]²⁵

Such humor skirted Victorian codes of behavior without risking confrontations over the issue of sex. By such stratagems, and more direct approaches (the Dr. Kronkhite sketch did allow for some leering at the doctor's nurse) the assault on Victorianism proceeded. Consider these observations on vaudeville from journalist Hartley Davis, published in 1905 and 1907.

When one has sat through an act that calls for expletives and resignation on one's own part, it is rather disconcerting to hear one's neighbor praise it as being "real refined and genteel," especially when one is sure that the nice

spectacled old lady is far less tolerant of moral shortcomings than one's self.

There may be a question as to taste; indeed, refined souls are often painfully shocked at vaudeville performances, but the shows are always clean, according to the standards of the vaudeville manager. They may not be your standards nor mine, but evidently they are accepted by the millions that support this form of show.[26]

Such ambiguities might be dismissed as rough remnants of variety theatre that were eventually smoothed off by moralizing entrepreneurs. But the continuing and complicated challenge to Victorianism persisted until the end of vaudeville.

In 1910, an anonymous writer in *American Magazine* set down this complaint.

The greatest peril of vaudeville lies in its previous good reputation. The "cheap and wholesome" slogan has been so well advertised by the vaudeville dealers and so innocently swallowed by those who ought to know better that fathers and husbands have come to take it for granted that any vaudeville show in a "first-class" theatre is a perfectly safe entertainment for the women and children of their families. Nothing could be further from the truth. Indeed, a somewhat objectionably wide experience with vaudeville bills has convinced the writer that a vaudeville show, especially in the "first-class" houses, that does not contain at least one number that is calculated to make a decent woman deeply ashamed of her presence in that theatre, is about as rare as snow in Panama.

The writer also lamented the passing of the rigorous morals of B. F. Keith, and concluded that protest, condemnation, and even censorship were needed to restore vaudeville's wholesomeness.[27]

The call for Keith's morals was somewhat ironic, because

at about the same time Keith's organization was doing all it could to keep vaudeville clean. And the job was getting harder and harder all the time.

There had always been a contradiction between managers' and middle-class patrons' professions of decency and the realities of the vaudeville stage, but by the years around 1910 it was becoming impossible to ignore. The increasingly divergent mores of middle-class patrons, a consequence of the decline and fragmentation of Victorian culture, made it very hard to appeal to a comparatively coherent sense of wholesomeness, as Keith had done in his early days.[28]

Nowhere was this more apparent than with Keith vaudeville's vaunted reputation for censorship, a device intended to guarantee the tone of their acts. Obscenities and the ridicule of physical defects were forbidden everywhere. But beyond these restrictions, control was largely left to the discretion of individual managers. The result was a kind of city- and nationwide geography of the risqué: certain jokes or songs would be allowed in one theatre and not another.[29] Theoretically, within one city, material could be banned in one Keith theatre but permitted in another. (True to expectation, Boston really did appear to have more cuts.)

The enforcement of nationwide censorship regulations was aided by the centralized Keith bureaucracy. In 1919, the Philadelphia Y.M.C.A. complained that it was slighted in an act at a local Keith's theatre. The Keith organization responded by sending every Keith theatre instructions forbidding criticism of the Y.M.C.A. In 1922, a newspaper noted Albee's policy forbidding references to Prohibition in all Keith theatres and houses booked through the Keith Vaudeville Exchange.[30]

For the individual performer, there was a bigger prob-

lem in the managers' policy of sending the cut portions of
the program to the Keith booking offices in New York.
They were filed there for future reference. Sophie Tucker
recalled the procedure; which began at a Monday matinee
when managers viewed the acts, noted the offending mate-
rial, and sent their instructions to performers in blue
envelopes.

> There was no arguing about the orders in the blue en-
> velopes. They were final. You obeyed them or quit. And
> if you quit, you got a black mark against your name in
> the head office and you just didn't work on the Keith
> Circuit anymore.[31]

But the Keith-Albee wall of moral purity had holes in
it. Censorship could be evaded. The subterfuge might take
the form of the variety staple of having pretty and shapely
women posing in full body tights pretending to imperson-
ate classical statues. An updated version of this ploy was
the big-time act of Annette Kellerman, a diver and swim-
mer who was best known for her figure and bathing ap-
parel. She surrounded herself with a musical stage show,
but as a reviewer who saw her at Keith's Riverside in Man-
hattan in 1918 noted, there was no mistaking the real
source of her appeal.

> It is all very well for her to present a diversified musical
> comedy tabloid, but the fact remains that the audience
> associates in its mind Miss Annette and union suits, and
> until the slim, graceful diver came to her feats in the
> tank the Riverside crowd was restless. Miss Kellerman's
> dance numbers were interesting and picturesque, and her
> patriotic number was well devised, but it was only when
> she appeared in an orange union suit and went into her
> old specialty that they displayed real interest and enthu-
> siasm. It is the finish which really puts the turn over, the
> rest of it, much of it clever stage manipulation, being

merely a time filler working up to the Kellerman specialty.[32]

The people at the Riverside knew what they wanted and what they were watching. That they gathered in a big-time Keith house for it was a testament to the crumbling of Victorianism, a crumbling that made standards and their enforcement erratic. In autumn of 1923, at the insistence of a priest working for Patrick Joseph Cardinal Hayes, the Keith organization cancelled "The Unknown Lady," a short play at the Palace that was critical of divorce laws. The play had already appeared at Keith theatres from California to New York without being censored. (It was replaced by a comedy sketch, "The Cherry Tree," about one George Washington Cohen who cannot tell a lie. Five years earlier, "The Cherry Tree" had been cancelled at the Palace because it showed Cohen talking with St. Peter at the gates of heaven.) And even though "The Unknown Lady" was cancelled at the Palace, there remained on the same bill a song and dance team who performed a song that asserted a highly sexual vision of marriage in which the secrets to happiness are "spooning, crooning," and the fact that Mama and Papa both love to squeeze each other.[33]

If big-time vaudeville was so wholesome, what about this act on the opening bill of the Palace Theatre in 1913? *The Billboard* noted that:

La Napierkowska is offered as a pantomimist and dancer. The truth of the matter is that La Napierkowska is a mighty good-looking and shapely dancer of the "cooch" variety, formerly so often seen in the Oriental Shows on the mid-way of a fair. But the young lady is some dancer of the kind. There isn't a portion of her body that she can not make wriggle at will, and there is very little of it that isn't constantly wriggling during the time which she spends on the stage in her offering The Captive. She is

supposed—so the story program runs—to have been stung by a bee and the gyrations that follow are consequent of the pain she feels. It must be some pain for such wriggling has never before been seen on a high-grade vaudeville stage.[34]

Offering a belly dancer in the guise of portraying a woman suffering from a bee sting is clearly being disingenuous. So, too, probably, were the people at the New Brighton Theatre in August 1916. There, "The World of Dancers" promised "prehistoric barbarians," "the flesh pots of Egypt," and a finale in which "dancers of the ages past become acquainted with syncopation."[35] The impression you get is that an entire city was walking around with tongue in cheek.

In his 1918 manual explaining how to run a vaudeville theatre, Edward Renton advised managers that

> in advertising a group of classical dancers, the fact that their wardrobe is scant should not be featured; rather, the aesthetic and beautiful points should be emphasized— and this may result in securing not only the patronage of those who might come with an idea of looking at nude limbs but as well of those who have a sincere appreciation for and knowledge of art and the beautiful. The latter *will not* be drawn by advertisements and stories of the attraction in which the feature of nudity is vulgarly or coarsely handled.[36]

"Clothes, Clothes, Clothes," a sketch about a lady choosing her wardrobe, presented in New York in the late teens and early twenties, took a similarly artful approach. Capitola DeWolfe, who performed it at Keith's Alhambra in Harlem, recalled that it opened with two young ladies awakening in a "beautiful boudoir." One of them didn't just roll out of bed, but kicked her leg straight out, then

slowly lowered it to the floor—a move guaranteed to attract maximum attention.

> And that's all we needed up in Harlem, to have the curtain go up with these two young ladies all in satins, and silks and laces, getting out of bed. There was a lot of whistling, but no incident of any kind; but simply they didn't understand the artistic side, you know.[37]

Ms. DeWolfe maintained that the Keith vaudeville houses featured only clean, wholesome, "puritanical" offerings. She stressed that her act was thoroughly respectable, and it certainly was. But the boundaries of respectability, especially for a young actress, were changing. And, by fits and starts, Keith vaudeville shows were participating in the transformation. Under their umbrella of propriety, performers could push beyond narrow definitions of propriety without having their standing jeopardized.[38]

Another way vaudeville undermined Victorianism was by presenting titillating characters who did not share the precepts of Victorian culture. The strategy was obvious in eroticized black stereotypes and coon songs—the fighting, emancipatory tradition of black spirituals never received as much attention on the vaudeville stage as the sensual strut of the cakewalk. This strategy also appeared when ethnic stereotypes were used to approach sexuality and conflict between men and women.

Back in Tony Pastor's days, writer John Joseph Jennings observed an Irish act in which a comedian described a horse that ran wild and upset a buggy, killing his wife and mother-in-law. "Now, whether you belave me or not, more than five hundred married men have been afther me thryin to b'y that horse." A few jokes later, the comedian described how he took his girlfriend to a slaughterhouse. "She wuz watchin' 'em butcher the poor craythers whin all

to wonst she turns to me an' sez, sez she, 'Whin'll yure turn come, dear John?' "[39]

Irving Berlin used an immigrant theme to explore sexual relations in two songs copyrighted in 1910, "Sweet Italian Love" and "Oh How That German Could Love."

> Sweet Italian love,
> Nice Italian love,
> You don't need the moon-a-light your love to tell her,
> In da house or on da roof or in da cellar,
> Dat's Italian love,
> Sweet Italian love;
> When you kiss-a your pet,
> And it's-a like-a spagette,
> Dat's Italian love . . .
> When you squeeze your gal
> And she no say "Please stop-a!"
> When you got twenty kids what call you "Papa!"
> Dat's Italian love,
> Sweet Italian love. . . .[40]

Or:

> Oh how that German could love,
> With a feeling that came from the heart,
> She called me her honey, her angel, her money,
> She pushed every word out so smart.
> She spoke like a speaker, and oh what a speech,
> Like no other speaker could speak;
> Ach my, what a German when she kissed her Herman,
> It stayed on my cheek for a week.[41]

"The Art of Flirtation" and "The German Senator," which were popular around 1915, used the dialect device to disguise characters who reveled in sexuality. In "The Art of Flirtation," a straight man uses a guide book to teach his comical friend how to flirt.

STRAIGHT: Ven you flirt, you meet a pretty woman in a shady spot.

COMEDIAN: Oh, you met a shady woman in a pretty spot.

STRAIGHT: Not a shady woman. A pretty woman in a shady spot. . . .

The lesson covers the proper use of a handkerchief to attract and communicate with members of the opposite sex. It concludes with advice on what to do when seated arm in arm on a couch, with the gas lamp turned down low.

STRAIGHT: Dat's the end of the book.

COMEDIAN: Is dat all?

STRAIGHT: Sure. What do you want for ten cents?

COMEDIAN: But vat do you do after you turn down the gas?

STRAIGHT: Do you expect the book to tell you everything?[42]

The popular "German Senator" combined this immigrant mask and a kind of laughing cynicism. After satire and wordplay on everything from the Statue of Liberty to Andrew Carnegie to socialists to crooked politicians, the monologue concludes with recognition of conflicts between men and women:

And that's why the women suffering gents have gotten together and are fighting for their rights.

And you can't blame them.

Now I see where one married woman has hit on a great idea.

She says there's only one protection for the wives.

And that's a wive's union.

Imagine a union for wives.

A couple gets married.

And as soon as they get settled, along comes the walking delegate and orders a strike.

Then imagine thousands and thousands of wives walking

up and down the street on strike, and scabs taking their places.[43]

The line between rough and respectable could blur to the point of disappearing. Much more so than before, one person could incorporate the two. Sophie Tucker did "blue" material and songs of motherhood, black jazz and Jewish popular music. The sentimental "My Yiddisha Mama" was one of her greatest hits, but her signature tune was the hot "Some of These Days." She dressed colorfully, in low-cut dresses with bare shoulders. A 1918 review noted that onstage she and her band were in constant motion, filling the stage "with noise and contortions from start to finish." Another reviewer noted in the early twenties that she "brings to an eager public with unerring technique all the reflected nuance of an apparently tottering monogamy. . . ."[44]

Tucker's songs included "Who Paid the Rent for Mrs. Rip Van Winkle," a song which wondered how Mrs. Van Winkle survived when her husband was asleep in the mountains; "I Just Couldn't Make Ma Feelins Behave"; "Vamp, Vamp, Vamp"; and "I'm Crazy About My Daddie (In a Uniform)," about a man whose military eyes mobilize her feelings, whose maneuvers put her in a trance. Between such songs and "My Yiddisha Mama," Tucker merged the maternal and the sensual,[45] just the way vaudeville combined old and new mores.

Sometimes performances discussed vice by criticizing vice. The plot of "Blackmail," a popular vaudeville play of 1910, included a faked marriage, blackmail, and a reference to pimps—all under the cover of condemning them. In 1923, the Palace featured a one-act play that included a monologue by an actor on how his sweetheart betrayed

him and went on to live a life of shame. "But it wasn't considered immoral," wrote Marian Spitzer, "apparently because the scarlet woman was only talked of. She didn't actually appear."[46]

Such irreverence had been growing in vaudeville for years. Nowhere was it more blatant than in the extraordinarily popular performer billed as "America's Biggest Drawing Card, Cyclonic Eva Tanguay," who defied older conceptions of character. Tanguay, Caroline Caffin wrote, took the stage with a "loud, chattering voice, high-pitched, strident, voluble." She was all vitality and vivacity, blond hair in a wild, stiff mop, a "saucy, broad, good-humored face, with large, smiling mouth and pertly turned-up nose. The eyes are small and impudent and snap and sparkle. . . ." Her colorful dress of ribbons bounced with her quick, fluttering steps.[47]

Tanguay dominated the stage with a "whirlwind of sound and the patter of restless, aimlessly pacing feet." She did not dance so much as she gleefully cavorted before the audience. "She dashes from one end of the stage to the other," a theatre manager wrote in 1907, "getting her audience from the first and clinching them to the finish." Her songs included "Hello, Everybody," "I Want Someone to Go Wild with Me," "There Goes Crazy Eva," and her most famous number, "I Don't Care."

> They say I'm crazy got no sense,
> But I don't care
> They may or may not mean offense,
> But I don't care
> You see I'm sort of independent
> Of a clever race descendant
> My star is on the ascendant
> That's why I don't care.

CHORUS:
I don't care, I don't care,
What they think of me,
I'm happy go lucky
Men say I am plucky,
So jolly and care free,
I don't care, I don't care,
If I do get the mean and stony stare,
If I'm never successful,
It won't be distressful,
'Cos I don't care.[48]

Victorian culture was built by people who were profoundly concerned about what other people thought of them, and what they thought of others. Tanguay spurned all of that, and laughed at the same time. Her moral code amounted to a cheerful nihilism. She exhorted people to be happy, but it was never clear what they were supposed to be happy about. Her stance, which foreshadowed a twentieth-century culture of personality and individualism, is captured in two assessments, the first printed in *Variety*, the second in a vaudeville newsletter.

Eva Tanguay is a striking example of the triumph of personality. That has been the one vital element of her success. She admirably personifies the American ideals of hurry. She is the spirit of the Subway Rush. She's more than that—she is personality tearing through the line of Art. She is excitement knocking a home run in the ninth with hysterics on third. She is a Krupp howitzer of restlessness hurling a 42-centimeter shell into Poise. . . .

Eva Tanguay is a mass of nerves quivering, shrieking, undeniable nerves, superbly harnessed to an indestructible ego. Her whole performance is of herself, for herself, by herself. She is motive, cue, subject and sub-subject. She

proclaims herself. And her magnetized world proclaims her the most vivid personality in all vaudeville. . . .[49]

A 1917 Palace program gave her a title that spoke volumes: "The Evangelist of Joy." Keith-Albee vaudeville, which arose in a cloak of pious sobriety, had become the first church of hedonism. Others would soon follow.[50]

By the teens and early twenties, vaudeville was often concerned with the culture that was replacing Victorianism: sensual, expressive, individualist, and slightly cynical. Classic Victorianism became harder to find. The "new woman," changes in sexual conduct and mores, and stress and conflict between men and women became major vaudeville themes. Such changes were a central element in the comedy teams of men and women like George Burns and Gracie Allen.[51]

When Burns and Allen played the Palace for the first time in 1926, they performed "Lamb Chops," which toyed with street-corner flirtations. Although they modified the act over the years, its fundamentals were memorable. They entered holding hands. Gracie stopped, turned toward the wings, and waved. She let go of George's hand and walked towards the wing, still waving, then stopped and motioned for whoever she was waving to to come out. A man came out, put his arms around Gracie, and they kissed each other. They then separated and waved to each other as he backed offstage. Gracie then returned to George at center stage.

GRACIE: Who was that?
GEORGE: You don't know?
GRACIE: No, my mother told me never to talk to strangers.
GEORGE: That makes sense.
GRACIE: This always happens to me. On my way in a man

stopped me at the stage door and said, "Hi ya cutie, how about a bite tonight after the show?"
GEORGE: And you said?
GRACIE: I said, "I'll be busy after the show but I'm not doing anything now," so I bit him.[52]

More repartee followed, then a song and dance by Gracie and some ten more minutes of dialogue, which included this celebrated exchange.

GEORGE: Do you like to love?
GRACIE: No.
GEORGE: Do you like to kiss?
GRACIE: No.
GEORGE: What do you like?
GRACIE: Lamb chops.
GEORGE: A little girl like you? Could you eat two big lamb chops alone?
GRACIE: No. But with potatoes I could.[53]†

Exchanges like this were not feminist statements. But they conjured up relationships that were far more complicated than the domestic bliss of the Victorian ideal. Vaudeville took middle-class entertainment out of the family parlor. Teams like Burns and Allen took the interaction between men and women out of the domestic scene, even out of courtship and marriage, and placed it on a more independent level. This was not necessarily liberating for women, but it did allow for more experimentation with new roles. Gracie Allen heightened the situation with her anarchic pronouncements. Although thoroughly benign, she was in her own way a disorderly woman, who at every moment threatened to turn the world upside down.[54]

† Reprinted by permission of The Putnam Publishing Group from LIVING IT UP (OR: THEY STILL LOVE ME IN ALTOONA!) by George Burns. Copyright © 1976 by George Burns.

Gracie Allen's popularity was entirely appropriate to its era, because from the standpoint of the nineteenth-century world that had cradled vaudeville, the old ways really were coming apart. A 1920s magazine article by Marshall D. Beuick discussed the cumulative effect of such changes. Some of the acts he described were still paying homage to ideals like the sanctity of motherhood, but most broke from such sensibilities:

> There are certain standard subjects that are used almost every night on vaudeville stages through the country. An audience, composed of many persons mentally fatigued after a day's work, learns a philosophy that embraces such precepts as: marriage is an unfortunate institution to which the majority of us resign ourselves; women are fashion-crazy, spend money heedlessly and believe that their husbands are fools; politics is all bunk, Prohibition should be prohibited; mothers are the finest persons in the world . . . next to grandmothers; fathers are unfortunate persons upon whom fall most of life's woes; marital infidelity is widespread; clandestine affairs of most any sort between at least one married person and another of the opposite sex are comical; and finally "nothing in life really matters. The main thing to do is get all the money you can and keep your mother-in-law as far off as possible."[55]

Beuick then repeated three typical vaudeville gags of the mid-twenties.

> Love makes the world go round.
> So does a punch in the jaw.

> Marriage is an institution.
> So is a lunatic asylum.

> I married my wife's sister because I didn't want to break in a new mother-in-law.[56]

The supposedly puritanical Keith vaudeville circuit featured such jokes every night of the week. Their appearance there was perfectly consistent with the reality of vaudeville. The Keith vaudeville houses were selling leisure, individualism, release, and abundance; a world to be enjoyed, not endured. A 1923 program from the Palace Theatre is a clear expression of a twentieth-century culture of pleasure-seeking. The cover reads:

> The music hall is a power for good in maintaining the morale of its patrons, and we are told by experts that Palace fans are the happiest and most hopeful people on earth; they always carry on because every week there is a wonderful new Palace show to look forward to. . . .[57]

Vaudeville had come full circle. Although it initially gained legitimacy by bowing (with a wink) to the dictates of Victorianism, by the twenties it was reveling in a newer, more expressive culture, one more concerned with release than with discipline, self-improvement, and self-control. At least part of this seemingly new tendency was an updated version of the old Bowery rowdiness that had been an important part of the first variety shows. The earliest entrepreneurs had attempted to control it, but it proved far more slippery—and attractive to audiences—than they anticipated.

The other half of vaudeville's blow to Victorianism came from its ability to lift people out of their accustomed communities, with all their restrictions. In the 1880s, men had most of the opportunities for urban experimentation and adventures. By the 1920s, thanks in part to vaudeville, women had their share of opportunities, too. City life would never be the same.

CONCLUSION

You have to look hard to find the physical remnants of vaudeville in New York City. In the spring of 1989, on Fourteenth Street, Keith's Union Square is hidden behind a bargain store and a billboard; the Jefferson is bricked up, a warning to crack dealers scrawled on its lonely front door, and the National Vaudeville Artists' clubhouse on Forty-sixth Street is a center for the Church of Scientology. The Palace, with a hotel being built around it, is buried inside a construction site; its sidewalk is no longer crowded with performers looking for work.

But their descendants are still around. On the night before Saint Patrick's Day in 1984, at the Eagle Tavern on Fourteenth Street in Manhattan, an audience politely appreciated Brian Conway and Gregg Ryan playing tradi-

tional Irish music. They burst into a cheering sing-along, however, when the duo performed a medley of George M. Cohan songs. American show tunes won out over the sounds of the old country to define ethnic identity. And on a hot August night in the summer of 1988, young black men appeared on a traffic island in Times Square, break-dancing for a heterogeneous crowd in a reprise of the street-corner hoofing that once launched so many towards the big time. The legacy of vaudeville is like that: still vibrant, if you know how and where to look for it. Part of the problem is that vaudeville was totally eclipsed by other forms of popular entertainment—almost all of which, ironically, had roots in vaudeville.[1]

Years before the Depression finished off vaudeville, its audience was being appropriated by revues, musical comedy, radio, and, most important, motion pictures. All of them exploited fields, forms, and themes first cultivated in vaudeville: the intimate appeal to a broad audience, opulent theatres for the masses, and the possibilities created by the collapse of older distinctions between high and low, rough and respectable.[2]

As early as 1905, revues like the Ziegfeld Follies featured graduates of the vaudeville stage in polished extravaganzas. Vaudeville managers often tried to create equally impressive offerings, but it was difficult to present such spectaculars for a widely affordable ticket price. Revues cost a little more, but those who could pay the price thought that they found bigger and better shows. When managers did duplicate the style of the revues, they often wound up with productions that were too rich for audiences accustomed to the snap of a vaudeville show.[3]

Radio, which grew rapidly through the 1920s, also drew performers and audiences from vaudeville. Vaudeville had brought nationwide stars and their imitators into the small-

est neighborhoods of New York. Radio brought them into the home. Distant performers, broadcast live to millions, came to seem like members of the family.[4] Entertainment moved out of the theatre and into the living room—and became far more private than anything an old-time gallery god could have imagined.

Radio had revolutionary implications for popular culture. Yet it had substantial roots in vaudeville, in both the format of radio shows and their personnel. Radio featured many performers who first appeared in vaudeville—among them, artists who had worked their way up from the small time, like Eddie Cantor.[5] The transition had its difficulties: some had to have an audience brought into the studio; they simply couldn't play to an inanimate microphone. But ultimately, radio's absorption of vaudeville was thorough. When a *Radio Guide* columnist described a gathering of "radio comics" in 1934, he was describing a group that fifteen years earlier would have been referred to as vaudevillians.[6]

The biggest challenge came from the movies. Although the first films shown in the late 1890s had a novel appeal, their poor technical qualities made them weak competition for live vaudeville acts. Managers often used them as another "dumb act" that required no sound to be understood. Early films became "chasers," acts used to signify the end of a bill.[7]

Yet the economics of the vaudeville industry, combined with improvements in the films themselves (such as the introduction of story lines), gave movies an increasingly important role in vaudeville. M. B. Leavitt, a veteran of theatrical management, summarized the case in 1912.

Many of the current vaudeville theatres depend for their profits on moving pictures, while several first-class the-

atres have been given up for the exhibition of this popular style of attraction. One great factor for its permanent sustenance is its economy, both of cost to the manager and to the patron, as in every programme they take the place of many performers, a number of whom are by this modern development kept out of work, and it is easy to foretell the day, which is not far distant, when the largest theatres in the country will thrive on moving picture shows.[8]

As Leavitt wrote, small-time vaudeville houses were profitably featuring a combination of films and vaudeville acts for ticket prices that rarely topped fifty cents and were as low as ten cents. Threatened by the competition, Albee warned vaudevillians that if they appeared in films, he would cut their pay or refuse to book them altogether. It was no use. By the mid-1920s, even big-time vaudeville houses were presenting vaudeville and film combinations. By 1928, there were only four theatres in the United States offering vaudeville without films. One of them was the Palace in New York City. Big-time acts, which once had no trouble arranging tours of forty weeks, now had problems putting together ten-week tours.[9]

A flurry of financial transactions created an illusion of vitality in the vaudeville industry, but they were really symptoms of decline. In 1927, the Keith Circuit merged with the Orpheum Circuit. A year later, Joseph P. Kennedy, political patriach and head of a film company called the Film Booking Office (F.B.O.), bought a large chunk of stock in Keith-Albee-Orpheum. Kennedy wanted to acquire the circuit's theatres for his film interests, which he ran in cooperation with the Radio Corporation of America (R.C.A.). In theory, Kennedy would be chairman of the board, while Albee remained as chief of operations. In reality, Kennedy was in charge. According to an often-

repeated anecdote, when Albee went to Kennedy to make a suggestion about the Palace, Kennedy brushed him off. "Didn't you know, Ed?" he is said to have asked. "You're washed up. You're through."[10]

Albee died rich and bitter in Palm Beach, Florida, in 1930. Keith-Albee-Orpheum combined with R.C.A. and Kennedy's F.B.O. to become Radio-Keith-Orpheum—R.K.O.—and R.C.A. supplied the facilities for broadcasting, movies, and eventually television; F.B.O. supplied movie-making facilities, and Keith-Orpheum supplied the theatres and a staff of entertainers. A major force in the American media had risen out of the ashes of vaudeville.[11]

The Depression struck the final blow to the few remaining vaudeville houses. In November 1932, the Palace abandoned vaudeville and became a motion picture house. The first film booked under the new policy was *The Kid from Spain*, starring Eddie Cantor.[12]

The obvious reminders of the old days were the stage shows presented to complement films, although these were a far cry from full-scale vaudeville. There were other continuities, however. The movie palaces of the thirties were direct descendants of the ornate vaudeville theatres. And many of the people projected on the big screens were former vaudevillians; perhaps none more identifiably so than James Cagney, whose bouncy, cocky style was the embodiment of the spirit of vaudeville. Even television was fertilized. Some of its earliest stars—Burns and Allen, Milton Berle, Groucho Marx, and others, all graduated from the vaudeville stage.

And so the vaudevillians went on, invigorating American popular culture to the end, just as light from a dead star illuminates the earth long after its source has burned out. Eddie Cantor became a star of radio, movies, and television before he died in 1964. Eubie Blake lived to be one

hundred, long enough to be internationally acclaimed as a composer and pianist, and long enough to see one of his songs, "I'm Just Wild About Harry," become the theme song of a Democratic president. Frances Poplawski, the longshoreman's daughter, moved into nightclub acts, then into Polish folk dancing. Sophie Tucker died in 1966, billed to the end as "The Last of the Red Hot Mommas."

Their careers formed a historical cornerstone, because in many respects, twentieth-century American popular culture is a post-vaudeville phenomenon. So many of its distinguishing characteristics were formed in and through vaudeville: the mass audience, the entertainment conglomerate, the testing of the boundaries of propriety, the creation of a commercial ethnic culture, the invigorating influence of racial and ethnic outsiders trying to become insiders.

"Three cheers for vaudeville"? No, its shortcomings were too pronounced for that. The grasping entrepreneurs set too many nasty precedents; the show-business corporations they founded came to exercise too tight a hold on our culture. Too often, the journey out of intimate communities turns out to be a trip from someplace to no place, a journey into an arena that offers something for everyone and everything for no one. Vaudeville never treated blacks as well as it treated whites, and in its own way it portrayed women as sex objects in a manner even more problematic than had been the case in the nineteenth century. A vaudeville show was a fine way to escape from a world of oppressive and meaningless work, but at best it was a momentary release that left the workaday world the same as before. For all the communication between New Yorkers inside the vaudeville house, outside it they could be quite hostile to one another. The conflicts between Jewish and Irish New Yorkers in the thirties and forties, and the city's racial

tensions that endure to this day, all testify to the limits of integration through popular culture.

But vaudeville certainly deserves two cheers. It took ordinary people seriously. Its vigor and energy were undeniably attractive. Its human, intimate touch respected the diversity of the city.

Vaudeville was not uniformly open, generous, and egalitarian. But the vaudeville theatre was far more open, generous, and egalitarian than most cultural institutions that people encountered. That was why they loved it.

The vaudeville days are gone, but their descendants and their history remain. They are there to remind us of the possibilities for vitality, openness, and genial subversion when theatre resounds with the spirit of the streets of New York.

Bibliographic Essay

People who lived through the vaudeville years provided me with important information used in this book. In interviews and written communication, they shared with me their unique knowledge.

Unfortunately, the passing of time means that one day there will no longer be any living witnesses to vaudeville. When that day comes, the articles, books and manuscript collections that illuminate vaudeville will assume even greater importance. This essay discusses the most significant of these printed sources so that future researchers will be able to build upon my work.

No search for information about vaudeville should be undertaken without consulting two bibliographies, both by Don B. Wilmeth: *American and English Popular Entertainment* (Detroit, 1980) and *Variety Entertainment and Outdoor Amusements: A Reference Guide* (Westport, Conn., 1982). Many of the sources cited by Wilmeth are reprinted in Charles W. Stein, ed., *American Vaudeville As Seen by Its Contemporaries* (New

York, 1984), a useful and enjoyable collection of writings from and about the vaudeville years.

Among the many show business autobiographies I read, four stand out: Fred Allen's *Much Ado About Me* (New York, 1956); Eddie Cantor, as told to David Freedman, *My Life Is in Your Hands* (New York, 1928); Edward B. Marks, as told to Abbott J. Liebling, *They All Sang: From Tony Pastor to Rudy Vallee* (New York, 1935); and Sophie Tucker, in collaboration with Dorothy Giles, *Some of These Days: The Autobiography of Sophie Tucker* (Garden City, N.Y., 1945).

Four archives and collections offer rich opportunities for anyone seeking to explore vaudeville. They are the Billy Rose Theatre Collection at the New York Public Library at Lincoln Center; the Washington National Records Center at Suitland, Maryland, home of the large collection of papers generated by The Federal Trade Commission *vs.* Vaudeville Managers' Protective Association, et al., docket number 128; the Keith/Albee Collection, Special Collections Department, University of Iowa Libraries, Iowa City, Iowa, which contains fascinating records from the Keith-Albee theatres on acts and their popularity, among other things; and the Warshaw Collection of Business Americana at the National Museum of American History, Smithsonian Institution, Washington, D.C., which contains material from both agents and performers.

Three "how-to" manuals provide valuable information on vaudeville from an inside perspective: William Harvey Birkmire, *The Planning and Construction of American Theatres* (New York, 1896); Brett Page, *Writing for Vaudeville* (Springfield, Mass., 1915); and Edward Renton, *The Vaudeville Theatre; Building, Operation, Management* (New York, 1918).

For a sociological survey of vaudeville audiences, see Michael M. Davis, Jr., *The Exploitation of Pleasure: A Study of Commercial Recreation in New York City* (New York, 1911). For an understanding of the economics of vaudeville, see Alfred L. Bernheim's *The Business of the Theatre* (New York, 1932), and his series "The Facts of Vaudeville" in *Equity* 8 (September, October, November, December 1923) and *Equity* 9 (Janu-

ary, February, March 1924). *Equity,* the journal of Actors Equity, is available at the Billy Rose Theatre Collection of the New York Public Library at Lincoln Center.

A fine scholarly treatment of vaudeville, despite its dated analysis, is Albert F. McLean, Jr.'s *American Vaudeville as Ritual* (Lexington, 1965). For general histories of vaudeville, see Douglas Gilbert, *American Vaudeville: Its Life and Times* (New York, 1940); Abel Green and Joe Laurie, Jr., *Show Biz from Vaude to Video* (New York, 1951), and Joe Laurie, *Vaudeville: From the Honky-Tonks to the Palace* (Reprint, Port Washington, New York, 1972).

More narrowly focused, but still valuable, are Marian Spitzer, *The Palace* (New York, 1969); William Marston and John Henry Feller, *F. F. Proctor, Vaudeville Pioneer* (New York, 1943), and Mary C. Henderson, *The City and the Theatre: New York Playhouses from Bowling Green to Times Square* (Clifton, 1973).

Biographical information on individual vaudevillians and a sense of their careers can be obtained from Bill Smith, *The Vaudevillians* (New York, 1976); John E. DiMeglio, *Vaudeville U.S.A.* (Bowling Green, 1973) and Anthony Slide, *The Vaudevillians: A Dictionary of Vaudeville Performers* (Westport, Conn., 1981).

Among doctoral dissertations, it is worthwhile to consult John Frick, "The Rialto: A Study of Union Square, the Center of New York's First Theatre District, 1870–1900," (Ph.D. diss., New York University, 1983); Robert C. Allen, "Vaudeville and Film, 1895–1915: A Study in Media Interaction" (Ph.D. diss., Univ. of Iowa, 1977); Paul Antonie Distler, "The Rise and Fall of the Racial Comics in American Vaudeville" (Ph.D. diss., Tulane University, 1963); Frederick Edward Snyder (no relation to the author), "American Vaudeville-Theatre in a Package: The Origins of Mass Entertainment" (Ph. D. diss., Yale University, 1970); and Shirley Louise Staples, "From 'Barney's Courtship' to Burns and Allen: Male-Female Comedy Routines in American Vaudeville, 1865–1932," (Ph.D. diss., Tufts University, 1981); along with her subsequent book, *Male-*

Female Comedy Teams in American Vaudeville, 1865–1932 (Ann Arbor, Michigan, 1984).

Works on culture that stimulated my thinking include: Carlo Ginzburg, *The Cheese and the Worms: The Cosmos of a Sixteenth-Century Miller* (New York, 1982); Robert D. Storch, ed., *Popular Culture and Custom in Nineteenth-Century England* (New York, 1982), which includes Peter Bailey's fine essay, "Custom, Capital and Culture in the Victorian Music Hall"; Todd Gitlin, *Inside Prime Time* (New York, 1983); and Eileen and Stephen Yeo, eds., *Popular Culture and Class Conflict, 1590–1914* (Atlantic Highlands, N.J., 1981).

The following works are useful for establishing the context and details of American culture in the general vaudeville era: Mark Slobin, *Tenement Songs: The Popular Music of the Jewish Immigrants* (Urbana, Ill., 1982); Alexander Saxton, "Blackface Minstrelsy and Jacksonian Ideology," *American Quarterly* 27 (March 1975), pp. 3–28; Lois W. Banner, *American Beauty* (New York, 1983); Daniel J. Czitrom, *Media and the American Mind: From Morse to McLuhan* (Chapel Hill, N.C., 1982); Lewis A. Erenberg, *Steppin' Out: New York Nightlife and the Transformation of American Culture, 1890–1930* (Westport, Conn., 1981); David Grimsted, *Melodrama Unveiled: American Theater and Culture, 1800–1850,* (Chicago, 1968); Neil Harris, *Humbug: The Art of P. T. Barnum,* (New York, 1973); Neil Harris, Arthur Mann, and Sam Bass Warner, Jr., *History and the Role of the City in American Life: Indiana Historical Society Lectures, 1971–1972,* (Indianapolis, 1972); John F. Kasson, *Amusing the Million: Coney Island at the Turn of the Century* (New York, 1978); Elizabeth Kendall, *Where She Danced* (New York, 1979); Lary May, *Screening Out the Past: The Birth of Mass Culture and the Motion Picture Industry* (Chicago, 1983); Robert C. Toll, *Blacking Up: The Minstrel Show in Nineteenth-Century America* (New York, 1974); Robert C. Toll, *On With the Show: The First Century of Show Business in America* (New York, 1976); and John D'Emilio and Estelle B. Freedman, *Intimate Matters: A History of Sexuality in America* (New York, 1988).

Notes

INTRODUCTION

1. My thinking on the fundamental characteristics of popular cul-
ture is influenced by Lawrence W. Levine, "William Shakespeare
and the American People: A Study in Cultural Transformation,"
American Historical Review 89 (February 1984): 46; and Carlo
Ginzburg, translated by John and Anne Tedeschi, *The Cheese
and the Worms: The Cosmos of a Sixteenth-Century Miller*
(New York: Penguin, 1982), xii, xviii, 130. My understanding of
the transformation of American popular culture at the turn of
the century has been influenced by Susan G. Davis, *Parades and
Power: Street Theatre in Nineteenth-Century Philadelphia* (Berke-
ley, Calif.: Univ. of California Press), n. 37, p. 181; Daniel J.
Czitrom, *Media and the American Mind: From Morse to Mc-
Luhan* (Chapel Hill, N.C.: Univ. of North Carolina Press, 1986)
xii, 30–31, 59, 190–92; and conversations with William R. Taylor.

CHAPTER 1

1. Junius Henri Browne, *The Great Metropolis: A Mirror of New York* (Hartford: American Publishing Co., 1868): 327–32.
2. Ferdinand Longchamp, *Asmodeus in New-York* (Longchamp and Co., 1868; reprint, New York: Arno Press, 1975), 239–40.
3. *New York Clipper*, April 23, 1864, "Broadway Below the Sidewalk," 16.
4. Ibid.
5. On the riot death toll, see Peter George Buckley, "To the Opera House: Culture and Society in New York City: 1820–1860" (Ph.D. diss., State Univ. of New York at Stony Brook, 1984), 3. On the riot as a social watershed, see David Grimsted, *Melodrama Unveiled: American Theatre and Culture, 1800–1850* (Chicago: Univ. of Chicago Press, 1968), 74–75. On the theatre and social differences, see Mary C. Henderson, *The City and the Theatre: New York Playhouses from Bowling Green to Times Square* (Clifton, N.J.: James T. White and Co., 1973), 118; also Grimsted, *Melodrama Unveiled*, 110.
6. On the development of the Bowery milieu, see Christine Stansell, *City of Women: Sex and Class in New York City, 1789–1860* (New York: Alfred A. Knopf, 1986), 89–100; also Sean Wilentz, *Chants Democratic: New York City and the Rise of the American Working Class, 1788–1850* (New York: Oxford Univ. Press, 1984), 257–63.
7. See Alexander Saxton, "Blackface Minstrelsy and Jacksonian Ideology," *American Quarterly* 27 (March 1975), passim; also Robert C. Toll, *Blacking Up: The Minstrel Show in Nineteenth-Century America* (New York: Oxford Univ. Press, 1974), v–vi, 31–32, 66, 173, 176–77, 185–87, 271–73.
8. See Grimsted, *Melodrama Unveiled*, 175, 189–92, 208, 221–23, 241, and 248.
9. George G. Foster, *New York Naked* (New York: n.p., 185—), 145.
10. Foster, *New York Naked*, 143.
11. George G. Foster, *New York in Slices: By an Experienced Carver* (New York: W. F. Burgess, 1849), 120; also Foster, *New York Naked*, 144.
12. P. T. Barnum, *Struggles and Triumphs; or, Forty Years' Recollections of P. T. Barnum* (Buffalo, N.Y.: Warren, Johnson and Co., 1874), 120–21, 134, 160–61.

13. Shirley Staples, "From 'Barney's Courtship' to Burns and Allen: Male-Female Comedy Teams in American Vaudeville, 1865–1981," (Ph.D. diss., Tufts Univ. Medford, Mass., 1981), 146, 158–59; Hartley Davis, "In Vaudeville," *Everybody's Magazine* 13 (August 1905): 231–40; Hartley Davis, "The Business Side of Vaudeville," *Everybody's Magazine* 17 (October 1907): 527–37; Marian Spitzer, "Morals in the Two-a-Day," *The American Mercury* 3 (September 1924): 35–39; George Odell, *Annals of the New York Stage* (New York: Columbia Univ. Press, 1949), 15: 350–51; Robert Grau, *The Business Man in the Amusement World* (New York: Broadway Publishing Co., 1910), 108; Robert Grau, *Forty Years of Observation of Music and the Drama* (New York: Broadway Publishing Co., 1909), 1; Edward B. Marks, as told to Abbott J. Liebling, *They All Sang: From Tony Pastor to Rudy Vallee* (New York: Viking Press, 1935), 135; George Fuller Golden, *My Lady Vaudeville and Her White Rats* (New York: Board of Directors of the White Rats, 1909), 3–4.

14. On temperance as a class and ethnic issue, and on the concert saloon, see Roy Rosenzweig, *Eight Hours for What We Will: Workers and Leisure in an Industrial City, 1870–1920* (New York: Cambridge Univ. Press, 1983), 93–126, passim, especially 93–94, 116–17, 126; also Perry R. Duis, *The Saloon: Public Drinking in Chicago and Boston, 1880–1920* (Urbana: Univ. of Illinois Press, 1983). On the New York City context for these conflicts, see James F. Richardson, *The New York Police, Colonial Times to 1901* (New York: Oxford Univ. Press, 1970), 181–85.

15. For these descriptions, see John Joseph Jennings, *Theatrical and Circus Life* (St. Louis: M. S. Barnett, 1882), 410; Longchamp, *Asmodeus in New-York*, 239–40; Parker Zellers, *Tony Pastor: Dean of the Vaudeville Stage* (Ypsilanti: Eastern Michigan Univ. Press, 1971), xii–xvi. On singing saloons, see Peter Bailey, "Custom, Capital and Culture in the Victorian Music Hall," in Robert D. Storch, ed., *Popular Culture and Custom in Nineteenth-Century England* (New York: St. Martin's Press, 1982), 180–81.

16. "Origins of the Variety Show," *New York Herald*, Sept. 3, 1893, p. 32. On the number of concert saloons advertising in the New York press, see Daniel Czitrom, Mount Holyoke College, "Mysteries of the City; Theatre Licensing, Popular Entertainment,

and the Underworld in Nineteenth Century New York," August 1988, unpublished essay cited with permission of the author, 9.

17. For the quote, see "The Concert Saloons," *New York World*, April 25, 1862, p. 4; Junius Henri Browne, *The Great Metropolis; A Mirror of New York* (Hartford, Conn.: American Publishing Co., 1868), 327–32; see also comments on such contemporary accounts in Bayrd Still, *Mirror for Gotham* (New York: New York Univ. Press, 1956), 197–98; Longchamp, *Asmodeus in New-York*, 239–40; for contemporary newspaper accounts, see "The Police and the Concert Saloons," *New York World*, April 26, 1862, p. 8; also "The Concert Saloons," *New York Times*, Jan. 5, 1862, p. 5. On the reformers themselves, their organization, and their expanded powers, see Czitrom, "Mysteries of the City," 5–6.

18. For the discussion of methods of dodging the law, see "The Concert Saloon Reform," *New York Times*, April 25, 1862, p. 5, and April 26, 1862, p. 8. For an assessment of how the law was ignored, see Zellers, *Tony Pastor*, xviii–xix. For the law itself, see *Laws of New York*, 85th session, 1862 (Albany: William Gould, 1862), 475–77.

19. For the estimate on the number of saloons, see James D. McCabe, Jr., *Lights and Shadows of New York Life; or, the sights and sensations of the great city* (Philadelphia: National Publishing Co., 1872; reprint, New York: Farrar, Straus and Giroux, 1970), 594. For the quote on the concert saloons' surrounding environment, see Browne, *The Great Metropolis*, 326–28, 341. Also see "Origins of the Variety Show," *New York Herald*, Sept. 3, 1893, p. 32.

20. Jennings, *Theatrical and Circus Life*, 397, 400–401; also McCabe, *Lights and Shadows*, 603; and Browne, *The Great Metropolis*, 327–32.

21. McCabe, *Lights and Shadows*, 596.

22. McCabe, *Lights and Shadows*, 550–53; Browne, *The Great Metropolis*, 162; on Little Germany, see Karl Theodor Griesinger's observations from his *Land und Leute in Amerika: Skizzen aus dem amerikanischen Leben*, 2nd ed., 2 vols. (Stuttgart, 1863), reprinted in translation in Still, *Mirror for Gotham*, 163.

23. On the middle-class ideal of family-centered leisure, see Rosenzweig, *Eight Hours*, 63.

24. On the history of the word "vaudeville," see Gunther Barth,

City People: The Rise of Modern City Culture in Nineteenth-Century America (New York: Oxford Univ. Press, 1980), 196–97. For analyses of the early history of vaudeville and its connection to variety, see M. B. Leavitt, *Fifty Years in Theatrical Management* (New York: Broadway Publishing Co., 1912), 209–210; on dime museums and variety, see Brooks McNamara, "A Congress of Wonders: The Rise and Fall of the Dime Museum," *Emerson Society Quarterly* 20 (third quarter, 1974): 218–20, 224–30; Douglas Gilbert, *American Vaudeville: Its Life and Times* (New York: McGraw-Hill, 1940), 20; Neil Harris, *Humbug: The Art of P. T. Barnum* (New York: Little, Brown & Co., 1973), 36–37. On concert saloons and vaudeville, see Lewis A. Erenberg, *Steppin' Out: New York Nightlife and the Transformation of American Culture, 1880–1930* (Westport, Conn.: Greenwood Press, 1981), 18.

25. Details on Pastor's early life are vague (Myron Matlaw's research is convincing on a birthdate of 1834, although other sources cite 1837), but a basic biography can be put together. See Myron Matlaw, "Tony the Trouper: Pastor's Early Years," *The Theatre Annual* 24 (1968): 72–90, passim, birth discussed, 73–74; and Robert C. Toll, *On With the Show: The First Century of Show Business in America* (New York: Oxford Univ. Press, 1976), 267–68.

26. Toll, *On With the Show*, 268, and Gilbert, *American Vaudeville*, 107–8. See also interview with Pastor in "Mirror Interviews," *New York Dramatic Mirror*, July 27, 1895, p. 2.

27. On "The Monitor and the Merrimac," see Tony Pastor, *Tony Pastor's New Union Songbook* (New York: Dick and Fitzgerald, 1862), 1. For "The New Ballad of Lord Lovel," see Pastor's *New Union Songbook*, 66–67.

28. This analysis of Pastor's songs is based on songsters in the rare book room of the Lincoln Center branch of the New York Public Library (hereafter NYPL-LC) and in the Library of Congress. Unless noted otherwise, all compositions are by Tony Pastor. See also John F. Poole, ed., *Tony Pastor's 'Own' Comic Vocalist: being a collection of original comic songs sung by the celebrated comic singer and jester, Tony Pastor* (New York: Dick and Fitzgerald, 1863); John F. Poole, ed., *Tony Pastor's Complete Budget of Comic Songs* (New York: Dick and Fitzgerald, 1864); *Tony Pastor's New Comic Irish Songster* (New York: Dick and Fitzgerald, 1863); *Tony Pastor's 444 Combination Songster* (New

York: Dick and Fitzgerald, 1864); *Tony Pastor's Great Sensation Songster* (n.p., 1864); *The Songs of Tony Pastor's Opera House* (New York: Robert M. De Witt, 1873); *Tony Pastor's Songs of the Flags and C.* (New York: A. J. Fisher, 1874); *Tony Pastor's Electric Light Songster* (New York: Popular Publishing Co., 1879; *Tony Pastor's Dot Beautiful Hebrew Girl* (New York: Popular Publishing Co., [188__]). On melodramatic characters, see Grimsted, *Melodrama Unveiled*, 189–92.

29. See the following Pastor songs in the *New Union Song Book,* "The Irish Volunteer," 50–51; "The Peaceful Battle of Manassas," 36–37; and, for the quote, John F. Poole, "No Irish Need Apply," *New Comic Irish Songster*, 1–2.

30. See John F. Poole, "The Contraband's Adventures" in Pastor, *New Comic Irish Songster*, 53–54; and similarly "You've Got It on the Brain," *444 Combination Songster*, 65.

31. For "Don't Crush the Poor People," see Pastor *Electric Light Songster, 36.* For examples of Pastor's attitudes towards class, see Pastor, in *444 Combination Songster,* "Polly Perkins of Washington Square," 13–15, and "I Always Take It Cool," 20–21; in Pastor's *New Comic Irish Songster,* "The Upper and Lower Ten Thousand," 10–11, "What Is and What Isn't," 50–51; in Pastor's *'Own' Comic Vocalist,* see "Wait Till You Get It," 7–8, "All the World Are Fishing," 33; and "It's a Folly to Talk of Life's Troubles," 63–64; and, in Pastor's *Great Sensation Songster,* "The Army Contractors," 35. For "We Are Coming, Father Abraham," see Pastor, *444 Combination Songster,* 31–32. For observations on similar repertoires among saloon singers in Chicago, Ill., and Worcester, Mass., see Rosenzweig, *Eight Hours,* 54–55.

32. Pastor, "The Upper and Lower Ten Thousand," in Pastor's *New Comic Irish Songster,* 10–11.

33. See "The Famous Tony Pastor," *New York World,* n.d., ca. 1895, Tony Pastor clipping file, NYPL-LC, cited in Zellers, *Tony Pastor,* 42.

34. Toll, *On With the Show,* 268; Henderson, *The City and the Theatre,* 49; also, Pastor's remarks in *New York Dramatic Mirror,* July 27, 1895, p. 2.

35. Handbill for Tony Pastor's Opera House, 201 Bowery; Tony Pastor collection, NYPL-LC, n.d.

36. *New York Herald,* Oct. 2, 1865, reprinted in Odell, *Annals of the New York Stage* 8: 85–86.

37. Zellers, *Tony Pastor,* 44–45. Also see 1873 program, Tony Pastor Opera House, Pastor Collection, NYPL-LC.

38. Program, n.d., Tony Pastor's Opera House, Pastor Collection, NYPL-LC.

39. See "In the Bowery," *Tony Pastor's Songs of the Flags & C.,* 29–33.

40. Allston T. Brown, *A History of the New York Stage: From the First Performance in 1732 to 1901* (New York, 1903; reprint, New York: Benjamin Blom, 1964), 2: 122; also Pastor obituary, *New York Dramatic Mirror,* Sept. 5, 1908, p. 6; advertisement (n.p.), week of December 20, 1878, Pastor clipping file, NYPL-LC; and Zellers, *Tony Pastor,* 54–57.

41. See Zellers, *Tony Pastor,* 55. On the raids, see "Raid on Broadway Saloons," *New York Times,* Jan. 23, 1872, p. 1; "The Concert Saloons," *New York Times,* Jan. 24, 1872, p. 5; and "The Broadway Concert-Saloons—Dismissal of the Complaints," *New York Times,* Feb. 9, 1872, p. 3. Also see *Laws of the State of New York,* 95th session, vol. 2 (New York: Banks and Bros., 1872), chap. 836, pp. 1988–91. For a report on a crackdown in 1877 using the 1862 law, see "Theatrical Record: City Summary," *New York Clipper,* Oct. 13, 1877, p. 230. The *Clipper* reported that the ban on liquor sales in auditoriums did not affect the bars in the front of theatres. For further information on the political conflict over morality and leisure, of which the licensing battles were only one part, see Timothy J. Gilfoyle, "The Moral Origins of Political Surveillance: The Preventive Society in New York City, 1867–1918," *American Quarterly* 38 (Fall 1986): 641; and Czitrom, "Mysteries of the City," 17–18.

42. On the move, see Brown, *A History of the New York Stage,* 2: 122. On the building, see Moses King, *King's Handbook of New York City 1893* (Boston, 1893; reprint, New York: Benjamin Blom, 1972), 2: 605. On neighborhood change, see John Frick, "The Rialto: A Study of Union Square, the Center of New York's First Theater District, 1870–1900" (Ph.D. diss., New York Univ., 1983), 147–49. On Pastor as the father of modern vaudeville, see Gilbert, *American Vaudeville,* 10; for an interpretation that recognizes the important role that Pastor's contemporaries also played in creating vaudeville, see Zellers, *Tony Pastor,* 71–72.

43. For police reports on Pastor's, see: June 3, 1885, report from Capt. Thomas M. Ryan, New York City Police Department, Box

86-GWR-26, "Police, Dept. of—Concerning Licensing of Theatres, Concert Halls, 1885–1886" folder, New York City Municipal Archives, hereafter NYCMA; April 14, 1890, report from Capt. William H. Clinchy, New York City Police Department, Box 88-GHJ-42, "Police, Dept. of—Concerning Licensing of Theatres, Concert Halls, etc. 1890" folder, NYCMA; and April 28, 1892, report from Capt. J. Westervelt, New York City Police Department, Box 88-GHJ-42, "Police, Dept. of—Concerning Licensing of Theatres, Concert Halls, etc. 1890–1892" folder.

44. For a summary of an investigation of concert and variety halls, see report titled "Concert and Variety Halls" and the February 27, 1882, statement of Augustine J. Wilson on the Metropolitan Theatre in Box 84-GWR-14, "Police, Dept. of—Concerning Licensing of Theatres, Concert Halls, 1881–1882" folder, NYCMA. On the attacks on the concert saloons, see Gilfoyle, "The Moral Origins of Political Surveillance," 643–45. For evaluations of Pastor's move to 14th Street, see Myron Matlaw's review of Parker Zellers' *Tony Pastor: Dean of the Vaudeville Stage* in *Educational Theatre Journal* 24 (October 1972): 336; Zellers, *Tony Pastor,* 72; and Frick, "The Rialto," 143.

45. Henderson, *The City and the Theatre,* 149; Frick, "The Rialto," 143.

46. February 1884 handbill and program, Pastor Collection, NYPL-LC.

47. On location, see Frick, "The Rialto," 143, and Zellers, *Tony Pastor,* 72. On Tammany as an interclass institution, I am indebted to an observation made by Thomas Bender. On Croker's fondness for Pastor's, see Matlaw review of Zellers' *Tony Pastor,* 337. On Bowery toughs at Pastor's, see "Maggie Cline, Vaudeville Idol of the '90s, Dies," *New York Herald Tribune,* June 12, 1934, p. 21. On newsboys at Pastor's, see "Maggie Cline, 195 Pounds of Fun," *The Morning Telegraph,* Jan. 15, 1905, in Robinson Locke Collection scrapbook, ser. 2, vol. 4, pp. 124–25; and clipping, ca. January 1910, *The Morning Telegraph,* Robinson Locke Collection scrapbook, ser. 2, vol. 75, p. 83, both NYPL-LC. For general observations on Pastor's, see "The Variety Stage: Early Creators of a Renumerative Vogue," *Harper's Weekly* 29 (March 1902): 414.

48. The quote is from a Pastor interview, *New York Dramatic Mirror,* July 27, 1895, p. 2.

49. On Pastor and the words "variety" and "vaudeville," see "The Late Tony Pastor, the Father of Vaudeville," *Philadelphia Telegraph,* Sept. 5, 1908, in the Robinson Locke Collection scrapbook, ser. 2, vol. 284, pp. 51–52, NYPL-LC. On the kiosk, see, in the Robinson Locke Collection scrapbook, ser. 2, vol. 284, p. 65. For further details on Pastor's style, see Marks, *They All Sang,* 15–16. For the anecdote on the prostitutes, see Albert E. Smith, in collaboration with Phil A. Koury, *Two Reels and a Crank* (Garden City, N.Y.: Doubleday and Co., 1952), 46.

50. Pastor interview, *New York Dramatic Mirror,* July 27, 1895, p. 2; for the quote, see "French Comiques," *New York Times,* Dec. 1, 1891, p. 4.

51. Pastor interview, *New York Dramatic Mirror,* July 27, 1895, p. 2.

52. For "earthquake obbligato," see "Maggie Cline Fights Death Like Her Famed McCloskey," *New York Post,* June 11, 1934, p. 4; for "swaggering, bragging," see report by C. E. Barnes, Keith's Philadelphia theatre, July 8, 1907, report book 6, p. 176, the Keith/Albee Collection, Special Collection Department, University of Iowa Libraries, Iowa City, Iowa (hereafter the Keith/Albee Collection); for the *Times* story, see "Three Popular Women," *New York Times,* Oct. 27, 1891, p. 4.

53. Marks, *They All Sang,* 90.

54. Marks, *They All Sang,* 3.

55. Helen Campbell, *Darkness and Daylight; or, Lights and Shadows of New York Life* (Hartford, Conn.: A. D. Worthington and Co., 1892), 465.

56. There is a wealth of material on concert saloons in the New York City Municipal Archives (NYCMA); I thank Daniel Czitrom of Mount Holyoke College for first bringing it to my attention. For one of many reports, see "Concert and Variety Halls," NYCMA, Box 84-GWR-14, "Police, Dept. of—Concerning Licensing of Theatres, 1881–1882" folder. On the lawsuit, see September 27, 1882, letter from Robinson, Scribner and Bright, attorneys at law, to Mayor W. R. Grace, in NYCMA, Box 84-GWR-14, "Police, Dept. of—Concerning Licensing of Theatres, 1881–1882" folder. On Koster and Bial's, see the following, all in NYCMA, Box 88-GHJ-41, "Police, Dept. of—Concerning Licensing of Theatres, Concert Halls, etc., 1890" folder; July 28, 1890, letter from Robert A. Gunn of The New York Society for the Enforcement of the Criminal Law to Mayor Hugh J. Grant, charging

that Koster and Bial's had violated laws governing Sunday openings, and the attached rebuttal from Capt. Thomas Reilly, New York Police Department. Also see "In the matter of complaints made by Robert A. Gunn, against . . . #115 and 117 W. 23rd Street, occupied by Koster and Bial," filed at the Mayor's Office, New York City, August 7, 1890; and on the charge of prostitution at Koster and Bial's, the September 14, 1890, letter from S. T. Drake to Mayor Grant.

57. On vows of a serious cleanup at Koster and Bial's, see Koster and Bial's August 10, 1893, letter to Mayor Thomas Gilroy, NYCMA, Box 89-GTF-15, "Police, Dept. of—Concerning Licensing of Theatres, Concert Halls, etc., 1893" folder.

CHAPTER 2

1. Toll, *On With the Show*, 269–70.
2. "E. F. Albee Dies of Heart Attack," *New York Herald Tribune*, March 12, 1930, p. 1.
3. Albert F. McLean, Jr., ed., "Genesis of Vaudeville: Two Letters from B. F. Keith," *Theatre Survey* I (1960): 89.
4. Walter Richard Eaton, "The Wizards of Vaudeville," *McClure's Magazine* 55 (September 1918): 44.
5. Eaton, "Wizards of Vaudeville," 44.
6. Ibid., 44–45.
7. Toll, *On With the Show*, 270.
8. Ibid.
9. See McLean, "Genesis of Vaudeville," 82–83.
10. Grau, *Forty Years of Observation of Music and the Drama*, 4–5.
11. Keith in McLean, "Genesis of Vaudeville," 94.
12. Edwin Milton Royle, "The Vaudeville Theatre," *Scribner's* 26 (October 1899): 487; also see a similar sign described in Robert Grau, "B. F. Keith," *American Magazine* 77 (May 1914): 87, cited in John E. DiMeglio, *Vaudeville U.S.A.* (Bowling Green, Ohio: Bowling Green University Popular Press, 1973), 50.
13. Keith in McLean, "Genesis of Vaudeville," 86.
14. On uplift and legitimation, see John F. Kasson, *Amusing the Million: Coney Island at the Turn of the Century* (New York: Hill and Wang, 1978), 6. On the profitability of self-censorship, see Abe Laufe, *The Wicked Stage: A History of Theater Censor-*

ship and Harassment in the United States (New York: Frederick Ungar Publishing Co., 1978), 21.

15. See Claudia D. Johnson, "That Guilty Third Tier: Prostitution in Nineteenth-Century American Theatres," *American Quarterly* 27 (December 1975): 575, 579, 584; also Foster Rhea Dulles, *A History of Recreation: America Learns to Play*, 2nd ed. (New York: Meredith Publishing Co., 1965), 106.

16. Stephen Crane, *Maggie: A Girl of the Streets* (New York: New-land Press, 1896), 51.

17. See Marian Spitzer, "The People of Vaudeville," *The Saturday Evening Post*, July 12, 1924, p. 151; Bill Smith, *The Vaudevillians* (New York: Macmillan, 1976), 12; Sophie Tucker, in collaboration with Dorothy Giles, *Some of These Days: The Autobiography of Sophie Tucker* (Garden City, N.Y.: Doubleday, Doran and Co., 1945), 115–16; Golden, *My Lady Vaudeville*, 4; and interviews with Terese Klein, New York, December 1983; Capitola DeWolfe, New York City, 1984; Murray Schwartz, New York City, January 11, 1984; and Harold Engel, the Bronx, New York, December 1983.

18. On nineteenth-century ordering of theatre behavior, see Michael Hays, "Theatre History and Practice: An Alternative View of Drama," *New German Critique* 12 (Fall 1977): 95; and Richard Sennett, *The Fall of Public Man* (New York: Alfred A. Knopf, 1977), 206–7.

19. Keith in McLean, "Genesis of Vaudeville," 93–94.

20. Royle, "The Vaudeville Theatre," 488; Eaton, "Wizards of Vaudeville" 48; Robert Grau, *The Stage in the Twentieth Century* (1912; reprint, The Bronx, N.Y.: Benjamin Blom, 1969), 143.

21. Royle, "The Vaudeville Theatre," 488.

22. Gilbert, *American Vaudeville*, 244.

23. Programs from NYPL-LC; hat anecdote from Keith, in McLean, "Genesis of Vaudeville," 93.

24. Grau, *Business Man in the Amusement World*, 108; Royle, "The Vaudeville Theatre," 495. Also see Proctor's remarks in *New York Dramatic Mirror*, Jan. 21, 1893, p. 3. On similar developments in theatres run by Keith, Pastor, and Percy Williams, see Golden, *My Lady Vaudeville*, 19–20.

25. The Keith/Albee Collection contains repeated references to managers' using special strategies to attract women. On attracting

women, see entry on an October 5, 1903, show at Keith's Union
Square; in particular, the remarks about John Healy in report
book for September 21, 1903–March 7, 1904, p. 19. Also see note
on Ethel Levey at the Harlem Opera House, and a report on
Lily Langtry at Keith's Philadelphia theatre, both in Report
Book 5, pp. 231 and 147, respectively. Also see a description of
muscleman Eugene Sandow appearing at the Temple Theatre
in Detroit in undated report book, p. 255. All citations from
Keith/Albee Collection.

26. Edward Renton, *The Vaudeville. Theatre: Building, Operation,
Management* (New York: Gotham Press, 1918), 12.

27. Renton, *Vaudeville Theatre*, 134, 238–39.

28. On managers' paying attention to the gallery, see Davis, "In
Vaudeville," 231–40, cited in Charles W. Stein, *American Vaude-
ville As Seen by Its Contemporaries* (New York: Alfred A. Knopf,
1984), 100.

29. Glenn Porter, *The Rise of Big Business, 1860–1910* (New York:
Thomas Y. Crowell Co., 1973), 63.

30. On the post-1870 changes in theatre economics, see Jack Poggi,
Theater in America: The Impact of Economic Forces, 1870–1967
(Ithaca, N.Y.: Cornell Univ. Press, 1968), 3–4, 8–9, 26–27; on
the economic transformation of the theatre and the "industrial
revolution" quote, see Alfred L. Bernheim, *The Business of the
Theatre* (New York: Actors' Equity Association, 1932), 31. Robert
Grau sees the formation of the vaudeville managers' association
in 1900 as an attempt to achieve some of the organization that
Klaw and Erlanger had already accomplished in the legitimate
theatre. See Grau, *Forty Years of Observation of Music and the
Drama*, 11.

31. Poggi, *Theater in America*, 4–7, 10–11; and Bernheim, *Business
of the Theatre*, 39, 44.

32. Poggi, *Theater in America*, 11–13; also Bernheim, *Business of
the Theatre*, 41, 52, 57, 68.

33. Figures by David Belasco cited in Poggi, *Theater in America*, 13.

34. Bernheim, *Business of the Theatre*, 65; also Poggi, *Theater in
America*, 14–15, 25.

35. See "The Facts of Vaudeville," *Equity* 8 (September 1923): 10.
"The Facts of Vaudeville" was published without a byline, but
it was attributed to Alfred L. Bernheim in an editor's note in
Business of the Theatre.

36. Grau, *Business Man in the Amusement World,* 2.

37. See Pat Rooney's testimony in the records of the Federal Trade Commission, case docket no. 128, Washington National Records Center, Suitland, Md. (hereafter referred to as FTC 128), Oct. 14, 1919, box 72, pp. 2489–91.

38. On this monopoly, see Bernheim, "Facts of Vaudeville," *Equity* 8 (November 1923), 38; Marian Spitzer, "The Business of Vaudeville," *Saturday Evening Post,* May 24, 1924, p. 18; and interview with Billy Glason, New York City, January 18, 1984.

39. See Bernheim, "Facts of Vaudeville," *Equity* (September 1923), 13.

40. Golden, *My Lady Vaudeville,* 68.

41. On the origins of the association, see Bernheim, "Facts of Vaudeville," *Equity* (September 1923), 9–11; for the official statement announcing formation of the association, see "The Vaudeville Combination," *New York Clipper,* June 9, 1900, pp. 326–27; and a related advertisement in the same issue, p. 348.

42. On the 5% plan, see Bernheim, "Facts of Vaudeville," September 1923, 10–11; Golden, *My Lady Vaudeville,* 141–42; and Grau, *Business Man in the Amusement World,* 89–90.

43. Golden, *My Lady Vaudeville,* 142.

44. On British unions and U.S. unionism, see Herbert G. Gutman, *Work, Culture and Society in Industrializing America* (New York: Alfred A. Knopf, 1976). On the Rats, see Golden, *My Lady Vaudeville,* 29–30, 33–35, 65.

45. Golden, *My Lady Vaudeville,* 72.

46. Ibid.

47. Golden, *My Lady Vaudeville,* 82–87; on membership, see *Billboard,* February 9, 1901, p. 7.

48. Golden, *My Lady Vaudeville,* 10–12, 95–97.

49. Golden, *My Lady Vaudeville,* 155; also Grau, *Business Man in the Amusement World,* 111; on sick-outs, see *Billboard,* February 16, 1901, p. 4; on the benefits, see *Billboard,* March 9, 1901, p. 7.

50. Golden, *My Lady Vaudeville,* 159–60.

51. Ibid., 164–65.

52. Ibid., 165–67.

53. Ibid.

54. Ibid., 162, 165, 175, 180–85.

CHAPTER 3

1. On Cline, see "Maggie Cline Rites Planned," *New York Sun*, June 12, 1934, p. 25; material on James Bevacqua from his interview in Mount Vernon, New York, November 1, 1983; on Capitola DeWolfe, from her interview in Queens, New York, January 23, 1984; on Cantor, see Eddie Cantor, as told to David Freedman, *My Life Is in Your Hands* (New York: Harper and Brothers, 1932), 6–9, 11, 14–17, for the quote, see p. 18; on Blake, see Robert Kimball and William Bolcom, *Reminiscing with Sissle and Blake* (New York: Viking, 1973), 36–37, 42.

2. Frances Peck Smith, "In Vaudeville," *The Green Book Album* 8 (July 1912): 142.

3. On Vaudevillians' social origins, see DiMeglio, *Vaudeville U.S.A.*, 197; Bill Smith, "Vaudeville: Entertainment of the Masses," in Myron Matlaw, ed., *American Popular Entertainment: Papers and Proceedings of the Conference on the History of American Popular Entertainment*, Contributions in Drama and Theatre Studies no. 1 (Westport, Conn.: Greenwood Press, 1979): 13. On the important immigrant influence on vaudeville, see Carl H. Scheele, "American Entertainment: An Immigrant Domain," in *A Nation of Nations*, Peter C. Marzio, ed. (New York: Harper and Row, 1976), 410–50, especially (on vaudeville) 425–34; Anthony Slide, *The Vaudevillians: A Dictionary of Vaudeville Performers* (Westport, Conn.: Arlington House, 1981), passim. Additional information from interviews conducted by Robert W. Snyder. On the limitations placed on blacks, see Kimball and Bolcom, *Reminiscing with Sissle and Blake*, 86; Helen Armstead-Johnson, "Blacks in Vaudeville: Broadway and Beyond," in Matlaw, *American Popular Entertainment*, 77–78, 84. Further information from questionnaires completed for the author by Richard Osk and George Weinstein. This claim of discrimination is born out by my own readings of the Keith-Albee report books in the Keith/Albee Collection.

Federal census statistics, which do not distinguish between vaudevillians and performers on the legitimate stage, provide little more than a hint at the vaudevillians' social background. Nevertheless, they testify to the significant presence of racial and ethnic minorities on the stage, particularly in New York City. See *Compendium of the 11th Census: 1890*, Part III (Washington, D.C.:

Government Printing Office, 1897), 452–53; *Special Reports: Occupations at the Twelfth Census,* prepared under the supervision of William C. Hunt, chief statistician for population (Washington, D.C.: Government Printing Office, 1904): for national statistics, see clxxxviii; for New York City statistics, see 634–35. See also Federal Census 1910, vol. 4, *Population, Occupation Statistics* (Washington, D.C.: Government Printing Office, 1914): for national statistics, see 428–29; for New York City statistics, see 428–29. See also 14th census of the United States taken in 1920, vol. 4, *Population, Occupation Statistics* (Washington, D.C.: Government Printing Office, 1923): for national figures, see 356–57; for New York City figures, see 1160 and 1162.

4. On actors' position in American society during the nineteenth century, see Benjamin McArthur, *Actors and American Culture: 1880–1920* (Philadelphia: Temple Univ. Press, 1984), ix, 235–36; on vaudevillians' not being "respectable" outside the theatre, see DiMeglio, *Vaudeville U.S.A.,* 199. For the Harpo Marx quote, see Harpo Marx with Rowland Barber, *Harpo Speaks* (New York: Bernard Geis Associates, 1961), 98–100, 103–4, cited in Stein, *American Vaudeville As Seen by Its Contemporaries,* 286.

5. McArthur, *Actors and American Culture,* 36–38.

6. Interview with Bunny Berk, New Jersey, February 4, 1984. Translation of the expression "the dybbuk" was generously provided by Dorothy Jacobs, National Museum of American History (NMAH), Smithsonian Institution.

7. On Baker, see "The Rise of Belle Baker," *Dramatic Mirror,* ca. 1917, in Belle Baker clipping file, NYPL-LC; on Cline, see "Cline Rites," *New York Sun,* June 12, 1934, p. 25.

8. Mark Slobin, *Tenement Songs: The Popular Music of the Jewish Immigrants* (Urbana: Univ. of Illinois Press, 1982), 2–3, 8, 15.

9. On salaries, see Davis, "The Business Side of Vaudeville," 527, 529; Grau, *Forty Years of Observation of Music and the Drama,* 10–11; also, FTC 128 files.

10. Newspaper clipping, n.p., ca. 1916, Belle Baker clipping file, NYPL-LC.

11. Cited in Sarah Blancher Cohen, ed., *From Hester Street to Hollywood: The Jewish-American Stage and Screen* (Bloomington: Indiana Univ. Press, 1983), 59; also, on the financial incentives that show business held for immigrants, ethnics, and blacks, see

June Sochen, "Fanny Brice and Sophie Tucker: Blending the Particular with the Universal," in Cohen, *From Hester Street to Hollywood,* 46; also Anthony Lewis, "The Jew in Stand-Up Comedy," in Cohen, *From Hester Street to Hollywood,* 59–60.

12. On the number of vaudevillians, see Casey's testimony in FTC 128, February 5, 1919, box 70, p. 258, 300–301; on actors' being four days ahead of the sheriff, see Casey, FTC 128, February 5, 1919, box 71, p. 306. Vaudeville writer Bill Smith estimates that from 1920 to 1930, only about 800 of 10,000 vaudevillians found work in the big time. See Smith, *The Vaudevillians,* 9–10. Although there is a discrepancy between Casey's and Smith's estimates of the total number of vaudevillians, the significant point is that they both state that there were far more performers than jobs available. For an example of the diverse dates performers would combine to produce a season's work, see handbill for Joe Hardman, ca. 1910, the Warshaw Collection of Business Americana, National Museum of American History, Smithsonian Institution (hereafter referred to as the Warshaw Collection), box 14, "Vaudeville Booking Agents: a-j" folders.

13. *The Player,* January 24, 1909, p. 15.

14. *The Player,* January 7, 1910, p. 21.

15. Kate Simon, *Bronx Primitive: Portraits in a Childhood* (New York: Viking, 1982), 160–61.

16. Joe Williams, "Real Napoleon of the Movies," *Cleveland Leader,* June 9, 1918, in Robinson Locke Collection scrapbook, ser. 2, vol. 270, pp. 66–67.

17. See exhibit 130, a salary list received November 5, 1919, in FTC 128, box 73.

18. On vaudeville salaries, see salary list, FTC 128, box 73; also "Theatres Booking in B. F. Keith Vaudeville Exchange, January 28, 1919," FTC 128, record group 122. On workers' average annual earnings nationwide, see *Historical Statistics of the United States: Colonial Times to 1970* (U.S. Bureau of the Census, Washington, D.C.: 1975), part 1, pp. 166–67.

19. On this trend, see, for example, Felix Isman, *Weber and Fields* (New York: Boni and Liveright, 1924), 183. About half or more of the White Rats in 1900 were of Irish background, according to advertisements and business cards listed in Golden, *My Lady Vaudeville.*

20. See *The Daily Graphic,* Nov. 26 (year missing), "Vaudeville and

Variety Miscellaneous" file, Harvard Theatre Collection (HTC).

21. On the predominance of different acts, see Gilbert, *American Vaudeville*, 62; on who performed ethnic comedy, see Paul Antonie Distler, "The Rise and Fall of the Racial Comics in American Vaudeville" (Ph.D. diss., Tulane Univ., May 1963), chaps. 5 and 6.

22. See "The Variety Stage," *Harper's Weekly* 29 (March 1902): 414.

23. Laurence Senelick, "Variety into Vaudeville, the Process Observed in Two Manuscript Gagbooks," *Theatre Survey* 19 (May 1978): 11.

24. On the origins of Irish performers, see Distler, "Rise and Fall," chap. 5, passim, especially 112–13, 117–18, 127–30, and 131–35.

25. On Bevacqua, November 1, 1983, interview; on Cagney, see James Cagney, *Cagney by Cagney* (New York: Doubleday, 1976), 26–27.

26. On Lower East Side street-life and candy stores, see John W. Martin, "Social Life in the Street," *Yearbook of the University Settlement Society of New York, 1899* (New York: The Winthrop Press, 1899), 22–23; and Benjamin Reich, "A New Social Center. The Candy Store as a Social Influence," *Yearbook of the University Settlement Society of New York, 1899*, p. 32. On street-corner dancing in Philadelphia in a slightly later period, see Honi Coles interview with Charlayne Hunter-Gault, *McNeil-Lehrer Newshour*, June 15, 1984.

27. Cantor, *My Life*, 1–5.

28. Ibid., 6–9, 11, 14–17, 19, 21, 40–41, 66–68.

29. Ibid., 34–35, 42–44.

30. Ibid., 23.

31. Ibid., 75–76.

32. Ibid., 77–87; 81–86 recount his first appearance on the "regular stage," which he dates to 1908.

33. Ibid., 87–88, 90–92, 96–103.

34. Ibid., 115–18.

35. Ibid., 118–33, 142, 148–49, 151–58.

36. Robert Lipsyte makes this point with regard to professional sports in his introduction to C. L. R. James, *Beyond a Boundary* (New York: Pantheon, 1983), xi–xii. Also see Royle, "The Vaudeville Theatre," 489. The motto appeared repeatedly throughout 1915 issues of *Billboard*. Otherwise, on this general theme, see Irving Howe, *World of Our Fathers* (New York: Harcourt Brace Jovanovich, 1976), 556–66.

37. See letter from Len Spencer's Lyceum to R. M. Colt, May 20, 1914, vaudeville file, Warshaw Collection, NMAH.

38. See Armstead-Johnson, "Blacks in Vaudeville," 78–79.

39. Glason interview, January 18, 1984; Isman, *Weber and Fields*, 44–45; Cagney, *Cagney by Cagney*, 27–29; on Smith and Dale, see Slide, *The Vaudevillians*, 140–42. Lary May notes how after 1914 the film industry was dominated by Eastern European Jews who seized the opportunities the then-new medium offered. See Lary May, *Screening Out the Past: The Birth of Mass Culture and the Motion Picture Industry* (Chicago: Univ. of Chicago Press, 1983), 169–71.

40. Kate Davy, "An Interview with George Burns," *Educational Theatre Journal* 27 (October 1975): 346.

41. On Cline, see "Cline Rites Planned," *New York Sun*, June 12, 1934, p. 25; on Mary Irish, from questionnaire returned by Mary Irish, 1984; on St. Denis and Tanguay, see Elizabeth Kendall, *Where She Danced* (New York: Alfred A. Knopf, 1979), 38; for the newspaper quote, see clipping, n.p., ca., 1900, "Vaudeville and Variety Miscellaneous" file, HTC.

42. Interview with Frances Poplawski, New York City, January 28, 1984. On the general issue of women's seeking of vaudeville careers for the personal freedom or income that they offered, see Albert Auster, *Actresses and Suffragists: Women in the American Theater, 1890–1920* (New York: Praeger, 1984); 1984 questionnaire completed for author by Mary Irish; author's February 23, 1984 interview in New York City with Ethel Hardey.

43. It is difficult to establish Tucker's history with certainty. She claimed that she was born while her parents were traveling from Russia to the United States. Probably she was born in Poland in 1888, although she later claimed to be born in 1884. See Slide, *The Vaudevillians*, 154–56. On Tucker's age, see obituary, *New York Times*, Feb. 10, 1966, p. 1; also "Sophie Tucker," *Variety*, February 16, 1966, p. 4. Tucker's memoir is vague on whether the establishment was a restaurant or delicatessen, rooming house or hotel, but the basic description of her years there is found in Tucker, *Some of These Days*, 1–7, 10.

44. Tucker, *Some of These Days*, 10–11.

45. Ibid., 10–11.

46. Ibid., 10, 32. Dates in *New York Times* obituary, Feb. 10, 1966, p. 1. On Willie and Eugene Howard and the Empire City Quar-

tette, see Marks, *They All Sang,* 283, 286, and Slide, *The Vaude-villians,* 75–77. On the Von Tilzer brothers, see Kenneth Aaron Kanter, *The Jews on Tin Pan Alley: The Jewish Contribution to American Popular Music, 1830–1940* (New York: Ktav Publishing House, 1982), 17.

47. For the story of Belle Baker, a Jewish singer from the Lower East Side, see *Dramatic Mirror,* n.d., ca. January 1917 and October 1919, and clipping, n.p., ca. 1916, and undated, untitled interview; and Keith program for week of April 12, 1915—all in Baker clipping file, NYPL-LC.

48. Fred Allen *Much Ado About Me* (New York: Little, Brown and Co., 1956), 236–43; also Groucho Marx, *Groucho and Me* (New York: Bernard Geis Associates, 1959), 131; Harry Jolson, as told to Alban Emley, *Mistah Jolson* (Hollywood: House-Warven Publishers, 1952), 167–68; and *Julius Cahn's Official Theatrical Guide* (New York: 1896–1897). The guide, which is in the collection of the New York Public Library at Lincoln Center, went through many name changes. In 1906, it became *Julius Cahn's Official Theatrical Guide Containing Authentic Information of the Theatres and Attractions in the United States, Canada and Mexico;* in 1912 it became *The Cahn-Leighton Official Theatrical Guide;* in 1921 it became *The Julius Cahn–Gus Hill Theatrical Guide and Moving Picture Directory,* and was then absorbed into *Gus Hill's National Theatrical Directory.*

49. George Burns, with Cynthia Hobart Lindsay, *I Love Her, That's Why!* (New York: Simon and Schuster, 1955), 55.

50. Marx, *Groucho and Me,* 131. Also see DiMeglio, *Vaudeville U.S.A.,* 110; Kimball and Bolcom, *Reminiscing with Sissle and Blake,* 80–81; and Hardey interview.

51. Spitzer, "The People of Vaudeville," 64.

52. Interview with Saun and Berk, *Birmingham News,* May 27, 1926, p. 10; also, interview with Capitola DeWolfe, New York City, January 23, 1984.

53. On the colonies in general and LIGHTS, see Toll, *On With the Show,* 275; on Freeport, see Tucker, *Some of These Days,* 166; Smith, *The Vaudevillians,* 13; on Bensonhurst, see undated clipping, probably 1906, Tony Pastor file, NYPL-LC.

54. See newspaper clipping, n.d., n.p., ca. 1900, in the Harvard Theatre Collection vaudeville clipping file.

55. Ibid.

56. Ibid.
57. On vaudevillians' hangouts, see Marian Spitzer, *The Palace* (New York: Atheneum, 1969), 91. The Somerset was later renamed Gus and Andy's. On the Palace sidewalk as "Panic Beach," see Cagney, *Cagney by Cagney*, 29; the quote, and more information on the Times Square neighborhood, came from an anonymous letter to the author from a vaudevillian born in 1912; Weinstein questionnaire. Additional reminiscences on the Times Square area from interview with Harry Stanley, Feburary 7, 1984; interview with Ethel Hardey, February 23, 1984; and interview with Hal Leroy, February 22, 1984.
58. Spitzer, "The People of Vaudeville," 15.
59. George Jessel, *So Help Me: The Autobiography of George Jessel* (New York: Random House, 1943), 25; Tucker, *Some of These Days*, 27–28; Cagney, *Cagney by Cagney*, 27. In a similar vein, see Allen, *Much Ado About Me*, 101–2.
60. Allen, *Much Ado About Me*, 248; Glason interview; Spitzer, "The People of Vaudeville," 64; Brett Page, *Writing for Vaudeville* (Springfield, Mass.: 1915), 93–95; and George Jean Nathan, *The Popular Theatre* (New York: Alfred A. Knopf, 1918), 212–13. Interview with Hal Leroy, February 22, 1984. For the letter exchange, see Nathan, *The Popular Theatre*, 212–13.
61. On the contrast between big-time and small-time conditions, see "The Facts of Vaudeville," *Equity* 9 (March 1924): 18.
62. See Glason in Smith, *The Vaudevillians*, 34; also see Allen, *Much Ado About Me*, 213, 256–57; Nathan, *The Popular Theatre*, 203–4; Cantor, *My Life*, 112–13, 158; Tucker, *Some of These Days*, 35, 38, 131; Smith, *The Vaudevillians*, 8–10; Will Ahern interview, ibid., 53; author's interview with Ted Arnow in New York City, December 6, 1983; Spitzer, "The People of Vaudeville," 64; Marks, *They All Sang*, 10; "Vaudeville Was Elite—and in Brooklyn," *New York Herald Tribune*, May 29, 1949, sec. 5, p. 3; Leroy interview; the Osk questionnaire.
63. Interview with Mike Ross, New York City, December 19, 1983.

CHAPTER 4

1. On these exhibits, see Eaton, "Wizards of Vaudeville," 44.
2. Marx, *Groucho and Me*, 181.
3. For the number of circuits, see Bernheim, "The Facts of Vaude-

ville," *Equity* 8 (November 1923): 39. On the effects of corporate
capitalism on American culture, see Alan Trachtenberg, *The In-
corporation of America: Culture and Society in the Gilded Age*
(New York: Hill and Wang, 1982), 3–5, 7–8; for the Leavitt
quote, see Leavitt, *Fifty Years in Theatrical Management*, 190;
on the significance of booking in controlling vaudeville, see
Grau, *Business Man in the Amusement World*, 1–2; Davis, "The
Business Side of Vaudeville," passim; and Bernheim, "The Facts
of Vaudeville," *Equity* (September 1923): 9–10 and 32; and Charles
Grapewine, FTC 128, October 14, 1919, box 72, p. 2550.

4. Spitzer, "The Business of Vaudeville," 18–19.
5. Spitzer, "The Business of Vaudeville," 18; Bernheim, "The Facts
of Vaudeville," *Equity* (December 1923): 20, 34; Billy Glason in
Smith, *The Vaudevillians*, 34; also Smith, "In Vaudeville," 138.
6. Spitzer, "The Business of Vaudeville," 18–19.
7. For a description of the office, see Spitzer, "The Business of Vaude-
ville," 19. On drawing up the shows, see Pat Casey, FTC 128,
February 4, 1919, box 70, p. 181; Maurice Goodman, FTC 128,
February 17, 1920, box 72, p. 3358.
8. On the importance of the order of the show, see Samuel Hodgdon
entry, report book for September 21, 1903 to March 17, 1904,
p. 74, Keith/Albee Collection. For elaboration on this point, see
the words of George Gottlieb, who booked shows for the Palace,
in Page, *Writing for Vaudeville* 7–10.
9. See Gottlieb in Page, *Writing for Vaudeville*, 7–8.
10. Ibid.
11. Ibid., 8.
12. Ibid.
13. Ibid.
14. Ibid., 9.
15. Ibid.
16. Ibid., 9–10.
17. Ibid.
18. For the evaluation of Bessie Wynne, see report book 6, p. 169,
Keith/Albee Collection. For similar entries gauging the popu-
larity of an act with a particular audience, see entry from Charles
Barnes on a February 4, 1907, show in Philadelphia, report book
6, p. 4; entry on the December 25, 1905, show at Keith's Union
Square, report book 4, p. 134; entry on a December 3, 1906, show
in Cleveland, report book 5, p. 185; and entries on two shows in

Union Hill, New Jersey: an April 4, 1910, show, report book 10, p. 200, and a December 12, 1910, show, report book 11, p. 166. All report books in the Keith/Albee Collection.

19. Spitzer, "The Business of Vaudeville," 19; also Casey, FTC 128, February 4, 1919, box 70, p. 172. For the "panic" quote, see Smith, "In Vaudeville," 138.

20. On signing with each theatre, see Spitzer, "The Business of Vaudeville," 19. On salary fixing, see Bernheim, "The Facts of Vaudeville," *Equity* 8 (December 1923): 34–35; also the testimony of John A. Collins, Max Hart vs. B. F. Keith Vaudeville Exchange, et al., Federal Court, Southern District, New York, January 4, 1926, pp. 264, 270, 273, 277.

21. On the blacklist, see "More Blacklisting," *The Player,* April 15, 1910, p. 1; "Albee and Blacklist to Go," *The Player,* April 8, 1910, p. 1; "Joe Woods Blacklisted," *The Player,* December 7, 1909, p. 1; and "Artist Cancelled Because Name Is on Blacklist," *The Player,* January 13, 1911, p. 1, and "Blacklist Abolished," *The Player,* March 17, 1911, p. 1. On pressuring acts, see Bernheim, "The Facts of Vaudeville," *Equity* 9 (March 1924): 20.

22. On the number of acts booked by the Keith exchange, see Samuel Hodgdon, FTC 128, February 6, 1919, box 71, p. 604.

23. FTC 128, exhibit 130, received November 5, 1919, box 73.

24. On these points, see Spitzer, "The Business of Vaudeville," 129; on the U.B.O. rationale for its deductions, see Casey, FTC 128, February 3, 1919, box 70, pp. 71–72, 421.

25. See contract of August 27, 1909, signed through United Booking Offices between Fonda, Johnstown and Gloversville Railroad Company, and Jordan, Braubeck and Chilita in vaudeville file, Warshaw Collection, box 14, "theatre: agents/booking" folder.

26. See February 1 Jule Delmar letter, Warshaw Collection, box 14, "vaudeville booking agents: K-11" folder. For an example of a cancellation and its consequences, see May 4, 1903, report from Keith's Boston theatre by M. J. Keating, n.d., unnumbered, report book, p. 258, Keith/Albee Collection.

27. Report from Keith's Union Square Theatre, week of August 12, 1907, report book 6, p. 199, Keith/Albee Collection.

28. Davis, "The Business Side of Vaudeville," 530; also see list of Keith theatre bills nationwide for the week of January 28, 1919, FTC 128-2, exhibits file, box 73.

29. Report from Carl D. Lothrop, Keith's Boston, week of May 17, 1909, report book 9, p. 140, Keith/Albee Collection.

30. On booking office records of censorship, see Sophie Tucker, *Some of These Days*, 149; Spitzer, "Morals in the Two-a-Day," 38; and Spitzer, "The Business of Vaudeville," 133. On censorship directed from the central office, see clipping, n.p., April 28, 1919, NYPL-LC, "No Jibes at 'Y' Allowed on Keith Circuit," and *Toledo Blade*, Aug. 18, 1922, "Keith Artists Ordered to Eliminate References to Prohibition," both in the Keith clipping file, NYPL-LC.

31. See Nellie Revell, "News and Gossip of the Vaudeville World," *The New York Morning Telegraph*, Oct. 24, 1915, sec. 4, p. 2.

32. "An Old Timer," FTC 128, August 16, 1918, file 128-A-14, box 73.

33. See Bernard A. Myers' testimony, FTC, 128, February 16, 1919, box 71, pp. 492–96.

34. On the dealings surrounding the Palace opening, see Spitzer, *The Palace*, 12–13; and Abel Green and Joe Laurie, *Show Biz: From Vaude to Video* (New York: Henry Holt and Co., 1951), 85–86. On the use of booking restrictions and the opening of the Riverside theatre at 96th Street and Broadway, see plaintiff's exhibit 63B, Hart vs. B. F. Keith Vaudeville Exchange, et al., January 24, 1926, p. 1140. On the Keith organization's acknowledgment of its ability to control theatres' access to performers, see Jule Delmar letter, Warshaw Collection; also see "The Facts of Vaudeville," *Equity* (September 1923): 35.

35. See "The Facts of Vaudeville," *Equity* (September 1923): 35; also Spitzer, *The Palace*, 13; and Green and Laurie, *Show Biz*, 85–86.

36. "The Facts of Vaudeville," *Equity* (September 1923): 11.

37. For examples of the Rats' organizing actions, see advertisement for a "theatrical masque," *The Player*, December 24, 1909, p. 17; and an advertisement for the Rats' third annual ball, *The Player*, March 4, 1910, p. 3.

38. On the bill, see Bernheim, "The Facts of Vaudeville," *Equity* (September 1923): 11. On consolidation, see "Actors Union and White Rats of America Consolidate," *The Player*, November 11, 1910, p. 1; "White Rats' Actors' Union Receives Charter," *The Player*, December 23, 1910, p. 3; and Bernheim, "The Facts of Vaudeville," *Equity* (September 1923): 11.

39. On *The Player* and its motto, see *The Player*, December 10, 1909,

to November 21, 1913. On the demise of *The Player* and the
shift to *Variety*, see "'The Player's Swan Song," *The Player*,
November 21, 1913, pp. 12–13. Later issues of *The Player*, avail-
able at the New York Public Library-Lincoln Center Billy Rose
Theatre Collection, indicate that the publication was revived in
1916 and 1917, during the second White Rats' strike. See *The
Player*, December 22, 1916–April 13, 1917. On the circuit and
clubhouse, see Joe Laurie, *Vaudeville: From the Honky-tonks to
the Palace* (1953; reprint, Port Washington, N.Y.: Kennikat,
1972), 312–13. On strike aid, see "Rats to Aid Strikers," *The
Player*, March 25, 1910, p. 1; also "White Rats to Aid Actors'
Fund," *The Player*, April 15, 1910, p. 5. On the 1911 strike
threat, see Maurice Goodman, FTC 128, February 17, 1920, box
72, pp. 3401–5.

40. On whites-only membership for men and women, with separate
branches for Japanese and Hawaiians, see "Ninety Days' Notice,"
The Player, March 17, 1911, p. 5. For the whites-only notice, see
Variety, December 26, 1913, p. 40. On women in the Rats and the
Associated Actresses of America, see "A Woman's View," *The
Player*, April 22, 1910, p. 22; also "The Associated Actresses of
America and Some of Its Advantages," *The Player*, September
6, 1910, p. 7.

41. On the internal disputes, see *Billboard*, October 23, 1915, pp. 3,
15; and November 6, 1915, p. 3.

42. Bernheim, "The Facts of Vaudeville," *Equity* (September 1923):
11; also Casey, FTC 128, February 5, 1919, box 71, pp. 257–58.

43. Laurie, *Vaudeville*, 313.

44. On blacklisting, which was invoked both to prevent actors from
unionizing and to prevent them from playing for circuits com-
peting with Keith-Albee, see Casey, FTC 128, February 3, 1919,
testimony, box 70, pp. 115–21; John Walsh, FTC 128, February
16, 1920, box 72, p. 3337; and Martin W. Littleton, in Max Hart
vs. B. F. Keith et al., U.S. District Court, Southern District of
New York, January 24, 1924, pp. 47–49; on the founding of the
Vaudeville Managers' Protective Association, see Goodman, FTC
128, February 17, 1920, box 72, pp. 3401–5; on the founding of
the National Vaudeville Artists, see Spitzer, "The Business of
Vaudeville," 130.

45. On the V.M.P.A., see Goodman, FTC 128, February 17, 1920,
box 72, pp. 3401–5, 3419. On dues and the strike levy, see Casey,

FTC 128, February 5, 1919, box 71, pp. 367–69; also Morris Slotkin, FTC 128, February 5, 1919, box 71, pp. 331–33. On spying, see Casey, FTC 128, February 5, 1919, box 71, pp. 271–72, 367–68.

46. Bernheim, "The Facts of Vaudeville," *Equity* (September 1923), 11.

47. Exhibit 10, FTC 128, February 3, 1919, box 70, pp. 65–66.

48. Laurie, *Vaudeville*, 313.

49. Casey, FTC 128, February 3, 1919, box 70, pp. 42–46, 56–57.

50. Goodman, FTC 128, February 17, 1920, box 72, pp. 3409–10. For "An Old Timer," FTC 128, File 128-A-14, box 73.

51. *Variety*, November 10, 1916, p. 14.

52. On losses, see Casey, FTC 128, February 5, 1919, box 71, pp. 271–72. On the blacklist, see Casey, FTC, 128, February 3, 1919, box 70, pp. 42–46, 56–57.

53. On managers' losses and the end of the strike, see Casey, FTC 128, February 5, 1919, box 71, pp. 274–5. The date of when the Rats gave up their charter is unclear. The year is 1934 in Laurie, *Vaudeville*, 316, but it is 1930 in Green and Laurie, *Show Biz*, 374. On the Rats' decline, see Bernheim, "The Facts of Vaudeville," *Equity* (September 1923): 11.

54. Letter from Edward F. Albee, November 18, 1921, Plaintiff's Exhibit 31, Max Hart vs. B. F. Keith Vaudeville Exchange, et al., 1111.

55. Laurie, *Vaudeville*, 315; also "The Facts of Vaudeville," *Equity* (March 1924): 19–20.

56. For an example of the continuation of restrictive contracts, see a Loew contract dated September 9, 1919, read by John Walsh, FTC 128, October 14, 1919, box 72, p. 2521. On the N.V.A., see application for membership in the National Vaudeville Artists, Inc., filed by Jean Russell, August 8, 1922, box 14, "vaudeville booking agents: N-W" folder, Warshaw Collection. On the pressuring of artists even after the clause inquiring about their standing in the N.V.A. was dropped from contracts, see "The Facts of Vaudeville," *Equity* (March 1924): 20.

57. "The Facts of Vaudeville," *Equity* (March 1924): 37.

58. Ibid.

59. "The Facts of Vaudeville," *Equity* 8 (November, 1923): 33–40. On the findings of the Federal Trade Commission, see resolution of case 128 in *Federal Trade Commission Decisions: Findings*

and Orders of the Federal Trade Commission, July 1, 1919, to June 30, 1920, vol. II (Washington, D.C.: Government Printing Office, 1920), 464.

CHAPTER 5

1. My thoughts on the configuration of vaudeville have been influenced by Robert E. Park and Ernest W. Burgess, *The City,* (Chicago: Univ. of Chicago Press, 1925; reprint, 1968), and the introduction to that volume by Morris Janowitz, viii–ix.

2. See *Vaudeville,* published by the American Vaudeville Circuit, n.d., box 14, "American Vaudeville Circuit" folder, Warshaw Collection.

3. On segregation in New York vaudeville houses, see DiMeglio, *Vaudeville U.S.A.,* 116–17; and Armstead-Johnson, "Blacks in Vaudeville," 85. In my interviews and correspondence with those who remember New York vaudeville, I always asked my sources if they remembered the presence of blacks in vaudeville houses, and if so, in what numbers. All agreed that blacks were either absent or a minuscule portion of the audience.

4. For discussions of these distinctions, see John Walsh, FTC 128, box 72, February 16, 1920, p. 3246; also Hodgdon, FTC 128, box 71, February 6, 1919, pp. 570, 574; FTC 128, February 3, 1919, box 70, pp. 72–74; FTC 128, Goodman, February 17, 1920, box 72, pp. 3380–81; also statistics in Michael M. Davis, Jr., *The Exploitation of Pleasure: A Study of Commercial Recreation in New York City* (New York: Russell Sage Foundation, 1911), 25, 26, 30.

5. Nellie Revell, "News and Gossip of the Vaudeville World," *Morning Telegraph,* June 6, 1915, Section 4, p. 2.

6. On the movement of Tin Pan Alley, see Isaac Goldberg, *Tin Pan Alley* (New York: Frederick Ungar Publishing Co., 1961), 108, 111; also Robert Baral, *Turn West on 23rd: A Toast to New York's Old Chelsea* (New York: Fleet Publishing Corp., 1965), 38–39.

7. On the vice district's movement, see Erenberg, *Steppin' Out,* 21; on the Tenderloin in the 1890s, see Marks, *They All Sang,* 294–311.

8. This description generally corresponds to the trend noted in

Henderson, *The City and the Theatre*, 49. On Proctor's slogan, see William Moulton Marston and John Henry Feller, *F. F. Proctor: Vaudeville Pioneer* (New York: Richard R. Smith, 1943), 50.

9. The quote is taken from an article, not on Times Square, but on general theatre trends. See Revell, "News and Gossip of the Vaudeville World," 2.

10. Edward Renton, *The Vaudeville Theatre; Building, Operation, Management* (New York: Gotham Press, 1918), 12–14; also "Keith Building Theatres," *The Billboard*, June 26, 1915, p. 6; also a notice on the opening of a Keith theatre in a "thickly populated district" at Church and Flatbush avenues, *The Billboard*, September 8, 1915, p. 6.

11. Henderson, *The City and the Theatre*, 49.

12. On Hammerstein's role in developing Times Square and the Olympia, see William Morrison, "Oscar Hammerstein I: The Man Who Invented Times Square," *Marquee* 15 (first quarter, 1983): 7–9. On the interiors and decor, see William Harvey Birkmire, *The Planning and Construction of American Theatres* (New York: John Wiley and Sons, 1896), 41–46.

13. See Morrison, "Oscar Hammerstein I," 7–9.

14. On the subway and the development of Times Square as a theatre district, see Brian J. Cudahy, *Under the Sidewalks of New York: The Story of the Greatest Subway System in the World* (Brattleboro, Vt.: The Stephen Greene Press, 1979), 14. On the square as a center of theatre and entertainment, see Stephen Jenkins, *The Greatest Street in the World: The Story of Broadway, Old and New, from the Bowling Green to Albany* (New York: G. P. Putnam's Sons, 1911), 256, 270.

15. Jenkins, *Greatest Street*, 256, 262.

16. On marquees, see Renton, *Vaudeville Theatre*, 51.

17. Birkmire, *Planning and Construction of American Theatres*, 16–19, 32–37, 41–46. The description of the Palace is derived from a photograph in a scrapbook of the Robinson Locke Collection, NYPL-LC, ser. 2, vol. 262, p. 162.

18. On seating, see *The Cahn-Leighton Official Theatrical Guide* (New York: 1913–1914), 433–447; on the Palace and the Hippodrome, see *Theatre and Hotel Directory of the Keith's-Albee Circuit* (Asbury Park, New Jersey: R. H. Bowers, 1925), 57; on

the Paradise, which was remodeled for 4,000 seats, see Michael R. Miller, "Theatres of the Bronx," *Marquee* 4 (Fall 1972), reprinted by the Bronx Historical Society, 5.

19. Renton, *Vaudeville Theatre*, 116.

20. See "Palace $2 Vaudeville a Joke; Double-Crossing Boomerang," *Variety*, March 28, 1913, p. 5. On Bernhardt and the early days of the Palace, see Green and Laurie, *Show Biz*, 29; also Spitzer, *The Palace*, 18–19.

21. Norman Hapgood, "The Life of a Vaudeville Artiste," *Cosmopolitan* 30 (February 1901): 396. Mention of the character of individual theatres' audiences can be found in the Keith/Albee report books. See notation for Keith's Union Square theatre on how the house attracted to its April 6, 1906, show a more aristocratic audience than in many seasons—report book 4, p. 25; also see mention of a holiday audience of confused suburbanites at Keith's Union Square February 23, 1903, in undated report book, 190. All from Keith/Albee Collection.

22. "Music Hall Audiences," *Variety*, December 25, 1914, p. 44.

23. Marks, *They All Sang*, 149.

24. Green and Laurie, *Show Biz*, 22–23.

25. Ibid., 18, 20, 22.

26. Ibid., 17–20, 155. The Cherry Sisters, who hailed from an Iowa farm family, are said to have thought that the missiles were directed at them out of jealousy. See Avery Hales' article in *Coronet* (September 1944): 92–96, reprinted in Anthony Slide, ed., *Selected Vaudeville Criticism* (Metuchen, N.J.: 1988), 45–50, especially 47–48. Also see their history in Slide, *The Vaudevillians*, 25.

27. Spitzer, *The Palace*, 131.

28. Eaton, "Wizards of Vaudeville," 48.

29. My thinking on this point is influenced by Park and Burgess, *The City*, 150–151. On the Riverside audience, see *Variety* clipping, ca. 1918, "New Acts 4" book, Keith/Albee Collection.

30. Birkmire, *Planning and Construction of American Theatres*, 32.

31. "For New Theatre," *The Staten Islander*, October 7, 1911, p. 1.

32. On the density and diversity of downtown Brooklyn at the turn of the century, see Brooklyn (formerly Long Island) Historical Society photographs taken between the 1890s and 1908. On the status of the Orpheum, see "Vaudeville Was Elite—And in Brooklyn," *New York Herald Tribune*, May 29, 1949, sec. 5, p. 3; "Orpheum Once Was Citadel of Vaudeville's Top Stars," *New York*

World-Telegram and the Sun, Brooklyn section, April 7, 1956, page 2B; also "Boro Man, 73, Tears Tickets As Orpheum Theatre Closes," *Brooklyn Eagle,* Dec. 8, 1953, p. 7. On the Williams theatres, see 1911 Orpheum program, NYPL-LC. In 1911, Williams had nine theatres in New York City: two in Manhattan, one in the Bronx, and six in Brooklyn.

33. On the purchase of the Orpheum, see the Percy Williams obituary, *Variety,* July 26, 1923, p. 33; on the refurbishing of the theatre, see "Keith's New Orpheum Pride of Brooklyn," *Billboard,* September 4, 1915, p. 6.

34. See John McNamara, "The Bronx in History," *Bronx Press Review,* April 5, 1962; also Miller, "The Theatres of the Bronx," 7.

35. On Bronx population growth, see Ira Rosenwaike, *Population History of New York City* (Syracuse: Syracuse Univ. Press, 1972), 133. On the boom that resulted from the subway, see Jenkins, *The Story of the Bronx,* 10; on subway construction, see Cudahy, *Under the Sidewalks of New York,* 34.

36. On the Metropolis and the Bronx Opera House, see Miller, "Theatres of the Bronx," 7; on the class aspect, see the Metropolis report in the Bronx Historical Societly theatre file.

37. On the early days of The Hub, see Harry T. Cook, *The Borough of the Bronx* (New York: self-published, 1913), 36; on The Hub's continuing status as a shopping district in the 1920s and 1930s, see Lloyd Ultan, in collaboration with the Bronx County Historical Society, *The Beautiful Bronx* (New Rochelle, N.Y.: Arlington House, 1979), 39; also see "Bronx Adds a House," *The Player,* December 11, 1909, p. 1, which noted that a vaudeville house, apparently Keith's Bronx, had been opened on Bergen Avenue opposite the Adams-Flanagan Co. department store. Also Joseph G. Herzberg, "The Bronx Had Everything, Including Own Shows," *New York Times,* Sept. 4, 1972, p. 17.

38. Miller, "Theatres of the Bronx," 8; information on the National in theatre file, Bronx Historical Society.

39. "Bronx Theaters" pamphlet in theatre file, Bronx Historical Society. Also Miller, "Theatres of the Bronx," 8.

40. On the small time and the Common People, see Charlotte C. Rowett, "Smalltime in Vaudeville," *The Green Book Album* 4 (September 1910): 546.

41. Information on the Jefferson from interview with Jack Robinson, Harrington Park, N.J., October 1983. Also see Jack Robin-

son, "A Glance Backwards," *Marquee* 13 (third quarter, 1981): passim. For Hartley's observations on vaudeville, see Marsden Hartley, *Adventures in the Arts: Informal Chapters on Painters, Vaudeville and Poets* (New York: Boni and Liveright, 1921; reprint, New York: Hacker Art Books, 1972), 162–63.

42. Williams, "Real Napoleon of the Movies," 66–67; and Arthur Prill, "The 'Small-Time' King," *Theatre Magazine,* 19 (March 1914), also in New York Public Library–Lincoln Center Robinson Locke Scrapbook Collection, ser. 2, vol. 270, pp. 63–65. For the Allen quote, see Allen, *Much Ado About Me,* 216.

43. Alexander Woollcott, "The Life of Marcus Loew," Hearst's *International,* September, October, and November 1926, reprinted in *Variety,* October 19, 1927, p. 8; also Donald King, "Marcus Loew, the Henry Ford of Show Business" *Marquee* 17 (third quarter, 1985): 3–4.

44. On prices, see Prill, "The 'Small-Time' King," 63. On the number of theatres, see Williams, "Napoleon of the Movies," Robinson Locke scrapbook, ser. 2, vol. 270, pp. 63–67.

45. Williams, "Napoleon of the Movies," and Woollcott, "Life of Marcus Loew," 6, 8. Also Prill, "The 'Small-Time' King," 64–65. There were a few exceptions to this policy, but overall, not many. The comparison to Henry Ford is from Green and Laurie, *Show Biz,* 162.

46. Prill, "The 'Small-Time' King." For the guide, see *The Cahn-Leighton Official Theatrical Guide,* 421.

47. Prill, "The 'Small-Time' King."

48. Eaton, "Wizards of Vaudeville," 48.

49. Eaton, "Wizards of Vaudeville," 48.

50. "Corona's New Theatre," *Newtown Register,* Jan. 5, 1911, p. 1.

51. "Halsey," *Variety,* December 27, 1912, p. 18.

52. Interview with Harold Applebaum, New York City, January 18, 1984; also Klein interview. Bill Smith, "Vaudeville: Entertainment of the Masses," 110–11; interview with Jack Gross, New York City, December 1983; Osk questionnaire; Harold Weintraub's questionnaire, summer of 1984; Norman Steinberg interview, New York City, December 7, 1983; and an anonymous 1984 letter from a Brooklyn man who recalls that when he was a child around 1908, mothers left their children at Keeney's vaudeville house while they went shopping.

53. See "Loew's Beauty Contest," *Variety,* June 4, 1915, p. 5. On

contests and promotions, see "Bronx Rivalry," *Variety*, July 30, 1915, p. 5. On the events at the Corona theatre, see *Newtown Register*, Jan. 5, 1911, p. 5; also see *Newtown Register*, "Hyperion Theatre," Feb. 2, 1911, p. 5. Keith's Riverside on 96th Street in Manhattan held a toy give-away at its September 13, 1924, show. B. F. Keith's Riverside Theatre *News* 2, September 28, 1924. On the Fogarty celebration, see *Variety*, "Prospect," February 20, 1915, p 19.

54. See George Jessel, *So Help Me*, 10; and Tucker, *Some of These Days*, 257. On the Tsardine, see Nathan, *The Popular Theatre*, 208–209.

55. The hook being used only at amateur nights—from Engel, Steinberg, Weinstein, and Joyce W. Zuk questionnaires, February 1984. On the atmosphere of amateur nights, see Tucker, *Some of These Days*, 33.

56. Cantor, *My Life*, 79–80, 82, 85–86.

57. Samuel Komansky, *Daily News*, Sept. 5, 1963, Brooklyn Historical Society clipping files, vol. 145, p. 55.

58. Information about restrained conduct in vaudeville theatres from Gross interview; questionnaire from Florence Sinow, 1984; interview with Murray Schwartz, New York City, January 11, 1984; questionnaire from Lewis Kornbluth, 1984; interview with Margaret Brown, New York City, December 1983; DeWolfe interview; and Weintraub and Osk questionnaires. On similar developments in the legitimate theatre, see McArthur, *Actors and American Culture*, 91.

59. On Brooklyn seaside vaudeville, see "Old Coney's Vaudeville Recalled by New Film," *Brooklyn Eagle*, June 13, 1943, p. 7; on the New Brighton Theater, see "Opening of New Brighton," *The Brooklyn Daily Eagle*, May 8, 1910, p. 8.

60. On the general history of North Beach, see Vincent Seyfried, *Queens: A Pictorial History* (Norfolk, Va.: The Donning Co., 1982), 220–23. Also "North Beach: The Rise and Decline of a Working Class Resort," exhibit brochure, Queens Historical Society, 1986.

61. On transportation and North Beach, see Seyfried, *Queens*, 220–23. Also see the following in the *Newtown Register*, all in the North Beach vertical file, Queens Borough Public Library: advertisement, "all trolleys direct or transfer," July 23, 1914, p. 2; on the promise of big-time acts, "Amusements Galore at North

Beach," August 19, 1915, p. 1; "Cool Breezes at North Beach,"
August 4, 1910, p. 5; "Free Vaudeville at North Beach," July 1,
1909, p. 5; "North Beach in Midsummer Attire," August 20,
1914, p. 5.

62. On attempts to attract women and children, see, in the *Newtown Register*, "North Beach a Recreation Paradise," July 14, 1910, p. 8; "North Beach Carnival," August 15, 1915, p. 4. Also in the North Beach vertical file are a note on the use of police to keep order in "A Day's Outing at Bowery Bay Beach," p. 8; and a letter by George Reichold from the December 4, 1969, *New York Daily News* mentioning bouncers at North Beach; also see Seyfried, *Queens*, 220–23; and "North Beach: The Rise and Decline of a Working Class Resort."

63. Henry G. Steinmeyer, "South Beach: The Resort Era," *The Staten Island Historian* 19 (July–September 1958): 18.

64. Steinmeyer, "South Beach," 18.

65. Ibid., 19–20.

66. Ibid.

CHAPTER 6

1. Mary Cass Canfield, "The Great American Art," *New Republic* 32 (November 22, 1922): 335.

2. The passage of time and the lack of comprehensive historical sources make it very difficult to identify the vaudeville audience that both shaped and was created by vaudeville. The ethnic composition of the audience was almost certainly influenced by the great immigrant presence in New York. In vaudeville's biggest years, from 1890–1920, more than three quarters of New York City's population were immigrants and their children. See Niles Carpenter, *Immigrants and Their Children: 1920*, Census Monograph VIII (Washington, D.C.: Government Printing Office, 1927), 27. According to Carpenter's statistics, "foreign white stock," defined as foreign-born whites and native-born whites of foreign or mixed parentage, comprised 77.2% of the city's population in 1890, 76.6% in 1900, 78.6% in 1910, and 76.4% in 1920. Immigrants and their children established an important presence in vaudeville as entrepreneurs, performers, and audiences. See Frederick Edward Snyder, "American Vaudeville—Theatre in a Package: The Origins of Mass Entertain-

ment," (Ph.D. diss., Yale Univ. 1970), 61; and Francis G. Cou-
vares, "Triumph of Commerce," in Michael H. Frisch and
Daniel J. Walkowitz, eds., *Working-Class America: Essays on
Labor, Community, and American Society* (Urbana, Ill.: Univ.
of Illinois Press, 1983), 147.

The only known contemporary social and statistical study of
New York vaudeville is that of Michael M. Davis, Jr.'s *The
Exploitation of Pleasure: A Study of Commercial Recreations in
New York City* (New York: Russell Sage Foundation, 1911).
Davis's work has its flaws. His social categories and terms—like
"clerical" class—are vague. His use of aggregate data blurs the
distinctions between particular theatres and their audiences.
There is no way to check his methodology. However, his study
is the only study of the sociology of the early twentieth-century
theatre audience in New York City. Despite its flaws, it merits
examination and provisional conclusions.

According to Davis, the average vaudeville audience was 64%
male and 36% female. Slightly less than a fifth of the men and
women were youths under 18; the rest were older. 60% of the
audience was "working" class, 36% "clerical" class, and 4% "va-
grant," "gamin," or "leisured." In comparison, the legitimate
theatre audience was only 2% working class, and movies were
72% working class. See Davis, *The Exploitation of Pleasure*, 30.

3. This point follows the argument in Kasson, *Amusing the Mil-
lion*, 108.

4. Stuart Hall, "Notes on Deconstructing 'the Popular'," in Samuel,
ed., *People's History and Socialist Theory*, 232. On these points
in general, see Christopher Lasch, "Mass Culture Reconsidered,"
Democracy 1 (October 1981): 11. For an assessment of this point
with regard to advertising, see T. J. Jackson Lears, "Some Ver-
sions of Fantasy: Towards a Cultural History of American Ad-
vertising, 1880–1930," *Perspectives* 9, ed. Jack Salzman (New
York: Cambridge Univ. Press, 1984): 355. Also Tim Patterson,
"Notes on the Historical Application of Marxist Cultural His-
tory," *Science and Society* 39 (Fall 1975): 289.

5. This analysis is influenced by the points made on city culture
and politics in Ira Katznelson, *City Trenches: Urban Politics
and the Patterning of Class in the United States* (Chicago: Univ.
of Chicago Press, 1982). On vaudeville and mass culture under-
cutting ethnic and working class culture, see Kathy Peiss, " 'Char-

ity Girls' and City Pleasures," in *Powers of Desire: The Politics of Sexuality*, ed. Ann Snitow, Christine Stansell, Sharon Thompson (New York: New Feminist Library, Monthly Review Press, 1983), 75–76; Neil Harris, "Four Stages of Cultural Growth: The American City," in Arthur Mann, Neil Harris, and Sam Bass Warner, Jr., *History and the Role of the City in American Life: Indiana Historical Society Lectures 1971–1972* (Indianapolis: Indiana Historical Society, 1972), 44; Oscar Handlin, "Comments on Mass and Popular Culture," in *Culture for the Millions? Mass Media in Modern Society*, ed. Norman Jacobs (Princeton: D. Van Nostrand Co., 1961), 70; and Rosenzweig, *Eight Hours*, 172.

6. See Jessel interview in Smith, *The Vaudevillians*, 29.

7. On vaudevillians attempting to make it to the big time, see Allen, *Much Ado About Me*, 256–57; Nathan, *The Popular Theatre*, 203–4; Cantor, *My Life Is in Your Hands*, 112–13, 158; Tucker, *Some of These Days*, 35, 38; see Smith, *The Vaudevillians*, pp. 8–10, 34, 53. On the importance of the Palace or equivalent big-time theatres: Allen, *Much Ado About Me*, 213; interview with Ted Arnow, New York City, Dec 6, 1983; Spitzer, "The People of Vaudeville," 64; Marks, *They All Sang*, 10; Tucker, *Some of These Days*, 131; "Vaudeville Was Elite—and in Brooklyn," *New York Herald Tribune*, May 29, 1949, sec. 5, p. 3.

8. Spitzer, "The People of Vaudeville," 6.

9. On an act receiving a good reception in all parts of the house, see review of Vesta Victoria's appearance in Philadelphia, April 22, 1907, in report book 6, p. 102; on acts receiving good receptions in only part of the house, see review of the "Watermelon Trust," June 29, 1903, undated report book, p. 282; and a review of an "all women headliners" show of January 29, 1912, in report book 13, p. 61. All report books from Keith/Albee Collection.

10. On the direct and immediate appeal to the audience that was the basis of vaudeville, burlesque, minstrelsy, the circus, and the works of Harrigan and Hart, see Garff B. Wilson, *A History of American Acting* (Bloomington, Ind.: Indiana University Press, 1966), 179–84. For Sophie Tucker's observation that vaudevillians played directly to the audience, unlike performers in the legitimate theatre, see "Those Early Days in Vaudeville Taught Sophie Tucker How to Count," *New York Herald Tribune*, April 9,

1939, sec. 6, p. 10. For a magazine writer's discussion of the importance of brevity and playing to the audience in vaudeville, see Harvey Denton, "The Technique of Vaudeville," *The Green Book Album* 1 (May, 1909): 1068–74, passim.

11. See August 9, 1910, report to Frank Melville, Vaudeville Agent, and similar reports—not all negative—from both the Melville and the Consolidated Booking Agencies, in vaudeville file, box 14, "vaudeville agents: Frank Melville" folder, Warshaw Collection.

12. On rapport, see Smith, *The Vaudevillians*, 8–9, 73. On the importance of originality, see Caroline Caffin, *Vaudeville* (New York: Mitchell Kennerly, 1914), 216–17; also Tucker, *Some of These Days*, 388. For additional praise for the abilities of vaudeville performers, see Cagney, *Cagney by Cagney*, 30–31; and Ethel Barrymore, *Memories* (New York: Harper and Brothers, 1955), 177. Playing to the audience, from Honi Coles interview; for illustrations of playing to the audience, see videotape of a reconstructed vaudeville show at the National Museum of American History (NMAH), Smithsonian Institution, January 27, 1979; also see a videotape of similar performance qualities in Honi Coles, recorded in "A Place to Be Somebody," a show on black vaudeville, recorded at the NMAH, January 15, 1981. The Barrymore quote is from Ethel Barrymore, *Memories*, 177.

13. Cagney, *Cagney by Cagney*, 31.

14. From Glason interview.

15. Caffin, *Vaudeville*, 26–27.

16. Cantor, *My Life*, 76.

17. On Rosenblatt, see Dr. Samuel Rosenblatt, *Yossele Rosenblatt: A Biography* (New York: Farrar, Straus and Giroux, 1954), 223–34, 252–55, 258–61, 270. On Rooney, see Jennings, *Theatrical and Circus Life*, 429; and on Cline, April 10, 1909, clipping, Cline clipping file, NYPL-LC.

18. On stereotypes see Grimsted, *Melodrama Unveiled*, 189–92, 194; on blackface minstrelsy, see Toll, *Blacking Up*, 37, 42–43, 185–87; on early variety comedy's ethnic and racial stereotypes, see Gilbert, *American Vaudeville*, 61–62; on the element of exaggeration in these stereotypes, see Distler, "The Rise and Fall of the Racial Comics," 67.

19. Raymond Williams, *Drama in a Dramatised Society* (Cambridge, England: Cambridge Univ. Press, 1975), 9.

20. Howe, *World of Our Fathers*, 401–5. The backstage visit from

the rabbi was described for me in 1984 by a Jewish man who toured with his vaudevillian father. On the boycotts and Hibernian protests, see Distler, "The Rise and Fall of the Racial Comics," 187–94. For examples of cuts, see the following from the U.B.O. report books in the Keith/Albee Collection: "kike," Keith's Boston, September 16, 1907, report book 6, p. 241; references to a "Jew boat" and "Jews running away from a sale," Keith's Boston, July 22, 1918, report book 20, p. 85; "wops," Keith's Providence, Rhode Island, theatre, December 29, 1919, report book 21, p. 123; "dirty little Greek," Keith's Boston, August 22, 1921, report book 22, p. 203.

21. On simplistic treatments of race and ethnicity in American entertainment, see Todd Gitlin, *Inside Prime Time* (New York: Pantheon, 1983), 179–87.

22. For examples of jokes involving ethnic stereotypes, see *McNally's Bulletin* (New York: William McNally 1916–1932), passim. For a list of the wide variety of types that could be impersonated by one performer, see box 14, "vaudeville performers" folder, Warshaw Collection; FTC 128, March 28, 1919, box 73, pp. 1127–31. Information on the Ross Brothers from interview with Michael Ross, New York City, December 19, 1983. On Lee Barth, see *The Player*, December 31, 1909, p. 29. On Leo Carillo, see Leo Carillo scrapbook, NYPL-LC. On Morris and Allen's appearance at the Fifth Avenue theatre in 1911, see report book 12, p. 105, Keith/Albee Collection.

23. On this point, see Carillo in March 2, 1921, clipping, n.p., NYPL-LC; remarks by David Warfield in Marks, *They All Sang*, 14–15; interview with John T. Kelly in Cleveland *Leader*, June 17, 1906, cited in Distler, "The Rise and Fall of the Racial Comics," 116–17.

24. Interview with Belle Baker, n.p., October 24, 1919, Belle Baker clipping file, NYPL-LC.

25. The description of Baker's performance is derived mainly from the following articles in the Belle Baker clipping file, NYPL-LC: on Baker at the Palace, see *New York Dramatic Mirror*, July 15, 1914, p. 17, and clipping, ca. 1916. For examples of audience reactions to a Baker performance, in particular "Eli, Eli," see the following in her clipping file, NYPL-LC: an account from an unidentified publication of her appearance at Henderson's Music Hall, Coney Island, for the week ending June 22, 1919; a clip-

ping from the *New York Star*, n.d.; on other Baker appearances, see the *Brooklyn Daily Eagle*, ca. July 1914; clipping without date or name of newspaper of origin; and, for her appearance, a picture of her from the *New York Star*, ca. June 1916.

26. The description of the Irish character is derived from Jennings, *Theatrical and Circus Life*, 420–22; and Charles R. Sherlock, "Where Vaudeville Holds the Boards," *The Cosmopolitan* 32 (February 1902): 33–34. The lyrics for "Is That Mr. Riley?" are from Gilbert, *American Vaudeville*, 68.

27. Sherlock, "Where Vaudeville Holds the Boards," 33–34.

28. On the Haggerty character, popular from the 1880s to the mid-1910s, see Distler, "The Rise and Fall of the Racial Comics," 124–26. See also "Irish Jubilee," words by J. Thornton and music by Charles Lawlor.

29. Reprinted in Slide, *The Vaudevillians*, 128.

30. For Rooney and Bent, see report book 14, p. 117; on Charles Lawlor and daughters, see report book 13, p. 86. Also see review on Joe Welch "in a study from life," report book 7, p. 157; review of "A Congressman at Large," week of September 29, 1902, undated report book, p. 12. All report books from Keith/Albee Collection.

31. All subsequent references to "The System" are from Taylor Granville, "The System" (1912), in Page, *Writing for Vaudeville*, 537–73.

32. On the prankster element in Irish-American popular music, see Mick Moloney, "Irish Ethnic Recordings and the Irish–American Imagination," in *Ethnic Recordings in America: A Neglected Heritage*, Studies in American Folklife, No. 1 (Washington, D.C.: American Folklife Center, Library of Congress, 1982), 89–90.

33. For the Bowery anecdote, see *New York Herald Tribune*, June 12, 1934, p. 21; for an anecdote on Cline's Irish appeal, see *Dramatic News*, n.d., ca. April 1907; and clipping, n.p., April 10, 1909: both in Cline clipping file, NYPL-LC.

34. See Howe, *World of Our Fathers*, 556–66.

35. See Gilbert, *American Vaudeville*, 72, 287–92; Howe, *World of Our Fathers*, 401–5.

36. Distler, "The Rise and Fall of the Racial Comics," 165–67, monologue, 208–9. For a Julian Rose recording that is very close to the version cited by Distler, see Julian Rose, "Levinsky at the

Wedding, Parts 3 and 4," Columbia A-2366, March 16, 1917. Carl H. Scheele generously introduced me to this recording and provided me with background information on it.

37. Slobin, *Tenement Songs*, 2.

38. Tucker, *Some of These Days*, 260.

39. Slobin, *Tenement Songs*, 203–5.

40. Ibid.; version of "My Yiddishe Momme" cited is from a two-sided English and Yiddish 78 rpm recording, Decca 23902. Spellings of the title vary.

41. Slobin, *Tenement Songs*, 204–5.

42. See Tucker, *Some of These Days*, 33; Jessel, *So Help Me*, photograph of Jessel and Cantor; Mark Slobin, "Some Intersections of Jews, Music, and Theater," in Cohen, *From Hester Street to Hollywood*, 36. Interview with Lloyd Pickard, Englewood, New Jersey, February 7, 1984; and Bevacqua interview.

43. Interviews with Steinberg, Schwartz, Bevacqua, Gross; Howard Basler, New York City, January 13, 1984; and Harold Applebaum, New York City, January 18, 1984.

44. Quoted in William S. Holler, "Apart but Not Alien," W.P.A. "Negro New York" file, Schomburg Center for Research in Black Culture, New York Public Library.

45. See report on May 11, 1903, show at Hyde and Behman's, Brooklyn, N.Y., undated report book, Keith/Albee Collection, 267.

46. All material cited is from Nat Wills, "Two Darkey Stories" ("Colored Social Club" and "The Headwaiter"), Columbia A-1765, March 29, 1915. I thank Carl H. Scheele for introducing me to this recording.

47. See Kimball and Bolcom, *Reminiscing With Sissle and Blake*, 52, 80.

48. See "The Facts of Vaudeville," *Equity* 8 (December 1923): 20. For an example of such books, see *McNally's Bulletin*, 1916–1918, 1920–1932, 1934, 1936, 1940. On sources of vaudevillians' material, anonymous questionnaire from a vaudeville dancer born in 1912 who wrote half of her material and learned the rest from dancers who approached her or were recommended by friends; and anonymous questionnaire from a woman born in 1904 who wrote 95% of her own material and purchased the rest from writers and music publishers.

49. For examples of inserts, see Arthur Denvir, "The Villain Still Pursued Her," in Page, *Writing for Vaudeville*, 481, and, for

the example cited, 489; DiMeglio, *Vaudeville U.S.A.*, 4; information on modifying the act from Glason interview and reminiscences communicated to the author by an anonymous female vaudevillian born 1912; on *not* modifying the act, from 1984 questionnaire from Joyce W. Zuk, DeWolfe, and reminiscences of an anonymous female vaudevillian born 1904. On this practice in the script-writing industry, see Page, *Writing for Vaudeville*, 160–62. Interview with Frank Rowan, Englewood, New Jersey, February 7, 1984. For an example of a performer being a big hit with material tailored specifically to New York City, see January 23, 1905, entry on Jack Noworth and Marie Dressler's appearance at Keith's Union Square, report book 3, p. 62, Keith/Albee Collection.

50. Glason interview; and interview with Ethel Hardey, February 23, 1984; similar information from questionnaire anonymously sent to the author in 1984 by a woman who appeared on the vaudeville stage.

51. Page, *Writing for Vaudeville*, 81.

52. See Caffin, *Vaudeville*, 62; also "Joins Joe Brady in Answering Questions on Identifying Gags," *Brooklyn Eagle*, Jan. 2, 1949, p. 20; and "Names Identifying Gags of Old Vaudevillians," *Brooklyn Eagle*, Jan. 9, 1949, p. 24.

53. Robert C. Toll, *The Entertainment Machine: American Show Business in the Twentieth Century* (New York: Oxford Univ. Press, 1982), 102–3; also Marks, *They All Sang*, 129; on performers' links to Tin Pan Alley, see Jolson, *Mistah Jolson*, 74; also Tucker, *Some of These Days*, 30, 45, 48–49, 82. DeWolfe and Hardey interviews.

54. For a discussion of the decline of urban neighborhood institutions, see Ernest W. Burgess, "The Neighborhood," in Park and Burgess, *The City*, 151. On the big time being superior to the small time, Applebaum, Gross, and Schwartz interviews; questionnaire from Florence Sinow, 1984; Basler, Steinberg interviews; interview with Arthur Kline, January 10, 1984; questionnaire from Osk and Lewis Kornbluth, 1984. Also see "Vaudeville, in Old Days, Was Classified Bigtime, Smalltime, and Lemon Time," *Brooklyn Eagle*, Sept. 17, 1950, p. 34. Interviews with fans who spoke about the stars they had seen from Gross interview, reminiscences of anonymous man born 1918, and Basler, Klein, Steinberg, and Schwartz interviews.

55. Basler, Applebaum, Kline, Gross, and Schwartz interviews.
56. For Rowett's appraisal, see "Smalltime in Vaudeville," 548. On amateur nights, interviews with Engel, Steinberg, Weinstein; Zuk questionnaire; Tucker, *Some of These Days*, 33; and Samuel Komansky, *New York Daily News*, Sept. 5, 1963, Brooklyn Historical Society clipping file, vol. 145, p. 55.
57. Following the points in Kasson, *Amusing the Million*, 39–40. Also Schwartz interview.
58. "For New Theatre," *Staten Islander*, Oct. 7, 1911, p. 1.
59. See *Newtown Register*, July 23, 1914, p. 5, and Aug. 19, 1915, p. 5.
60. See "Bronx Wants 'Big Time' Back As Summer Policy Continues," *Variety*, September 17, 1915, p. 6.
61. See "Lambs at Sing Sing," *Billboard*, June 26, 1915, p. 6; and "New York Vaudeville Notes by Walter," *Billboard*, December 14, 1915, p. 13; on Tucker, see December 17, 1918, letter to Tucker from D. S. Barr that also thanked her for her performance for wounded soldiers, Tucker clipping file, NYPL-LC. Tucker's file at the NYPL-LC contains many other letters stating that she was a hit entertaining troops in World War I. On the Van and Schenk Club, see "Brooklynite Finds Veteran Vocalist in Rockaway Beach," *Brooklyn Eagle*, Sept. 2, 1945, p. 18; "Van and Schenk Club Always Remembers," *Brooklyn Eagle*, Aug. 27, 1950, p. 25; "Mom Schenk Speaks Again About Old Days," *Brooklyn Eagle*, Oct. 14, 1951, p. 33; and "Van and Schenk Club to Honor Klink," *Brooklyn Eagle*, Nov. 18, 1951, p. 29. On audience loyalty to mass culture and the meanings it attached to mass culture, see Couvares, "Triumph of Commerce," 147.
62. Tucker, *Some of These Days*, 90. On specific acts' having followings, interviews with Michael Ross, New York City, December 19, 1983; and Engel, Glason, and Schwartz interviews.
63. Davis, *The Exploitation of Pleasure*, 24.
64. Sinow, written communication with author, 1984.

CHAPTER 7

1. "Thou Hast Learned to Love Another, or Farewell, Farewell, Forever," music by Charles Slade, Boston, 1845, reprinted in Nicholas E. Tawa, *Sweet Songs for Gentle Americans: The Parlor Song in America* (Bowling Green, Ohio: Bowling Green Univer-

sity Press, 1980), 124–25. Piano accompaniment to such songs is discussed in Tawa, *Sweet Songs for Gentle Americans,* 78.

2. Sophie Tucker, "Some of These Days," music and lyrics by Shelton Brooks, 1910, performance recorded 1911, Edison 4M-691, in *American Popular Song: Six Decades of Songwriters and Singers,* selected by James R. Morris, J. R. Taylor, and Dwight Blocker Bowers (Washington, D.C.: Smithsonian Institution Press, 1984).

3. On Victorianism see Kasson, *Amusing the Million,* 4; Lois W. Banner, *American Beauty* (New York: Alfred A. Knopf, 1983), 175–76; and John Higham, "The Reorientation of American Culture in the 1890s," in *Writing History: Essays on Modern Scholarship* (Bloomington, Ind.: Indiana Univ. Press, 1970), 79–80, 82.

4. See Albert McLean, *American Vaudeville As Ritual* (University of Kentucky, 1965), 69; Barth, *City People,* 202–3; DiMeglio, *Vaudeville U.S.A.,* 50–53, 195–96; Stein, *American Vaudeville As Seen by Its Contemporaries,* xiii.

5. Royle, "The Vaudeville Theatre," 487. Also see Leavitt, *Fifty Years,* 186; Keith, "The Origin of Continuous Vaudeville," 54; Grau, *The Stage in the Twentieth Century,* 143; Royle, "The Vaudeville Theatre," 487; Grau, *The Business Man in the Amusement World,* 108; Golden, *My Lady Vaudeville,* 19–20; and Sherlock, "Where Vaudeville Holds the Boards," 420. On performers and fans, Weintraub, Gross, Applebaum, Glason interviews.

6. On this sort of phenomenon in cultural change, see Raymond Williams, *Marxism and Literature* (Oxford: Oxford Univ. Press, 1977), 122, 113, 114. For the quip and song title, see New Brighton Theatre programs for weeks of July 7, 1919, and September 1, 1919, HTC.

7. Erenberg, *Steppin' Out,* 67.

8. Peter Bailey, "Ally Sloper's Half-Holiday: Comic Art in the 1880s," *History Workshop Journal* 16 (Autumn 1983): 22; on similar arenas of experimentation in the United States, see Peiss, "'Charity Girls' and City Pleasures" in *Powers of Desire,* 76–77, 84; and William R. Leach, "Transformation in a Culture of Consumption: Women and Department Stores, 1890–1925," *The Journal of American History* 71 (September 1984): 320–21, 327, 336–37, 341–42.

9. Bailey, "Ally Sloper's Half-Holiday," 23–24.
10. On sentiment and middle-class identity, see Karen Halttunen, *Confidence Men and Painted Women: A Study of Middle-class Culture in America, 1830–1870* (New Haven: Yale Univ. Press, 1982), xvii, 95–96, 194, 197.
11. On sentiment as an evasion, see T. J. Jackson Lears, *No Place of Grace: Antimodernism and the Transformation of American Culture, 1880–1920* (New York: Pantheon Books, 1981), 17. For the Whitman quote, see Walt Whitman, *Democratic Vistas*, 1871, reprinted in Bernard Rosenberg and David Manning White, *Mass Culture: The Popular Arts in America* (Glencoe, Ill.: The Free Press, 1957), 39–40.
12. On sentiment and self-control, see Lears, *No Place of Grace*, 12–14, 17. On moral order, see Paul Boyer, *Urban Masses and Moral Order in America, 1820–1920* (Cambridge: Harvard Univ. Press, 1978), passim. On sentimental ritual and middle-class identity, see Halttunen, *Confidence Men and Painted Women*, 33–55, 194, 196–97.
13. Francis H. McLean, "Bowery Amusements," *Yearbook of the University Settlement Society of New York, 1899*, 15–16.
14. McLean, "Bowery Amusements," 16.
15. Ibid.
16. Irving Sablosky, *American Music* (Chicago: Univ. of Chicago Press, 1969), 113–14; Rudi Blesh and Harriet Janis, *They All Played Ragtime*, 4th ed. (New York: Oak Publications, 1971), 7, 39–40; Edward A. Berlin, *Ragtime: A Musical and Cultural History* (Berkeley: Univ. of California Press, 1980), 2, 162; David A. Jasen and Trebor Jay Tichenor, *Rags and Ragtime: A Musical History* (New York: Seabury Press, 1978), 34, 101–2, 171, 182, 190; and William J. Schafer and Johannes Riedel, *The Art of Ragtime: Form and Meaning of An Original Black American Art* (Baton Rouge: Louisiana State Univ. Press, 1974), 24, 44–45, 89, 103.
17. For the "powerfully stimulating" quote, see F. H. F., *Étude Magazine*, October 1898, cited in Schafer and Riedel, *The Art of Ragtime*, xix. For the 1899 criticisms, see Arthur Weld, "The Invasion of Vulgarity in Music," *Étude Magazine*, February 1899, 52, cited in Berlin, *Ragtime*, 43. For general points on the moral judgments against ragtime, see Blesh and Janis, *They All Played Ragtime*, 9; Neil Leonard, *Jazz and the White Americans: The*

Acceptance of a New Art Form (Chicago: Univ. of Chicago Press, 1962), 26; Banner, *American Beauty*, 184.

18. For the phrase "powerfully stimulating," see F. H. F., *Étude Magazine*, October 1898, cited in Schafer and Riedel, *The Art of Ragtime*, xix. On ragtime musicians on the vaudeville stage, see Blesh and Janis, *They All Played Ragtime*, 210–13; Schafer and Riedel, *The Art of Ragtime*, 28. On Benjamin Harney at Keith's, see Blesh and Janis, *They All Played Ragtime*, 3, 210–13. On composers Egbert Van Alstyne and Percy Weinrich performing in vaudeville, see Schafer and Reidel, *The Art of Ragtime*, 110; on other ragtime composers in vaudeville, see Jasen and Tichenor, *Rags and Ragtime*, 55, 101–2, 143–44, 151, 226; and on Eubie Blake, 190. On Joplin and vaudeville, see Blesh and Janis, *They All Played Ragtime*, 232–33. On ragtime and the music industry, see Schafer and Riedel, *The Art of Ragtime*, 32–34, 37; Blesh and Janis, *They All Played Ragtime*, 3–4; Berlin, *Ragtime*, 32; Jasen and Tichenor, *Rags and Ragtime*, 6–7, 134.

19. On the different sources of ragtime's popularity, see Berlin, *Ragtime*, 45; and Hiram K. Moderwell, "Ragtime," *The New Republic* 4 (October 16, 1915), 285–86, cited in Schafer and Riedel, *The Art of Ragtime*, 41. On the redrawing of the lines between rough and respectable, see Kendall, *Where She Danced*, 95.

20. On skirt dancing, see Kendall, *Where She Danced*, 36–37. All films discussed here are in the Library of Congress, Washington, D.C. For the "Betsy Ross Dance," see American Mutoscope and Biograph, 32994, 1903. For other examples of very un-Victorian dancing from the turn of the century, see the following films: "Ella Nola, à la Trilby," Thomas A. Edison, S9209, 1898; "Girls Dancing Can-Can," American Mutoscope and Biograph Co., H23791, 1902; "Foxy Grandpa and Polly in a Little Hilarity," American Mutoscope and Biograph Co., H18034, 1902; "Dance, Franchonetti Sisters," American Mutoscope and Biograph Co., H30723, 1903; and "Theatre Hats Off," American Mutoscope and Biograph Co., H26849, 1903. For an example of the cakewalk, see "Ballyhoo Cakewalk," Biograph, H32078, 1903; "Comedy Cake Walk," American Mutoscope and Biograph Co., H31675, 1903.

21. William Dean Howells, "On Vaudeville," *Harper's Monthly*

Magazine 106 (April 1903), reprinted in Stein, *American Vaudeville As Seen by Its Contemporaries,* 72–73.

22. On the decline of slapstick in the 1910s, see Nathan, *The Popular Theatre,* 198–200; Hartley, *Adventures in the Arts,* 160; and Page, *Writing for Vaudeville,* 100.

23. Joe Weber and Lew Fields, "Adventures in Human Nature," *The Associated Sunday Magazines,* June 23, 1912, reprinted in Page, *Writing for Vaudeville,* 103–4.

24. See Weber and Fields in Page, *Writing for Vaudeville,* 103–4. On the "subversive autonomy" of Charlie Chaplin, see Couvares, "The Triumph of Commerce," 147. Bert Lahr developed his vivid, brash caricatures in burlesque and vaudeville. When he moved onto Broadway, audiences accustomed to a more restrained form of comedy considered his gestures daring. John Lahr, *Notes on a Cowardly Lion: The Biography of Bert Lahr* (New York: Alfred A. Knopf, 1969), 90.

25. The Dr. Kronkhite sketch is reprinted in Joe Smith, "Dr. Kronkhite Revisited," in Matlaw, *American Popular Entertainment,* 121–27; for biographical information, see introduction to the sketch, 128–31.

26. The opportunity for leering at the nurse is in Smith, "Dr. Kronkhite Revisited," 122; for the "expletives and resignation" quote, see Davis, "In Vaudeville," 233; for the quote on "questions as to taste," see Davis, "The Business Side of Vaudeville," 533.

27. The quote on un-Victorianism in vaudeville was made in the anonymous "The Decay of Vaudeville," *American Magazine* 69 (April 1910): 840–48, reprinted in Stein, *American Vaudeville As Seen by Its Contemporaries,* 63.

28. My thinking on these points has been influenced by Marybeth Hamilton, whose Princeton University dissertation on Mae West deals with many of these issues.

29. Examples of acts being censored from interview with anonymous woman performer born 1904; Hardey interview; DeWolfe interview; Engel interview; Tucker, *Some of These Days,* 148. On the geography of censorship, see Spitzer, "Morals in the Two-a-Day," 36; Smith interview, December 5, 1983.

30. "No Jibes at 'Y' Allowed on Keith Circuit," Philadelphia newspaper, n.p., April 28, 1919, and, on the prohibition policy, see clipping, n.d., n.p., both in Keith clipping file, NYPL-LC.

31. On the filing of cuts, see Spitzer, "Morals in the Two-a-Day," 38; and Spitzer, "The Business Side of Vaudeville," 133. For the Tucker quote, see Tucker, *Some of These Days*, 149.

32. For Kellerman, see review clipping dated January 31, 1918, in new acts book 4, p. 217; on "temptation" see report on Keith's Union Square, July 14, 1913, report book 15, p. 113; for dancers, see New Brighton Theatre program, week of August 14, 1916, p. 9; on "two nice looking shapely girls" on a tight wire, see October 5, 1906, report by C. J. Stevens on Keith's New York, report book 5, p. 137; for a report on an act called "The Bathing Girl," in which a woman in full tights was a big hit, see May 6, 1907, Lindsay Morrison report on Keith's Union Square, report book 6, p. 113. All materials cited in Keith/Albee Collection.

33. See Spitzer, "Morals in the Two-a-Day," 37.

34. "Opening of the Palace," *The Billboard*, March 24, 1913, p. 4.

35. On the dance routine, see New Brighton Theatre program, week of August 14, 1916, p. 9, HTC.

36. Renton, *The Vaudeville Theatre*, 226–27.

37. DeWolfe interview.

38. DeWolfe interview. In a similar vein, the Palace featured Annette Kellerman in 1914, a champion swimmer and diver who appeared in a tight, one-piece black tank suit. See Spitzer, *The Palace*, 42.

39. Jennings, *Theatrical and Circus Life*, 423.

40. "Sweet Italian Love," words by Irving Berlin, music by Ted Snyder, reprinted in Page, *Writing for Vaudeville*, 339–40.

41. "Oh How That German Could Love," Berlin and Snyder, reprinted in Page, *Writing for Vaudeville*, 341–42.

42. "The Art of Flirtation," by Aaron Hoffman, reprinted in Page, *Writing for Vaudeville*, 447–56, quotes from 450, 456.

43. "The German Senator," by Aaron Hoffman, reprinted in Page, *Writing for Vaudeville*, 435–43, quotes from 443.

44. See photos taken 1921, 1916–17, 1909, 1923, 1926, 1910–1914, Sophie Tucker's scrapbook, NYPL-LC. For 1918 description of Tucker's "noise and contortions," see New Acts 4, p. 217, Keith/Albee Collection; for the quote on "tottering monogamy," see *Chicago Evening Post*, by Sam Putnam, ca. 1923, Tucker clipping file, NYPL-LC.

45. For Tucker's songs and assorted reviews, see "I'm Crazy About My Daddie (In a Uniform)," by Charles R. McCarron and Carey

Morgan, 1918; on the Rip Van Winkle song, see a clipping from a July 1927 *Billboard* in Tucker's scrapbooks at NYPL-LC; on Tucker's song on divorce, see review by Sam McKee, *The Morning Telegraph* ca. Nov. 1922, Tucker clipping file, NYPL-LC; on "I Just Couldn't Make Ma Feelins Behave," see Sochen, "Fanny Brice and Sophie Tucker," 48; on "Vamp, Vamp, Vamp," see "Sophie Tucker Wins Reward of Talent," *The New York Sun*, Nov. 9, 1919, section 8, p. 6. For the point on Tucker's merger of the maternal and sensual, see Sochen, "Fanny Brice and Sophie Tucker," in *From Hester Street to Hollywood*, 48.

46. See "Blackmail" in Page, *Writing for Vaudeville*, 515–36. For the 1923 Palace monologue, see Spitzer, "Morals in the Two-a Day," 37.

47. Caffin, *Vaudeville*, 36–37.

48. On the billing, see New Brighton Theatre program, week of August 23, 1915, HTC. The bulk of the description of Tanguay in performance is taken from Caffin, *Vaudeville*, 36–38; review of Eva Tanguay performance at the Palace in *Variety*, January 1, 1915, p. 20; manager's quote is from manager of Keith's Philadelphia, May 13, 1907, report book 6, p. 124, Keith/Albee Collection. Also Schwartz letter, and interviews with Gross, Brown, and Klein. For lyrics to "I Don't Care," see Jean Lenox and Harry O. Sutton, "I Don't Care," (Shapiro, Remick and Co., 1918), reprinted in Robert A. Fremont, *Favorite Songs of the Nineties* (New York: Dover Publications, 1973), 127–31.

49. *Variety*, January 23, 1915, p. 44. For the second quote, see *Caricatures*, p. 30, Keith/Albee Collection.

50. The title "The Evangelist of Joy" was used in a program for B. F. Keith's Palace Theatre, May 14, 1917, p. 25, Palace clipping file, NYPL-LC.

51. Staples, "From 'Barney's Courtship' to Burns and Allen," 223, 420, 427–30, especially one of their vaudeville acts reprinted on 375–79; see interview with Irving Berlin on his song, "My Wife's Gone to the Country," in Page, *Writing for Vaudeville*, 368; Lahr, *Notes on a Cowardly Lion*, 67, 70–75. For a cranky but insightful analysis of changes that had occurred in vaudeville even by 1910, see the anonymous "The Decay of Vaudeville," reprinted in Stein, *American Vaudeville As Seen by Its Contemporaries*, 60–67.

52. George Burns, *Living It Up or They Still Love Me in Altoona!*

(New York: G. P. Putnam's Sons, 1976), 56–61, quoted portion is from 56–57.

53. Davy, "An Interview with George Burns," 349.

54. For an illuminating analysis that influenced many of my points here, see Shirley Staples, *Male-Female Comedy Teams in American Vaudeville, 1865–1932* (Ann Arbor: U.M.I. Research Press, 1984), 240–47.

55. Marshall D. Beuick, "The Vaudeville Philosopher," *The Drama* 16 (December 1925): 92–93, reprinted in Stein, *American Vaudeville As Seen by Its Contemporaries*, 330.

56. Beuick, "The Vaudeville Philosopher," in Stein, *American Vaudeville As Seen by Its Contemporaries*, 320.

57. On therapeutic culture, see Fox and Lears, *Culture as Consumption*, xiii; on abundance, see Warren Susman, *Culture as History: The Transformation of American Society in the Twentieth Century* (New York: Pantheon, 1984), xix–xxx. Also see Palace Theatre program, New York, NY, 1923, Palace clippings and programmes collection, NYPL-LC.

CONCLUSION

1. For a summary of the explanations for the decline of vaudeville, see Robert C. Allen, "Vaudeville and Films 1895–1915" (Ph.D. diss., Univ. of Iowa, July 1977), 298–303.

2. On vaudeville's blurring of audience divisions, see undated clipping from *The Daily Graphic*, "Vaudeville and Variety Miscellaneous" file, HTC; also a quote from Fanny Brice, "The Feel of the Audience," *Saturday Evening Post*, November 21, 1925, p. 181.

3. On vaudeville's displacement by other media, see Snyder, "American Vaudeville—Theatre in a Package," 133–140; also McLean, *American Vaudeville as Ritual*, 212. On the challenge from revues and musical comedy, see Staples, "From 'Barney's Courtship' to Burns and Allen," 344, 351.

4. On the growth of radio as an entertainment medium, see Green and Laurie, *Show Biz*, 231–244.

5. On Cantor and other vaudevillians and radio, see John E. DiMeglio, "Radio's Debt to Vaudeville," *Journal of Popular Culture* 12 (Fall 1979): 228–32. Also see Czitrom, *Media and the American Mind*, 83–84.

6. See Martin J. Porter, "Along the Airalto," *Radio Guide,* Northwestern Edition, III, April 21, 1934, p. 6, cited in DiMeglio, "Radio's Debt to Vaudeville," 230.

7. On the early years of film and vaudeville, see Robert Sklar, *Movie-Made America: A Cultural History of American Movies* (New York: Random House, 1976), 13–14; Czitrom, *Media and the American Mind,* 39; Toll, *The Entertainment Machine,* 33; and Grau, *The Business Man in the Amusement World,* 109, 111. For an extensive discussion of the relationship between early films and vaudeville, see Charles Musser, "The Chaser Theory," *Studies in Visual Communication* 10 (Fall 1984).

8. Leavitt, *Fifty Years in Theatrical Management,* 210.

9. Allen, "Vaudeville and Film 1895–1915," 230, 233–34; also Green and Laurie, *Show Biz,* 272.

10. Doris Kearns Goodwin, *The Fitzgeralds and the Kennedys: An American Saga* (New York: Simon and Schuster, 1987), 375–80; Stein, *American Vaudeville As Seen by its Contemporaries,* 336.

11. See Kearns Goodwin, *The Fitzgeralds and the Kennedys,* 379–80; Snyder, "American Vaudeville," 139.

12. Green and Laurie, *Show Biz,* 377.

Index

Slobin, Mark, 45
Small time, 61–62, 95–100, 158
Smith, Albert E., 22
Smith, Bill, 44
Smith, Frances Peck, 43
Smith and Dale, 54, 124, 138–39
Society for the Prevention of
 Cruelty to Children, 20
Society for the Reformation of
 Juvenile Delinquents, 9, 20
"Some of These Days," 131, 148
South Beach, Staten Island, 102–3
Spitzer, Marian, 107, 149
Spivak's Grand Pier, 101
Staten Island theatre districts, 92–
 93. *See also* South Beach,
 Staten Island
Stereotypes, ethnic and racial, xiv,
 6, 14, 110–12, 160
 blacks and, 14, 110, 120–23
 Irish and, 14, 23–24, 110, 113–14
 Jewish and, 110
 protests of, 110
Subways and vaudeville, 87, 94
"Sweet Italian Love," 146
Syndicate, the, 35–37, 65
"System, The," 114–17

Tammany Hall, 20
Tanguay, Eva, 54, 149–51
Terminal Music Hall, 101, 127
Theatre interiors, 28, 86–88, 97–98
Theatres
 determining the location of, 85–
 86, 88, 91–95
 expenses, 71
 management of, 66, 68, 70–72
"There Goes Crazy Eva," 149
"Thou Hast Learned to Love An-
 other, or Farewell, Farewell
 Forever," 130–31
Thompson, U. S., 53
Ticket prices, 28, 84, 86, 88, 91, 96,
 102–3
Times Square, 60, 85–87, 156
 and its diversity, 88–89, 91
Tony Pastor's Theatre, 20–21
 promotion of, 21–22

Tucker, Sophie, 55–56, 60, 131, 142,
 148, 160
"Twin Sisters," 137

Union Square, 17, 36, 58, 85
Union Square Theatre (B. F.
 Keith's), 28, 70, 155
United Booking Office (U.B.O.), 63,
 65–66, 68–74, 126–27
 advantages and disadvantages for
 managers, 70–71
 contracts, 70
 reports on acts, 72–73, 141–42
"Unknown Lady, The," 143
"Upper and Lower Ten Thousand,
 The," 16

"Vamp, Vamp, Vamp," 148
Van and Schenk, 128
Variety, 75, 78, 89, 99, 150
Variety theatre, 8, 12
 and vaudeville, 12–13, 22, 24–25,
 26
Vaudeville
 characteristics of, xiii–xvi
 cleanup of, 21, 28–30, 131–32,
 140–42
 critics of, 24–25, 128, 134, 139, 140
 cultural significance of, xv–xvi,
 12, 22–23, 124–29, 155, 160–61
 defined, 12
 economic organization of, 34–37,
 65, 83
 end of, 156–59
 relationship to New York City,
 xiii–xiv, xvi, 21–23, 82–84, 91–
 92, 103, 114, 116–17, 160–61
 shows, organization of, 66–68, 71–
 72
Vaudeville Collection Agency, 69
Vaudeville Managers' Protective
 Association, 76–80
Vaudevillians
 careers, 44–48, 52–57, 62
 communities, 58–60
 learning their craft, 49–52, 60
 origins, 42–44